The PRINT
PRODUCTION
HANDBOOK

The PRINT PRODUCTION HANDBOOK

· DAVID BANN ·

Macdonald Illustrated

A *Macdonald Illustrated* BOOK

Copyright © 1985 Quarto Publishing Ltd
First published in Great Britain in 1986
Published by Macdonald & Co (Publishers) Ltd
London & Sydney
A member of Maxwell Macmillan Pergamon Publishing Corporation

British Library Cataloguing in Publication Data
Bann, David
The print production handbook
1. Printing
I. Title
686.2 Z244

ISBN 0-356-10788-4

This book was designed and produced by
Quarto Publishing Ltd
The Old Brewery, 6 Blundell Street
London N7 9BH

Editor Michelle Newton
Designer Andy Luckhurst

Art Editor Marnie Searchwell

Art Director Alastair Campbell
Editorial Director Jim Miles

Photoset by A B Consultants, London
Colour origination by Hong Kong Graphic Arts
Printed by Leefung-Asco Printers Limited, Hong Kong

Macdonald & Co (Publishers) Ltd
Orbit House
1 New Fetter Lane
London EC4A 1AR

The author would like to thank the many people who have helped in
the preparation of this book, particularly the following: Alastair
Campbell; Geoffrey Hook of Bridge Graphics; Len Guthrie and Ken
Brown of Gilchrist Bros; Frank Smith of Ambassador Press; Dennis
Cole of New Edition; Fred Kleeberg of Kleeberg Associates, New
York; and Richard Hendel of University Press of North Carolina.
Special thanks to Crosfield Electronics Ltd for scanning services and
to the following for supplying pictures: Agfa Gevaert; Archer Press, Caslon Ltd;
Colin Cohen; Fishburn Inks Ltd; Graphic Arts Equipment Ltd: BPCC/Hazell,
Watson and Viney Ltd; Heidelberg; Leslie Hubble Ltd;
Pershke Price Ltd. Special thanks to Colin Cohen for reading the
entire manuscript and preparing the glossary and the staff of Quarto
Publishing who worked on this book.

Contents

res speciosi[or]

iniuisa terra · Dediſq;

cuius hereditaté inter ſ

Dixit auté iob post h

adragita ãnis: ⁊ uid

us et filios filioꝝ ſuo

quartã generationé

us é senex et plenus d

aliud liber iob · Inap

s b̄ ieronimi p̃ bi

ſalteriũ

dum po

darã: ⁊

nagita

magna

ſ rſim ·

INTRODUCTION

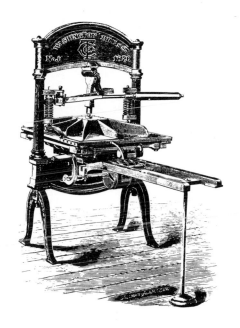

Many pundits have prophesied the demise of printing and its replacement by video disk, computer software or other types of electronic media. Why then are you reading this page, which is printed in ink on paper, rather than getting this information on the screen of a VDU? Why is printing thriving rather than in steep decline?

There are many reasons. Books and magazines are portable and do not need a power-supply to make them work; they can be read anywhere; the reader can easily go back to check something not clearly understood; advertisers like the printed page, because it cannot be switched off in the way that a TV can; moreover, to get from one article to another in a magazine you have to turn over advertising pages, so that, if the advertiser has made the image arresting enough, you read the advert.

Sometimes the very forces that are supposed to be killing print actually succour it. Books thrive in the wake of TV series or films. The spectacular growth of home and business computers has created a tremendous demand for printed matter in the form of

manuals or computer textbooks. Printed posters decorate the streets, and our frozen, dried, tinned and other foods come in brightly printed packaging.

The printed word (and picture) is not in danger as long as its exponents can be flexible and react quickly to the changing demands of the market. They must also continue to invest in the latest techniques, such as those which have not only brought down the cost of typesetting and colour separation in real terms but have also improved quality.

The last decade has given the real test of print's ability to cope with change. In this period, hot metal typesetting and the letterpress process have almost disappeared, except for certain specialist uses. Jobbing printing has moved into the high street with the 'instant print' shop. Type can be set (or at least keyboarded) by a typist or a journalist, rather than by someone with a minimum five years' apprenticeship. Typesetting and reproduction are often carried out by small, specialist businesses rather than within a large printing house.

This has not been achieved without great upheaval, and many printers who were too slow to adapt have closed. Many jobs have been lost in the printing industry as tasks that were once performed by skilled craftsmen have been taken over by machines or are now performed by the printer's customer. The printing trade unions have had an almost impossible task in reconciling the need to change with the resulting loss of jobs in the industry.

Perhaps the most noticeable change is that printing has become more accessible to the layman. Printing used only to be practised by those who had a long training in one particular aspect of the craft and spoke in a jargon incomprehensible to the outsider (rather in the way that computer experts do today). Now the barriers within the printing industry are breaking down; someone joining it from school may work in several different areas of print during his or her career, rather than being confined to one, specialist skill. Also, the barrier between print and the outside world is starting to crumble, as journalists, authors, advertisers and so on become involved in various parts of the process.

One thing that has not changed is the excitement of being involved in printing. Printed items have to be produced to a

deadline, whether they are newspapers for tomorrow's breakfast tables or a book to coincide with the launch of a new TV series. And the printed word has an authority which other media can only hope to emulate. Printers are usually obsessed with avoiding errors, because they remain on the printed page for all time and cannot be edited out — as on a TV programme. It is said that printers have 'ink in their veins', and it is certainly true that most people who start their careers in printing (or related fields) find their work exciting and fulfilling, and normally work in print for the whole of their working lives.

This book is intended primarily for those new to printing, but should also be helpful to those already working in the industry, both as a refresher and as a guide to the 'new technology'. The glossary, which contains 'state-of-the-art' definitions, will be of use to all in the industry.

Above all, rather than trying to explain such a visual subject using words alone, this is one of the few books to use the full resources of graphic design, illustration and colour printing to help explain the subject.

David Bann

1
PRINTING PROCESSES

Letterpress / Offset lithography /
Gravure / Screen printing /
Flexography / Collotype /
Die stamping and copper
engraving / Thermography /
Duplicating / Xerography /
Laser printing / Ink-jet printing

There are certain principles in printing that apply regardless of the particular process that is being used. It is important, for instance, to use the right size of press for the job: it would be inappropriate to use a large book press for a short run of headed notepaper, and equally inappropriate to use a small offset press for 100,000 copies of a magazine. Conversely, the size of the job should in general be tailored to the machine being used for printing. For example, a machine might print four pages of A4 size to view (ie, on one side of the sheet), but, should the page size used be increased to just a few millimetres bigger than A4 in either direction, this could mean that only two pages to view could be printed at once, thus doubling the amount of platemaking and printing and the time taken to do the job.

The main printing processes can be defined according to the physical characteristics of the printing surfaces used. Letterpress is a 'relief' process, where the image to be printed is raised above the background; this raised surface is inked by rollers and then pressed against the paper to make the impression. Lithography is 'planographic', with a flat printing surface: the image area is chemically treated so that it accepts ink and rejects water, while the non-image area is treated to accept water and reject ink. Gravure is an 'intaglio' process, with the printing image recessed into the plate and filled with liquid ink; the non-image area is wiped free of ink, so that ink is deposited on the paper only from the recessed wells.

Most printing processes require the paper to be either sheet-fed or web-fed.

In sheet-fed printing the paper, which is made in the form of reels (large rolls), is cut into sheets of a suitable size for the press being used. The 'feeder' section of the press picks up the sheets, usually with a combination of metal fingers and vacuum suckers, and feeds them through to be printed. The sheets then pass on to the delivery end of the press, still as flat sheets — folding or other finishing processes are a separate operation requiring other machinery.

With web-fed (also known as reel-fed) printing, the paper is supplied to the machine in the form of reels. The front end of the press has a reelstand, which holds the paper as it is unwound and fed through the press. The actual method of printing is the same as with a sheet-fed press, but printing can take place at much

higher speeds because the machine is not slowed down by having to pick up and put down each sheet before printing the next. Most web presses also incorporate some form of finishing facility after printing. Usually this is folding, but it can also include various types of gluing, stitching and perforating to give special products for direct-mail and other purposes; here the folding section of the machine may have added equipment for gluing and perforating.

The advantages of web-fed printing are speed, the fact that folding can be done at the same time as printing, and that paper on reels is cheaper than paper in sheets. Web-fed presses therefore lend themselves to long runs. The disadvantages, compared with sheet-fed printing, lie with the machines: web-fed presses involve a very high initial outlay, need more time before they are ready to start printing (the make-ready time — see below), and mostly produce only items of a fixed length. This last limitation arises from the fact that each length of paper going through the press to be brought into contact with the printing

Printing presses require paper to be either sheet-fed or web-fed. In sheet-fed printing the paper is cut into sheets of the required size before being printed. In web-fed

printing a large reel of paper is unwound as it passes through the press and is folded at the other end — the web is cut *after* it has been printed. The diagrams (**below**)

illustrate this difference between the two methods and also show the usual sequence for four-colour printing, each unit being inked with yellow, magenta, cyan or black.

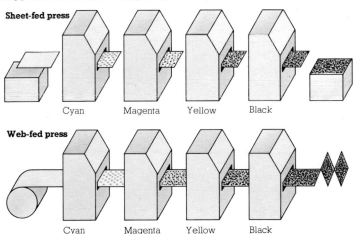

Sheet-fed press

Cyan Magenta Yellow Black

Web-fed press

Cyan Magenta Yellow Black

Letterpress (below) is a relief process. The printing surface is raised above the non-printing surface. Halftone dots vary in size.

Lithography (below) has a planographic (flat) printing surface. The image area accepts ink and repels water. The non-image area repels ink and attracts water.

Gravure (below) is an intaglio process. The printing image is recessed into the plate and filled with ink. The cells vary in depth but not in size.

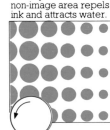

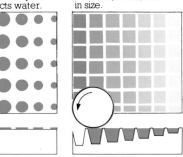

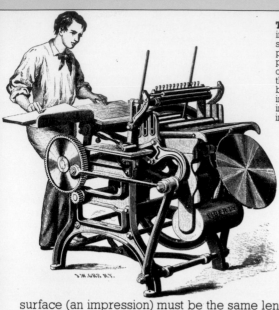

The treadle platen press in this engraving is the simplest of the letterpress presses. The treadle powers the press which operates by rollers inking the forme and then paper being pressed against the inked forme to create the impression (printed image).

surface (an impression) must be the same length as that printing surface. This length is known as the 'cut-off'; if the press were to be used to print a shorter printing image, it would require the same length of paper per impression. The printed sheets would then have to be cut down to size, with consequent wastage. Furthermore, web-fed presses waste more paper than sheet-fed paper in the make-ready process, as their high speed means that more paper is spoiled before acceptable copies are produced.

An operation that applies to all printing processes is 'make-ready' — that is, all the operations that take place prior to the first good copies being produced on a press. These operations include setting up the press to accept the size and thickness of paper being used, putting the printing plates on, putting the correct sort and colour of ink on the press, adjusting the folder (on a web-fed press), ensuring that the colour is of the right strength and that the image is in the right position — checking, in fact, that everything is correct prior to printing. Thus make-ready is a crucial area in printing, as the eventual cost of the job and the quality of the result depend on this part of the process. Obviously, while the press is being made ready it is not producing anything, and the high capital cost of equipment is not being recovered. Most modern printing techniques therefore aim to reduce the time and expense involved in make-ready.

Letterpress
Letterpress is a 'relief' process — that is, the printing surface holding the image to be printed is raised above the non-printing background. This raised surface is inked by rollers and then pressed against the paper to make the impression. Because the background is lower than the printing area, it comes into contact with neither the inking rollers nor the paper, and so does not print.

In traditional letterpress, all the text is printed from metal type and the pictures from letterpress blocks. These elements are assembled together (imposed) to create a 'forme' inside a rigid frame (chase), which is placed in the press. The printing surface therefore may be made up of hundreds or thousands of different

Making ready on an offset press. The machine minders are adjusting the register, colour, plates and paper, prior to printing.

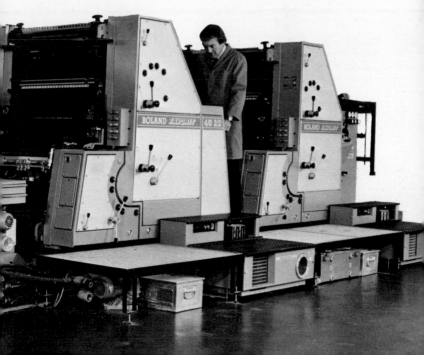

There are several letterpress printing methods — of these three are illustrated (**right**). In the **flat cylinder press** the forme lies on a flat bed, which moves under inking rollers. The paper is fed on to a rotating impression cylinder which presses it on to the inked forme. In the **sheet-fed rotary press** the printing surface is wrapped around a cylinder and by this means sheets can be printed at great speed. With the **platen press**, the forme is held vertically. The press opens, the forme is inked by rollers, and then it closes, pressing the paper against the inked forme.

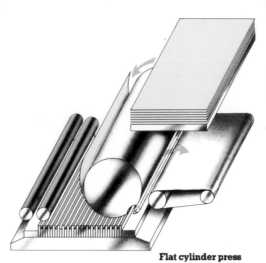

Flat cylinder press

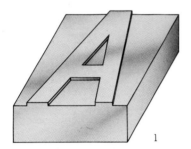

Letterpress The image areas of the letterpress block are raised while the non-image areas are recessed so that they do not pick up ink. The plate is (**1**) inked by a roller (**2**). Paper is placed over the inked image (**3**) and pressed on to the image (**4**) in the press by an impression cylinder, resulting in the image being printed on the paper (**5**).

1

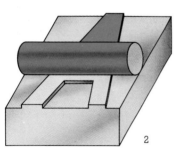

2

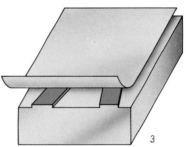

3

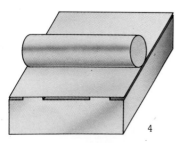

4

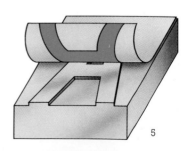

5

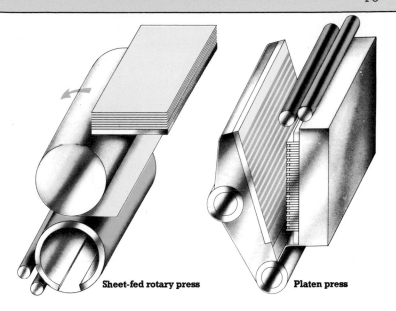

Sheet-fed rotary press **Platen press**

pieces of type, blocks and spacing. A development of letterpress uses 'stereo' or 'electro' plates for each page or for the whole 'forme'; these are described in the chapter on Origination (see page 65).

There are four main types of letterpress printing machine. All combine the following elements. Inking, printing, feeding and delivering.

The platen press The platen press consists of two plane surfaces: the forme constitutes one of these, the blank paper being placed on the opposite surface. The forme is inserted into the machine vertically and locked firmly into place. Ink is picked up by inking rollers from a revolving disc or drum above the machine, and these are then passed across the forme to charge it with ink. While the machine is open, the paper is inserted and the two flat surfaces, which are hinged at the bottom, are brought together under pressure by the press to make the impression (the printed sheet).

Such presses range from those where the paper is hand-fed and the power supplied by a food treadle to high-speed, electrically powered machines where the paper is fed in automatically by a vacuum feeder. On a platen press it is very easy to adjust the impression for different thicknesses of paper and board by altering the distance between the two surfaces, so the machine lends itself to a variety of types of work. Platen presses are normally small (up to A2) and used for jobbing work such as stationery, tickets and small leaflets. Most of this work can now be, and usually is, printed by the process of offset lithography; nevertheless, platen presses are still used for embossing, cutting and creasing and for hot-foil stamping.

The flat-bed cylinder press In this type of press, the forme is held horizontally in the flat-bed while the ink rollers and sheets of paper rotate over it alternately, the paper being held around a cylinder while it is being pressed on to the forme to make the impression.

These presses can print a sheet up to A0 size or even larger, and used to be used for printing more substantial work, such as

An automatic platen press This Heidelberg machine (**right**) is electrically driven and picks up the paper using a combination of vacuum suckers and metal fingers and places it in the correct position; ink rollers pick up ink from the large roller at the top and ink the image; the platen closes to make the impression and the paper is picked up and put on the stack of printed sheets.

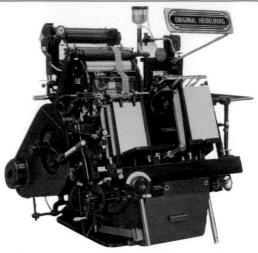

books and magazines. However, most of this work is now produced using offset lithography and, apart from a few machines operated by private presses for fine bookwork, flat-bed cylinder machines are today mainly used in commercial printing for cutting and creasing.

The rotary press Rotary presses print from a curved or flexible metal or plastic plate. The plate can be produced from a forme — by moulding from it and then making the plate from the mould — or photographically (see page 65). It is clamped to a cylinder which revolves against another cylinder carrying the paper. The plate cylinder first revolves against ink rollers and then makes an impression on the paper carried on the impression cylinder.

Rotary presses can be sheet-fed or web-fed, and letterpress is still widely used with this latter kind of press, although even here offset and gravure processes are nowadays often used instead

A belt press (**right**) Two continuous belts carry letterpress plates, printing both sides of a web of paper as it passes through the machine (arrows indicate the path the paper takes through the press). It works in the following way: the paper is fed from mill rolls (**1**) by rollers to the first printing belt (**2**), which is inked by inking rollers (**3**) — this belt prints the first side of the paper. The printed paper passes through driers (**4**) which dry the ink. The dried paper is turned over by turning bars (**5**) so that the second side of the paper can be printed by the second belt (**6**), which is inked by a second set of inking rollers (**7**). The paper, now printed on both sides, is dried by driers (**8**). The paper is then slit (**9**), folded by formers (**10**) and cut (**11**). The cut and folded paper passes along a conveyor belt to the collator (**12**), where the sections are stacked in the correct order. The stacked sections (**13**) are now ready for binding.

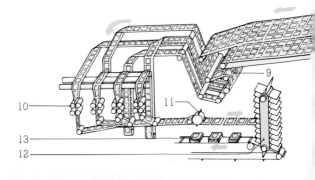

Web-fed rotary letterpress is used for labels, business forms, computer stationery and national newspapers. The technique is used also for a large proportion of mass-market paperback books, with specialized presses printing by letterpress from plastic or, by flexography (page 30), rubber plates. Sheet-fed rotary letterpress presses are now rare.

The belt press The belt press is a version of the rotary press where flexible relief plates are mounted on two continuous belts that revolve against a web of paper. The belts vary in length depending on the number of pages in the book. The printed pages are cut and folded into four-page units, collated in order, and fed directly into a binding machine, so the process can turn reels of paper into bound books in one operation. However, the belt press can print in only one colour, and the binding has to be unsewn.

These presses are used almost solely for bookwork, and the majority of the machines are made by Cameron, the company which invented this technique. The great advantages of belt presses are that they can produce virtually any size of book and lend themselves to short runs, down to two or three thousand copies, enabling the publisher to gear his runs closely to the demands of the market.

Letterpress characteristics Letterpress ink is dense and gives a strong black image. When type is printed on to a soft paper the 'squash' can be seen around each character, and this adds distinction to private-press work — when the right typeface is used: typefaces made up from fine lines print better on paper with a smooth surface using a lighter impression, as otherwise their fine detail is buried in the soft paper.

Letterpress blocks of photographs need a high quality art paper to obtain the best results in either black-and-white or colour, and the blocks themselves are very expensive compared with the equivalents used in other processes. This is because the zinc or copper used is itself expensive, and because the etching process is slow, with corrections difficult to achieve.

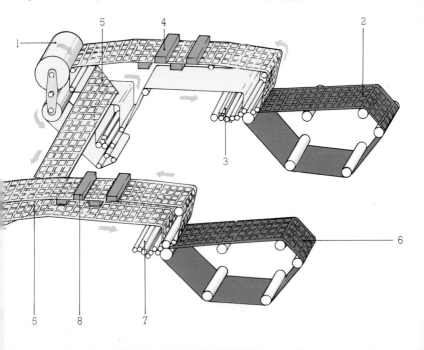

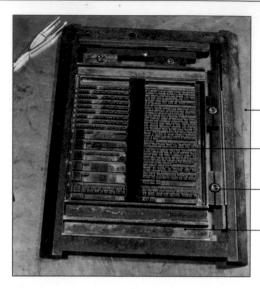

A letterpress forme The type is held in position in a chase (frame). Furniture fills the non-printing space and pressure is exerted by quoins to hold the contents firm.

Chase

Type

Quoins

Furniture

Advantages and disadvantages Except in the specialized areas mentioned above, letterpress, the dominant printing process until the mid-1960s, has largely given way to offset lithography. The disadvantages of letterpress are the high cost of the metal type and blocks: the fact that more expensive papers are required to achieve the kind of quality offset can achieve using cheaper ones; the relatively slow speed of most letterpress machines; and the fact that modern methods of origination are mainly photographic and do not lend themselves to the creation of a raised surface.

The advantages of the process are the denseness of the ink (not diluted by water or spirit, as in offset or gravure) and the quality of the impression — excellent characteristics for high-quality private-press work. In the case of newspapers and paperbacks, letterpress survives where the origination process (for example, hot metal typesetting) lends itself to the production of a raised surface. Letterpress also wastes less paper than offset, as there are no problems of holding the balance between ink and water (see below).

LETTERPRESS

Advantages
- Dense ink
- Good printing of type for high-quality books
- No problems with ink and water balance
- Less paper wastage than other processes

Disadvantages
- High cost of printing surface
- Costlier paper needed to get same results as other processes
- Sheet-fed machines run slowly
- Modern origination methods suit other processes better

Offset lithography
This is the predominant process used in printing today, being used for a wide range of items from letterheads to books and magazines. The basic process of lithography was invented by Senefelder in Bavaria in 1798, but it was only when the offset principle was applied early this century that lithography started

to be used for commercial printing, and only in the 1960s that it started to overtake letterpress as the major printing process. Prior to its commercial development, it was used mainly in the field of art, with prints made from stone printing surfaces.

The development of the process for commercial use was held back by the problems of achieving the right balance between ink and water: the water had a tendency to dilute the ink and this resulted in a rather weak and dull appearance. Now developments in inks, presses and techniques have allowed the process to exploit its obvious advantages.

The lithography process Lithography (generally known simply as 'litho') is a 'planographic' process, as the printing surface is flat rather than raised, as in letterpress, or recessed, as in gravure. The area to be printed is treated chemically so that it accepts grease (ink) and rejects water, while the non-image, or background, area is treated to accept water and reject grease. The whole surface has both ink and water applied to it. When the inked and dampened plate is then pressed against paper, only the image area is printed.

When lithography was first employed, smooth stone slabs were used to make the printing surface — this method is still used for some specialist work, such as limited editions of fine-art prints, using flat-bed presses. The next development in litho printing came with the use of grained metal plates of zinc, and now, aluminium. These can be curved around a cylinder to allow the use of a rotary press, which gives higher press speeds than flat-bed presses.

The offset lithography principle Where lithography is used it is nearly always as offset lithography. This means that the inked image on the metal plate is 'offset' (printed) onto a rubber blanket wrapped around a rotating metal cylinder; the image is transferred from the blanket onto the paper. One reason for using the blanket is to prevent the delicate litho plate from coming into

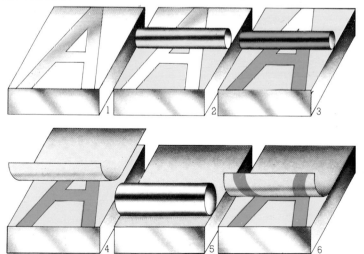

Lithography, a planographic printing process, utilizes the principle that grease and water do not mix. The image area of the plate is treated with a greasy medium (**1**) and then dampened by rollers (**2**). The plate is inked (**3**), the ink adhering to the greasy image but not to the dampened areas. The paper is moved into position over the plate (**4**) and then plate and paper are run through the press (**5**), producing the printed page (**6**).

contact with the more abrasive paper surface, which would wear the plate more significantly.

An advantage of the offset principle is that less water comes into contact with the paper than in direct lithography. Moreover, the rubber responds to irregularities of surface so that it is possible to print on to a wide variety of surfaces, including metal, for cans and boxes: special inks are used for this, and the printed metal is heat-treated after printing to give a rub- and scratch-resistant surface.

The offset press As with letterpress, all offset presses have to perform the operations of feeding, inking, printing and delivering the paper but, in addition, water has to be applied to the plate by a dampening unit.

Almost all offset presses use the rotary principle, which means that the press acts rather like a mangle — the cylinders roll against each other. This principle means that offset presses can run much faster than letterpress machines using the flat-bed principle. The printing section of the press consists of three cylinders: a blanket cylinder around which the sheet of rubber is wrapped; a plate cylinder, with the metal plate wrapped around it; and the impression cylinder, which rolls and presses the paper against the blanket cylinder to create the impression.

Offset litho requires minimal make-ready compared with letterpress, as the image is made on one piece of metal, rather than from many pieces of type and blocks. Furthermore, as we have noted, the rubber blanket compensates for differences in the surfaces being printed by adapting itself to the profile of the material.

Sheet-fed offset Sheet-fed offset presses range in size from small offset presses, which can print on paper up to A4 size, to huge machines that can print on sheets twice A0 size. Sheet-fed offset machines may print a single colour on only one side of the sheet, or they can be more sophisticated, like 'perfector' machines,

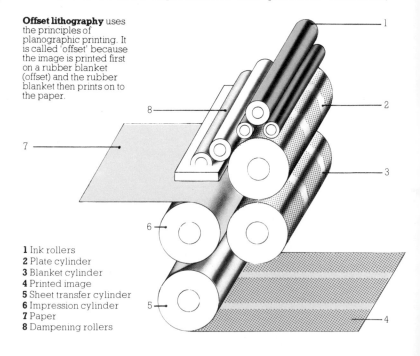

Offset lithography uses the principles of planographic printing. It is called 'offset' because the image is printed first on a rubber blanket (offset) and the rubber blanket then prints on to the paper.

1 Ink rollers
2 Plate cylinder
3 Blanket cylinder
4 Printed image
5 Sheet transfer cylinder
6 Impression cylinder
7 Paper
8 Dampening rollers

which can print a single colour on both sides of the sheet in one pass through the machine; perfecting is made possible through the use of two printing units instead of one, with a device to turn the sheet over, so that the reverse side can be printed by the second unit.

Even more sophisticated, however, are the multi-colour machines used to print several colours in a single pass through the machine. Most often, these are four-colour machines, creating a full-colour effect by overlaying the four constituent colours yellow, magenta, cyan and black. The process can achieve virtually any colour from these four process colours (a fuller description of the four-colour process is given in the chapter on Origination, see page 38).

Multi-colour presses allow the final result to be seen immediately and the ink adjusted accordingly, whereas with single-colour presses the final result is seen only after printing of the first three colours has been completed. Multi-colour presses also prevents some of the problems of loss of register (correct relative positioning) as a result of paper stretching, which happens on single-colour presses when moisture gets into the paper between the printing of one colour and the next. On multi-colour machines, each colour is printed only a fraction of a second after the previous one, so that there is little time for stretching to take place.

Sheet-fed presses can print from 4,000 to 12,000 sheets per hour. The range of work that can be printed using sheet-fed offset is enormous and covers most items printed with the exception of specialized work, such as certain types of packaging and long runs (50,000 plus) of publications.

Presses can be categorized by grouping them into three size ranges. The first of these includes those that print on paper up to A3 size. Described as 'small offset', these are the machines used by 'instant' printers and small local printers. Work produced using small offset presses consists of business cards, stationery, short runs of business forms and price lists. Those machines are also used by 'in-house' (in-plant) printers, where a large company has an internal facility for its smaller printing and photocopying requirements.

The middle category includes machines that print on paper up to A0 size. Most print two or more colours. They are used by medium to large commercial printers for publicity brochures and medium runs (5,000 to 20,000) of general colour work.

The largest sheet-fed presses can print on up to twice A0 size paper, or even larger, and are used for long runs (up to 100,000) of colour work, or on 'perfectors' (see above), for bookwork and also for posters.

Web-fed offset presses These offset machines, which print on to reels rather than sheets of paper, are taking over from sheet-fed machines in many areas of printing. Their advantages compared with sheet-fed machines, as discussed earlier (see page 10), account for their growing use with the offset litho process.

Most web-offset presses are 'blanket-to-blanket' — that is, the web of paper runs between two blanket cylinders, so that both sides are printed simultaneously; each of the two blanket cylinders thereby acts as an impression cylinder for the other (see diagram). Speeds range from 15,000 to 50,000 impressions per hour. Many of these machines have four printing units so that they can print four-colour images. A commonly used size of web-

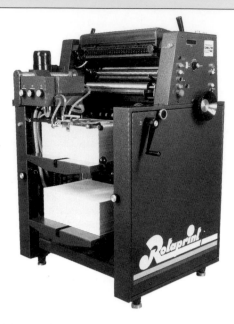

A small offset press which prints an A3 sheet and is used for letterheads, forms and other stationery. This type of press is used by in-plant and 'instant' printers.

offset press will print 16 pages of A4 paper at once.

The term 'mini-web' refers to colour presses that will print only eight A4 pages at a time. Many of these have been installed recently, and they compete keenly with the medium to large sheet-fed presses because, although they print fewer pages at a time, they print much more quickly; moreover, the folding is done on the machine.

The term 'mini-web', however, can also be used to describe the specialized bookwork presses that print 32 or 64 pages in black only — in fact, most straightforward black-and-white books, such as novels, are now printed using this type of machine. Unlike most colour web-offset machines, they have short make-ready times and are economical for runs as low as 2,000.

Web-offset machines fold the paper as they print, and colour work will usually require drying to prevent smudging of the

colours. This is achieved by passing the web through a heated tunnel after printing and before folding. Methods of drying include gas-flame, hot air, ultraviolet and infra-red radiation.

Although web-offset printing is carried out at high speeds, the quality can be as good as that of sheet-fed, because of the sophisticated controls on the presses. In fact, where a thick film of ink is used, web-offset machines can produce better results than sheet-fed ones because they normally include a drying facility. Many colour web-offset presses have a silicone applicator at the end of the machine which adds extra gloss to the product by applying a thin layer of silicone after printing.

In web-offset printing, the paper characteristics are critical. Moisture content is important for drying. Also, the paper mill must ensure that the paper is reeled in a way that will avoid it breaking on the press, which is time-consuming and expensive.

Web-offset machines are used to print magazines, holiday brochures, mail-order catalogues, books and long-run (50,000 plus) brochures; anything, in fact, that suits the offset process, has a reasonably long run and fits the fixed size of the press. In recent years many local newspapers have exchanged their web-fed letterpress machines for web-offset, which gives much better quality on photographs and also links more readily with modern typesetting methods.

Press controls Modern sheet- and web-offset machines have sophisticated electronic controls to adjust and maintain colour and register and reduce make-ready times. Although the capital cost of the machines is thereby increased, the outlay should soon be recovered as the press will spend more of its time printing and less being made ready. These controls also allow better and more consistent quality. They include plate scanners, which 'read' the amount of colour required in different areas of the plate and automatically set the ink controls on the press accordingly; computerized ink controls, which maintain the correct level of ink throughout the run, avoiding manual ink-duct adjustment; and electronic controls to maintain register by automatically keeping the colours in the correct position.

Offset characteristics As the image is laid on the paper rather than, as in letterpress, pressed into it by a raised surface, there is

Four-colour sheet-fed offset press (left)
Each unit is used for printing one of the four process colours. This type of press is used for colour brochures, magazines and books.

Blanket-to-blanket printing (right) The sheet or web of paper is printed on both sides simultaneously and the blanket cylinders act as impression cylinders to each other. The ink is transferred by a bank of inking rollers (**1**) on to the plate cylinder (**2**). The plate cylinder is kept damp by dampening rollers (**3**). The image area is transferred (or offset) on to the blanket cylinder (**4**) which in turn transfers the image on to the paper (**5**). The same sequence takes place on the underside of the paper so that both sides of the paper are printed in one pass through the machine.

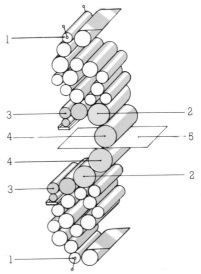

little 'squash', or thickening, of the image. Even on soft fibrous papers, fine detail can be maintained as the rubber blanket responds to the surface. In the past, offset blacks tended to greyness because of dilution by water, but modern inks have largely overcome this problem.

Advantages and disadvantages of the offset process Most of the disadvantages of the offset process originate from the use of water for dampening. This factor makes it difficult to maintain the colour balance throughout the run, although modern press controls (described above) are coping with this more and more efficiently. Moreover, some water from the dampening system comes into contact with the paper and can make it stretch, causing register problems. Offset inks are tacky and can cause a problem known as 'picking', where the fibres are lifted off the surface of the paper, leaving holes in the image. It is important when printing high-quality colour to monitor the atmospheric conditions of the press-room and, in many print companies, these are air-conditioned and humidity controlled; this is desirable to maintain the correct moisture content of the paper and helps to ensure good register.

The advantages of the process include the faithful reproduction of detail and the ability to print fine-screen halftones (see page 36). The printing plate for offset is many times cheaper than its letterpress equivalent, because of the cheaper metal used and the higher speed of platemaking. As the origination for the offset process is photographic, it works well with modern typesetting and reproduction methods. Make-ready times are shorter than those for letterpress and the rubber blanket accommodates most paper surfaces. The rotary principle also makes offset litho faster than letterpress.

Unless some completely new process is discovered, offset litho will undoubtedly be used in the future even more than it is at the moment, because of its advantages over other processes, which are becoming more and more limited to specialized types of work.

Dry offset printing This version of the offset process is also known as 'indirect letterpress' or 'offset letterpress'. There is no dampening, and the zinc or aluminium plate has a slightly raised surface — it is, in effect, a letterpress plate. This prints on to a rubber blanket and the image is then printed on to the paper.

Platemaking costs are high, as plates are made by etching. The process is used for specialist work, such as for colouring books where the colour appears when water is applied or for carton work where very strong, solid colours are required. It is

OFFSET LITHOGRAPHY

Advantages
- Good reproduction of detail and photographs
- Cheap printing surface
- Fast make-ready
- Rubber blanket enables the use of a wide range of papers
- Lends itself to photographic origination methods
- Rotary principle means higher printing speeds

Disadvantages
- Colour variation due to problems with ink/water balance
- Dampening can cause paper-stretch
- Dense ink films difficult to achieve

also used for certain kinds of security work, such as banknotes and cheques.

Gravure

Before the modern version of gravure was invented, the basic principles had long been applied: pictures were engraved on plates and printed on flat-bed presses. The introduction of photographic methods of preparing the plates has enabled the development of the modern gravure process — photogravure or rotogravure — where the printing surface is produced from film, rather than engraved by hand.

The process Gravure is an 'intaglio process'; that is, the printing image is recessed into the plate, rather than being flat, as in lithography, or raised, as in letterpress. The image consists of cells engraved into a copper-plated plate or cylinder (for a description of how these are made, see page 66). On the gravure press these cells are filled with liquid ink. The cells vary in depth, so that they will leave the required amount of ink on the various parts of the printed image. A blade called a 'doctor blade' is pulled across the surface of the plate or cylinder to remove any excess ink. The paper is fed through the press on a rubber-covered cylinder which presses the paper into the recesses to pick up the drops of ink that form the image.

The ink is very thin and, being spirit-based, dries through evaporation immediately after printing. The process, therefore, unlike web-offset, does not need elaborate drying arrangements (although these presses do need equipment to extract the solvent fumes)

The gravure press Most gravure printing is done with web-fed machines which, as in other web-fed processes, use reels of paper and folds the printed paper. The machines are usually very large, printing up to 128 pages of A4-size and running at speeds of 50,000 impressions per hour. As with web-offset, the machines have sophisticated electronic controls for register and colour. There are now very few sheet-fed gravure presses.

Uses of gravure Sheet-fed gravure is used for fine-art prints and high-quality art and photographic books, as well as the higher-denomination postage stamps. Increasingly, however, offset techniques are improving so that a similar quality can be achieved for a much lower cost.

Web-fed gravure predominates where runs are very long (300,000 copies or more), such as weekly magazines, mail-order catalogues and colour supplements. It is also used for some kinds of packaging, printing on cellophane, decorative laminates and wallpaper (where these are not printed by flexography).

Characteristics of gravure Because of the cell structure, type can look fuzzy close-to, as the cell walls break up the fine detail. However, gravure printing of photographs is often superior to that produced by other processes, as gravure gives a 'true' halftone effect: the darker areas of the photograph actually carry more ink as they are printed from the deeper cells. Also, photographs printed by gravure have greater contrast between light and dark areas, as a heavy film of ink is carried. They have good detail (unlike the type) as finer screens are used than with other processes. These qualities are evident even on cheaper papers.

Advantages and disadvantages The main disadvantage of gravure printing is the very high cost of plates and cylinders. Modern electronic techniques (see page 68) are bringing this cost

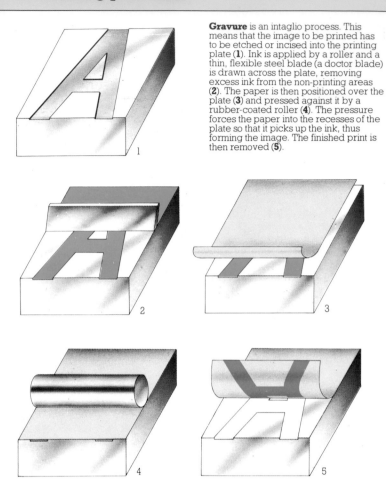

Gravure is an intaglio process. This means that the image to be printed has to be etched or incised into the printing plate (**1**). Ink is applied by a roller and a thin, flexible steel blade (a doctor blade) is drawn across the plate, removing excess ink from the non-printing areas (**2**). The paper is then positioned over the plate (**3**) and pressed against it by a rubber-coated roller (**4**). The pressure forces the paper into the recesses of the plate so that it picks up the ink, thus forming the image. The finished print is then removed (**5**).

down through automation of the process, but the cylinders are still many times the cost of offset plates. This is why gravure is used only for long runs (300,000 or more); the high cost of start-up has to be recovered over a large number of copies. Correcting colour by hand on the cylinders is much more difficult and expensive than in the simpler offset technique, where the work is done on film prior to platemaking. Proofing, to check the colour, is also expensive as the gravure proofing press is virtually a scaled-down production machine — although modern photographic proofing methods are reducing this disadvantage (see page 49). Last-minute alterations have to be done by hand, and are therefore slow and expensive; this obviously causes special problems when gravure-printed items contain time-sensitive information, as in price lists.

One of the advantages of the process is its relative simplicity — compared to offset lithography, for example — after the printing surface has been made. There is no problem of ink/water balance, and thus maintenance of consistent colour throughout the run is not as difficult. The process also allows presses to run at very high speeds (50,000 impressions per hour), and drying is straighforward.

The process permits fine-screen work on papers for which

GRAVURE

Advantages

- Simple printing method and press mechanism
- Can maintain consistent colour
- High speed
- Straightforward drying by evaporation
- Good results obtainable on cheaper paper

Disadvantages

- High cost of plates or cylinders
- Web-fed gravure viable only for long runs (300,000 +)
- Colour correction and last-minute corrections difficult and expensive
- Proofing expensive

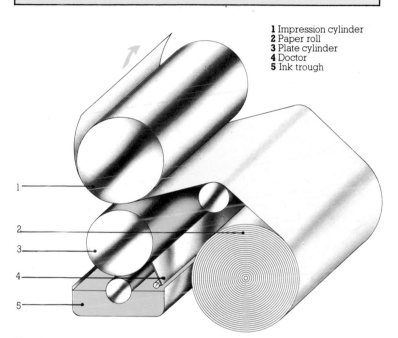

1 Impression cylinder
2 Paper roll
3 Plate cylinder
4 Doctor
5 Ink trough

Web-fed gravure presses (above) are used for long runs, printing at high speeds. They are often used for the printing of packaging. Four or five units can be used together to print in colour at high speeds.

Web-fed gravure press (below) for multi-colour printing of magazines and mail-order catalogues. In the foreground are the electronic controls for colour strength and register.

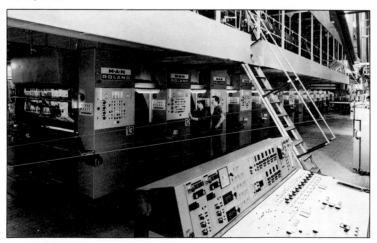

offset lithography would need a coarser screen. Nowadays, with paper costs accounting for an increasing proportion of the total cost of any print job, gravure's ability to print on lower-quality, lightweight paper is probably its biggest single advantage.

Screen printing
The use of stencils to apply an image goes back many centuries, but it was only at the beginning of this century that this was allied to the use of a screen, thus giving the process its name. It is the most versatile of the printing processes.

The process A stencil, cut by hand or made photographically (see page 68), is supported on a screen of synthetic fibre or metal. Originally, this screen was made of silk — hence the name 'silk screen printing'. The screen is stretched tightly over a frame of wood or metal, and ink is spread across the screen by means of a rubber squeegee, which squeezes the ink through the screen in the image areas. The stencil prevents ink going through in the non-image (background) areas.

The screen printing press Many screen printing presses are manually operated and consist of a simple frame hinged to a flat surface. The equipment can be very cheap and, as such, is often used by people printing at home. There are also semi-automatic presses in which, while the screen is raised and lowered and the squeegee is pulled across the screen automatically, the material to be printed has to be inserted and removed by hand.

Automatic and hand-operated machines may have vacuum bases to help them separate the paper from the screen after printing. These consist of a flat piece of plastic laminate with regularly spaced holes connected to a vacuum pump; the vacuum suction holds the paper firmly to the base. Fully automatic presses also feed and deliver the paper (or whatever is being printed on) automatically, and some have an impression cylinder which holds the paper while the screen moves in unison and the squeegee remains stationary. These presses can attain speeds of up to 6,000 copies per hour.

For hand-operated presses used on short runs (a few hundred or even less) of items such as posters, the sheets are laid out to dry on racks. The semi-automatic and automatic machines often have drying tunnels and sometimes ultraviolet drying units.

Uses of screen printing The fact that the process can apply a very thick film of ink makes it ideal for posters. Also, virtually any type of material can be printed on, including wood, fabric, glass, plastic and metal. Screen printing is therefore used for plastic and metal signs, bottles (even printing on their inside surface), transfers and electronic circuits. It can also print on very light papers and is therefore used for printing dressmaking patterns.

Advantages and disadvantages of screen printing Screen printing usually has a distinct appearance because of the thick film of ink. Although this is an advantage for most screen-printed products, it does mean that small type does not always reproduce very sharply and the fine details of photographs are difficult to reproduce to the same standard as can be achieved using other processes.

Because of the thick film of ink, screen printing can even print white on black, as well as printing metallic and fluorescent colours to much better effect than other processes. Also, the stencils are cheap to produce and short runs are more economical than with other processes. Another obvious

Squeegee arm

Screen frame

Perforated surface
attached to vacuum
pump

Screen printing press
(**right**) The paper is laid
on the flat surface which
is perforated and a
vacuum holds the paper
flat. The screen frame is
then pulled down onto the
paper and the squeegee
pulled across to force ink
through the mesh in the
image areas of the screen
onto the paper.

Silkscreen printing in its simplest form
uses a stencil. The image is cut into it and
the printing area is peeled off. A fine
gauze, stretched over a wooden frame,
forms the frame (**1**). The stencil is then
transferred to the underside of the frame
by heat and the stencil's protective
backing is peeled away, masking off the
non image areas so they do not print (**2**).
The paper is placed beneath the screen
(**3**) and ink is applied to the top of it and
spread by a squeegee (**4**). The ink
passes through the screen in the areas
where the stencil is cut away to produce
the image (**5**). In commercial silkscreen
printing, photostencils are used.

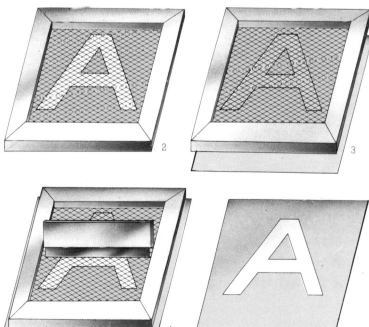

SCREEN PRINTING

Advantages
- Can print a heavy film of ink
- Economical for short runs (even below 100 copies)
- Can print on virtually any material

Disadvantages
- Difficult to achieve fine detail
- Low output
- Drying requirements

advantage is the wide range of materials on which printing can be done.

As noted, however, it is difficult to achieve fine detail and the mechanical characteristics of the process make it difficult to match the high speeds of other processes. Nevertheless, this is a very versatile process and very effective if used appropriately.

Flexography

This process is a derivative of letterpress, using flexible plates and thin, fluid inks that dry by evaporation (sometimes assisted by heat). The plates are made from rubber or photopolymer and the image is raised as in conventional letterpress.

The flexographic press Most flexographic presses are web-fed because of the nature of the products they are usually used to print. Ink is applied to the plate by a metal roller; this roller, known as an anilox roller, has cells etched into it which hold ink and transfer it to the flexible plate for printing. Many machines are multi-colour, for four-colour work.

Uses of flexography Flexography is used mainly for packaging — printing on cellophane, plastics and metallic foils; in fact, it can be used to print on virtually any material that will physically pass through the press. It is used also to produce some of the less expensive magazines as well as local and national newspapers. Its advantage for newspapers is that it can print on the same presses (sometimes rebuilt) as the metal plates of letterpress. This means that newspapers can use filmsetting, with its advantages of cheapness and speed, make photopolymer plates (see page 66) and still use letterpress presses. In fact, flexography is now rivalling offset lithography for newspapers.

Many paperback books are printed using flexography with rubber plates; the speed and cheapness of the process have greatly assisted the growth of the mass-market paperback.

Advantages and disadvantages of flexography Flexography is relatively inexpensive as the plates are cheap to make and make-ready times are short. Also, the drying part of the process is rapid and the rotary principle enables high-speed presses to be used.

The disadvantages include difficulty in reproducing fine detail and a tendency to colour variation.

Flexography used to be the poor relation of the other processes, but improvements in inks, presses and techniques have ensured that it can more than hold its own in areas such as packaging and newspapers.

Other printing processes

Collotype This process (also known as 'photogelatin') is, like lithography, a planographic process. It is now rarely used: only a handful of printers in the world still use collotype. However, this process is the only one that can produce high-quality black-and-

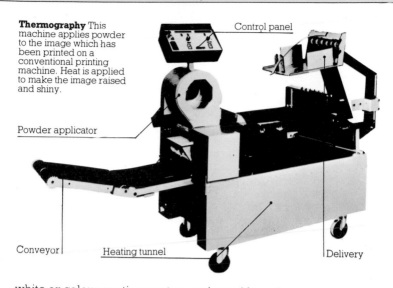

Thermography This machine applies powder to the image which has been printed on a conventional printing machine. Heat is applied to make the image raised and shiny.

Control panel

Powder applicator

Conveyor | Heating tunnel | Delivery

white or colour continuous-tone prints without the use of a screen.

The image is carried by a film of gelatin that has been made light-sensitive by being treated with potassium or ammonium bichromate (called, confusingly, 'dichromate'). The gelatin, which lies in a film on a thick sheet of plate glass or a metal plate, is placed in contact with a photographic negative and exposed to light. The gelatin then hardens according to the amount of light reaching it — the harder the gelatin, the more capable it is of accepting ink

As with lithography, the process depends on the physics of water repelling grease; the unexposed parts of the gelatin are kept moist with water and glycerine so that they repel the ink, while the other parts accept ink to a greater or lesser degree. This gives a result rather like a photograph as it can print gradations from the deepest black to the lightest tones of grey. The tone is not broken into dots, as it is with a screen.

Collotype presses are similar to direct (as opposed to offset) litho machines but run at particularly slow speeds; it may take two days to produce 2,000 sheets — the maximum that can be taken from any one plate. Nevertheless, this process can produce extremely high-quality results and is consequently sometimes used for printing small runs of fine-art reproductions.

Die stamping and copper engraving This, like gravure, is an intaglio process, where a steel or copper plate is engraved by hand or etched using photographic techniques to create a recessed image. Ink is deposited in the recesses of this 'female' die and a 'male' die of card or plastic (previously made from the 'female' die by pressure) presses the paper on to it to deposit the ink and simultaneously produce a bas-relief effect. The paper or card is raised in the image area and indented on its back.

Copper is cheaper to prepare than steel and is therefore used for shorter runs. Most of this work is done on hand presses but power-driven presses, known as die stampers, are used for runs of 1,000 or more. This technique can also be used for 'blind-embossing', where a raised image is produced but no ink is used.

The process is used for high-quality business cards, letterheads and invitations, where the glossy bas-relief effect adds distinction. Rotary versions of this process are used also in

banknote and security printing.

Thermography In this process the image is first printed in the normal way by letterpress or offset using an adhesive ink. The ink image is then coated with a resinous (thermoplastic) powder and the surplus is shaken off (from the non-image areas). The printed sheets are subjected to heat, which fuses the thermoplastic resin with the ink to give a hard, raised image. The result is glossy and simulates the results of copper engraving, but is coarser and much cheaper. It is commonly used for invitations, business cards and letterheads.

Duplicating This process is used mainly in offices, rather than by commercial printers, to produce circulars, forms, price lists and other items with runs of perhaps a few hundred where quality is not a paramount consideration. In the past, gelatin and spirit duplicating were used, but these have now almost completely given way to 'stencil duplicating', whereby a waxed stencil is cut by a typewriter. The stencil is held around a drum and ink is forced through it on to the paper.

It is possible also to produce photostencils, where a picture or handwriting is photographed and a stencil made from this. The quality of duplicators has greatly improved, giving a much sharper, cleaner result, but is still inferior to offset duplicating.

'Offset duplicators' are, in fact, true offset machines and are called duplicators simply because they are small and used for short runs of black-and-white work.

Xerography This process gave its name to 'Xerox' — the photocopier manufacturer which developed the process commercially. It works by utilizing the physics of electrostatics: particles of matter that are charged negatively and positively are attracted to their opposites. In the original version of the process, a specially coated paper was given a positive charge of static electricity. A lens projected the image to be printed on to the paper. The positive charge remained where no light fell (that is, in the black parts of the image), but was removed from the non-printing areas by means of the light reflected from them. The paper was then dusted with negatively charged black powder (toner), which stuck only to the positively charged areas. The toner was fused to the paper by heat, hardening as it cooled.

The modern development of the process uses a variation of the offset principle. The toner is deposited electrostatically on a selenium drum or belt which then prints on to plain paper. The process is also used to make plates for small offset machines.

This process has developed in a dramatic way in the last few years: the quality has improved to near-offset standard, speeds have increased to 7,000 copies per hour or more and the larger machines can collate, print both sides and insert staples. This has meant that some work, which was formerly the province of small offset presses, is now produced on these machines — particularly small numbers of manuals and price lists — and the process is now used by 'instant' printers as well as in offices. Developments in laser printing are likely to produce further advances.

Laser printing In laser printing, the image that is normally produced photographically in xerography or similar methods is produced instead by a laser beam. The laser can be controlled by a computer tape or disk holding information in digital form, and this information can be printed in the form of proper typefaces. To take an example, a manufacturer might have a parts-list on magnetic tape produced by his or her mainframe

computer. The suitably programmed laser printer can convert this taped information into typeset pages instantly and produce a parts-manual whose typeset quality compares well with that of one produced by offset litho, but at a much lower cost.

Typical products of this process are workshop manuals, timetables, business forms and other items with short runs where a fast response is required and the initial information can be stored in digital form. The process can be used also for personalized items such as address labels, direct-mail letters and so on, and can produce bar-coded labels.

A further significant use of the process is in typesetting, where proofs can be produced directly by laser printing rather than having to be output by the typesetting machine on expensive photographic paper and then photocopied. Laser printing is even used sometimes to produce the final typeset camera-ready copy — at much lower cost, although with lower resolution.

Ink-jet printing Ink-jet heads deposit droplets of ink on paper, in response to instructions given by paper tape, magnetic tape or magnetic disk. The image is produced by means of a dot matrix, which creates the letter or graphic image. As in laser printing, this process is particularly useful for labels and direct-mail.

Xerography The paper (1) is given a positive charge of static electricity (2) and the image is projected onto the paper (3), the light removing the positive charge in the non-image area. Powdered ink, which is negatively charged, is applied to the paper and sticks to the positively-charged image area (4) to produce the final print (5).

2
ORIGINATION
Originals for reproduction /
Reproduction techniques for offset
lithography / Proofing / Electronic
page planning / Specifications /
Film assembly / Imposition /
Platemaking / Origination /
Photopolymer plates

The term 'origination' describes the operations which convert original photographs or illustrations into the printing surface; the word is also sometimes used to embrace typesetting (see page 70). Most of this chapter deals with origination for offset lithography, as this is the predominant printing process today.

Originals for reproduction
The careful selection and preparation of illustrations prior to reproduction is vital if good quality is to be achieved at a reasonable cost.

Line originals These are often specially commissioned, in which case whoever is briefing the artist can ensure that they are prepared in the right way.

The original should be black, and may be drawn larger than the finished size, as reduction can help to minimize any slight inaccuracies in the artwork. It should be mounted on stable board and should include trim marks and indications of 'bleed' (where the picture is to be trimmed off at the edge of the page). Tints can be laid on by the artist or inserted by the reproduction house — the latter is more expensive, but gives a much cleaner result.

The reproduction size can be indicated either by a linear measurement or in terms of a percentage reduction or enlargement. If the work is to be reproduced at the same size it should be marked simply 's/s'.

Halftones Photographs to be reproduced as halftones should have good contrast and detail and be free from blemishes. It is possible to retouch photographs, either to remove blemishes or to improve contrast or detail, but this is expensive and should be avoided if possible. Sizing will normally be done by the designer and, in the case of photographs, the area to be used needs to be indicated (cropping) as well as the reduction or enlargement. Cropping is normally indicated on a tracing paper overlay or by marking with a *soft* pencil on the back of the picture.

Colour photographs These originals can be either trans-parencies or colour prints; the former give a brighter, sharper result. The original should have reasonable contrast. There should not be an overall colour cast. Excessive grain (normally from fast films) should be avoided as this will reproduce, particularly if the picture is enlarged. Original transparencies are preferred to duplicates, as the duplicating process always

adds somewhat to the density of the original. Although 35mm transparencies can stand a fair amount of enlargement, where the printed result is to be big (for example, a double page spread in a magazine), better results are obtained from larger transparencies, such as 5 x 4in (127 x 102mm). The sizing of transparencies is done in the same way as for monochrome halftones.

An important point is that the reproduction house will, unless instructed otherwise, attempt to reproduce the transparency exactly as it stands. So, if you want the final result to be different (for example, losing a colour cast), the relevant instructions must be given at the outset. This will avoid expensive correction and reproofing later.

Colour flat artwork Ideally, the board used by the artist should be flexible, as most colour reproduction is done on a scanner (see page 42) and the artwork should be able to be wrapped around the scanner's drum. If rigid board is used, either the artwork has to be reproduced conventionally using a camera or the top surface of the board has to be stripped off so that it can go around the drum — this can cause cracking and other damage and is to be avoided wherever possible unless the board is made for stripping.

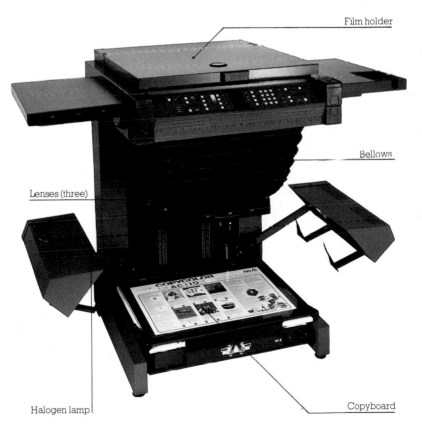

Film holder

Bellows

Lenses (three)

Halogen lamp

Copyboard

A process camera for the production of line and halftone film from originals. The original is placed on the copy board and film in the filmholder. The lens is moved to give the correct enlargement or reduction. The lamps are then switched on to give a correctly timed exposure.

Reproduction techniques for offset lithography

These can be broadly grouped under three headings: line origination, halftone origination, and colour separation.

Line origination

For this the original, normally black-and-white, is placed on the copy board of the process camera (a very large version of an ordinary camera). Film coated with a light-sensitive emulsion is placed in the back of the camera, behind the lens. On exposure, light reflected from the white areas of the original passes through the lens to fall on the film emulsion, which contains grains of silver halide that respond to light and blacken during the development process. After development, unexposed silver, which has not developed black, is dissolved in a fixing solution of sodium thiosulphate (Hypo). The developed negative can then be used for platemaking (see page 55) or sometimes, where the process requires it, contact-printed to make a positive.

The process camera's lens can be adjusted to produce film smaller or larger than the original and the exposure time can be altered to ensure that the resulting image is neither too thick (underexposed) nor too thin (overexposed).

Typesetting can come direct from the typesetter in the form of negatives or positives, but more often the typesetter supplies camera-ready copy. This is in fact a line original, and like any other line original has to be photographed (shot) to produce a negative or positive for platemaking.

Halftone origination

This process is used to produce a halftone negative or positive from continuous-tone originals, such as black-and-white photographs.

Unlike a line original, a photograph does not consist only of areas that are either black or white, but is made up of an almost infinite number of shades of grey. These cannot be printed as such by the offset process and so the greys have to be simulated by breaking the picture up into small dots: the dots are largest in the dark areas and very small in the pale areas so that the printed effect is shades of grey, although only black ink has been used.

This halftone effect is obtained by placing a 'screen' in the back of the camera, between the lens and the film. This screen (normally made of film) carries a fine grid of lines and thereby breaks the image up into dots, so producing a halftone negative.

In black-and-white reproduction, the halftone screen is usually placed at an angle of 45 degrees to the horizontal, as this makes the rows of dots less obvious to the eye.

Screens can be coarse or fine, depending on the paper that is to be used — the rougher the paper, the coarser the screen required. The numbers used to describe screens represent the number of lines per inch or, in metric, lines per centimetre on the screen; for example, 133 screen (per inch) is 54 screen (per centimetre). In the UK and USA screens are normally described in lines per inch. Most commercial, magazine and book printing on reasonable papers uses 133 or 150 screen, but newspapers on coarse paper can use halftones as low as 65 screen.

Although 150 is the finest screen used in normal commercial printing, some printers specialize in the high-quality printing of halftones for photographic books, medical textbooks or photographs of coins. Here screens as fine as 200 or even 300 are used. However, to reproduce properly, these screens need a very smooth, expensive paper.

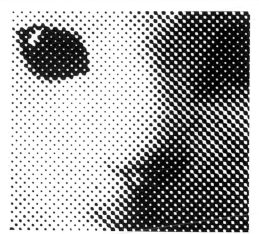

To make halftones from an original (**above**) a screen is used. If the image is enlarged (**right**) the halftone dots can be clearly seen. The lightest areas are made up of black dots on white, the shaded areas from larger black dots.

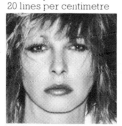

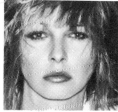

Halftone screens (left) are placed at an angle of 45° so that the pattern of dots produced is not visible to the eye. Screens are available in degrees from coarse to fine (**below**) — they range from 55 lines per inch to 300 lines per inch.

A screen angled at 90° A screen angled at 45°

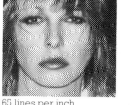

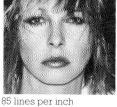

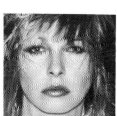

55 lines per inch
20 lines per centimetre

65 lines per inch
26 lines per centimetre

85 lines per inch
35 lines per centimetre

100 lines per inch
40 lines per centimetre

120 lines per inch
48 lines per centimetre

133 lines per inch
54 lines per centimetre

150 lines per inch
60 lines per centimetre

175 lines per inch
70 lines per centimetre

200 lines per inch
80 lines per centimetre

Another type of screen used is a 'vignetted contact screen', which also breaks the picture up into dots. However, instead of a grid of lines, the screen is made up of dots which are vignetted — that is, each dot is solid at the centre but fades away gradually towards its circumference until it disappears. This screen is placed in direct contact with the film emulsion and the eventual size of each dot on the film is determined by the amount of light passing through the respective dot on the contact screen.

Halftones can also be produced as PMTs (photomechanical transfers). PMTs are screened halftone prints on photographic paper. Since they are already screened, they can be pasted into a camera-ready paste-up and the whole can then be photographed as a line shot, instead of the photographs having to be shot separately and stripped in at film stage. This procedure can give reasonable quality as long as the screen used is no finer than 120 lines per inch.

The key to good halftone reproduction is the control of the density range — that is, the range between the highlight (nearly white) areas and the shadow (black) areas. A typical range will have highlight dots printing only 5 per cent of their screened area and shadow dots printing 95 per cent, but this can be adjusted on the camera to give different results where the original requires it. What is needed is a compromise between contrast and detail.

Most pencil drawings are treated as halftones in order to reproduce the subtle shades of grey, something line origination cannot do. Often the backgrounds of such halftones are 'dropped out', so that in these areas there are no dots, just white unprinted paper.

A variant of the halftone process is the 'duotone', a two-colour halftone printed from two negatives. There are many ways of producing duotones. As an example, the printer might shoot the black negative at normal intensity and then shoot one to print in orange ink at a lighter intensity, producing a hint of brown (black plus orange) in the shadow areas of the photograph. Or, the printer might shoot the black as a 'ghost' and print it with a full range halftone in orange, thus producing a full, brownish orange range throughout. Duotones can be particularly effective when photographs are printed with grey as the second colour; many high-quality photographic books are printed using this technique.

Additional methods of halftone origination A line-and-halftone combination employs a negative contacted from two films — one line and the other halftone. The process is used, for example, where solid type is to appear superimposed on a photograph.

It is good practice to use a grey scale when producing halftones (see page 39). This enables the camera operator to measure the result against a common standard.

Some repro houses are now producing monochrome halftones on scanners (see page 42), which can give better results because of the greater degree of control possible. Until recently this has been done on colour scanners, which is not very economic, but monochrome scanners are now being introduced.

Colour separation

Colour originals have to be 'separated' — that is, the effect of full colour has to be achieved in printing by breaking the original picture down into four components, corresponding to the three basic colours — magenta, cyan and yellow — plus black, added to give finer detail and great density in dark areas. This separation process, known as the 'four-colour process', results in

Black halftone

Full value colour halftone over black

Above left is a
conventional black
halftone. On the **right** is
the same original
reproduced as a duotone
with the second colour
originated as a full value
halftone.
An original (**left**) drawn in
pencil and reproduced
as a halftone to pick up
the subtle shades of grey
Cruder pencil drawings
can be reproduced
as line.

The colour control patch
(**below**) is placed
alongside a painting
being photographed so
that the photographer
and reproduction house
can aim to a common
standard.
A grey scale (**below**) is
used for black-and-white
photography in a similar
way to that of a colour
control patch.

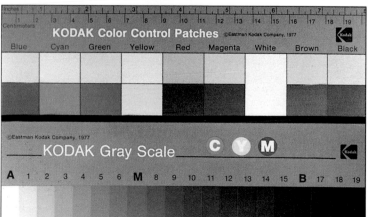

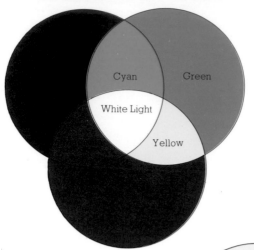

Knowing something of the colour properties of light (**left**) helps further an understanding of how the four-colour printing process works. Red, green and blue are called 'additive primaries' because they produce white light when they are added together. The combination of two additive colours produces a third colour, known as a 'subtractive' colour. Red and green therefore will produce yellow; blue and green will produce cyan; red and blue will produce magenta.

Following the same principle, when two additive primaries are combined (**right**) they will produce a 'subtractive primary' — two subtractive primaries mixed together will create an additive primary. In short, cyan and yellow make green; yellow and magenta make red; cyan and magenta make blue. Unlike the additives which produce white light when combined, the three subtractives together make black.

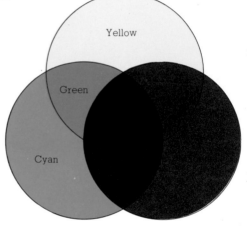

four pieces of film, one for each colour. Virtually any colour can be reproduced from combinations of these four colours; for example, greens are produced by combining a certain amount of yellow with a certain amount of cyan, the proportions varying according to the particular shade of green desired.

To explain this, some understanding of the nature of light is required. 'White' light from the sun or an artificial source is formed by a combination of all the colours of the spectrum, and these can be broken down into three 'primary' colours — red, green and blue. Since these three colours, when added together, create white light they are known as the 'additive' primaries. If one of them is taken away, the remaining two primaries combine to produce a different colour. The combination of red and blue together produce magenta; and green and blue give cyan. Magenta, yellow and cyan are therefore known as 'subtractive' primaries — or, more formally, as 'secondary' colours.

In colour separation, therefore, the negative for each of the process colours (subtractive primaries) requires the use of a filter of the respective additive primary colour. For example, to make a negative record of the yellow component of the original, a blue filter, the effect of which is to absorb all wavelengths of light reflected from the yellow components of the original, with the

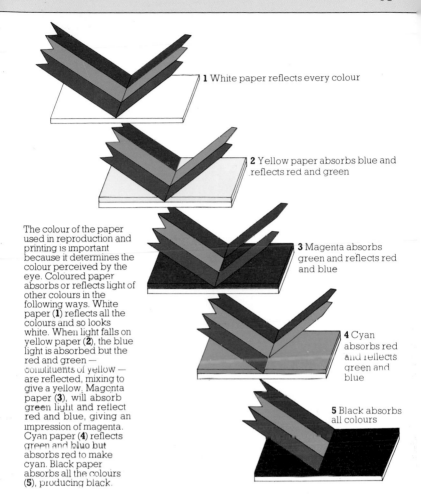

1 White paper reflects every colour

2 Yellow paper absorbs blue and reflects red and green

3 Magenta absorbs green and reflects red and blue

4 Cyan absorbs red and reflects green and blue

5 Black absorbs all colours

The colour of the paper used in reproduction and printing is important because it determines the colour perceived by the eye. Coloured paper absorbs or reflects light of other colours in the following ways. White paper (**1**) reflects all the colours and so looks white. When light falls on yellow paper (**2**), the blue light is absorbed but the red and green — constituents of yellow — are reflected, mixing to give a yellow. Magenta paper (**3**), will absorb green light and reflect red and blue, giving an impression of magenta. Cyan paper (**4**) reflects green and blue but absorbs red to make cyan. Black paper absorbs all the colours (**5**), producing black.

result that yellow is not recorded on the photographic emulsion. The blue light reflected from the original is, however, recorded. In a similar way, a green filter will produce a negative record of magenta and a red filter a negative record of cyan. To separate black, either all three filters are used, or no filter at all.

Colour originals may be transparencies, which have light shone through them, or 'flat copy' — that is, a painting or photographic print, from whose surface light is reflected. In both cases the halftone principle is used: each colour film is made up of dots whose sizes depend on the density of the relevant colour in various areas of the image. In conventional colour separation on a camera, a halftone screen has to be introduced; this can be done by either the 'direct' or 'indirect' method. In the direct method, the halftone screen is used at the time of the initial separation, so that a screened negative is produced. The indirect method starts with the production of a continuous-tone negative for each colour, with the halftone screen being introduced at a second stage, when the continuous-tone negative is contacted through a screen to produce a screened positive.

To avoid screen clash, which produces an effect known as 'moiré', the screen lines are set at different angles to each other — normally 30 degrees between each. This produces a 'rosette'

pattern that can be seen under a magnifiying glass.

To correct colour casts or to compensate for the limitations of the process, the camera operator makes masks, which are separated negatives made with special filters and combined with the original negatives.

Scanning Most colour separation is now done using electronic scanners. These use the same principles as conventional separation but work at much higher speeds, give superior quality and can produce all four colours at once. They use a high-intensity light or a laser beam to scan the original; colour filters

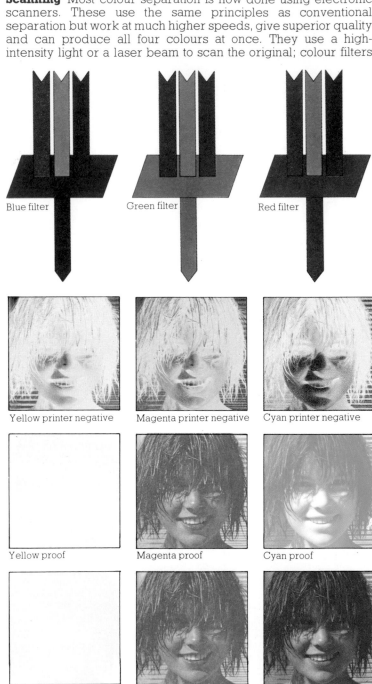

Blue filter Green filter Red filter

Yellow printer negative Magenta printer negative Cyan printer negative

Yellow proof Magenta proof Cyan proof

Yellow proof Yellow plus magenta Yellow, magenta plus cyan

and a computer are built into the scanner to convert the signals picked up by the beam into screened negatives or positives for each of the four colours.

If a job has originals that are to be reduced or enlarged by the same percentage, these can be scanned together to give savings, as long as their density range is similar. Such originals are described as 'in pro' (in proportion). (If the originals for a job require different enlargements and reductions, and so have to be scanned separately, they are described as 'out of pro'.) The originals are taped to the drum of the scanner, and the scanner

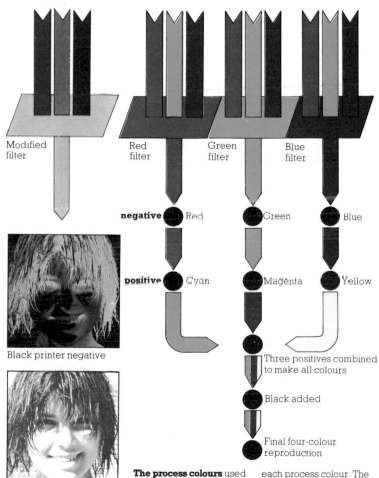

Modified filter

Red filter

Green filter

Blue filter

negative Red Green Blue

positive Cyan Magenta Yellow

Three positives combined to make all colours

Black added

Final four-colour reproduction

Black printer negative

Black proof

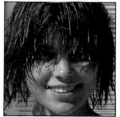

Yellow, magenta, cyan plus black

The process colours used in four-colour printing are yellow, magenta, cyan and black. Each colour is printed as tiny dots and, because they are so small, the eye visually mixes the colours to reproduce all the colours of the original. The reproduction process consists of several stages (**left**). The original is photographed four times through different colour filters using a process camera which results in a separation negative for each process colour. The blue filter, for example, gives a separation negative for the printing of yellow. After colour separation, positives are made from the separation negatives (**above** and **left**). This produces positives that will print in yellow, cyan, magenta and black. The positive images are combined in the printing process to produce full-colour images. Black is usually the last colour to be printed.

Ensuring that all the screens have been positioned correctly is one of the most important elements in printing, otherwise moiré patterns can occur. When printing an image in two colours (**1**), the black screen needs to be placed at a 45° angle (as this produces the least visible dots) and the screen for the second colour should be at a 75° angle. For three-colour printing (**2**) the same screen angles are used but the screen for the third colour is placed at an 105° angle. In four-colour printing (**3**), the black screen is placed at an angle of 45°, the magenta at 75°, the cyan at 105° and the yellow at 90°. This latter angle produces the most visible dots and this is why the screen for yellow — the lightest of the process colours — is placed at this angle. The four process colours overlap to give full-colour reproduction of the original image and this can be clearly seen (**below**). The dots have been greatly enlarged to show how the principle works, but at their normal size individual dots cannot be seen and merge to produce a full-colour effect.

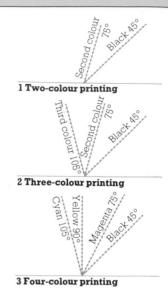

1 Two-colour printing

2 Three-colour printing

3 Four-colour printing

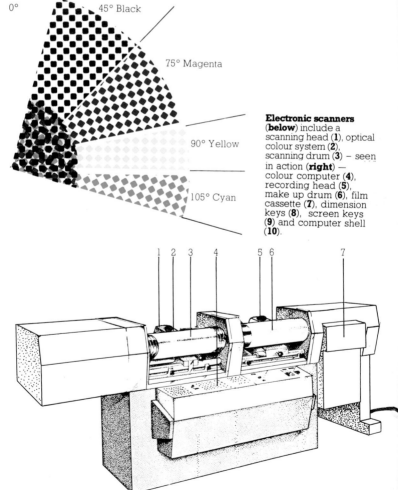

0° 45° Black

75° Magenta

90° Yellow

105° Cyan

Electronic scanners (**below**) include a scanning head (**1**), optical colour system (**2**), scanning drum (**3**) – seen in action (**right**) — colour computer (**4**), recording head (**5**), make up drum (**6**), film cassette (**7**), dimension keys (**8**), screen keys (**9**) and computer shell (**10**).

1 2 3 4 5 6 7

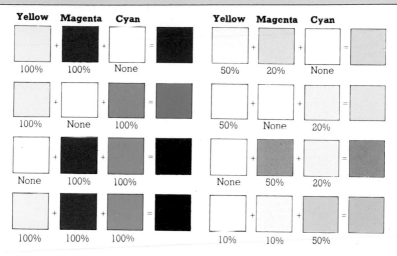

Yellow	Magenta	Cyan			Yellow	Magenta	Cyan	
100%	100%	None	=		50%	20%	None	=
100%	None	100%	=		50%	None	20%	=
None	100%	100%	=		None	50%	20%	=
100%	100%	100%	=		10%	10%	50%	=

The four process colours (yellow, magenta, cyan and black) can be printed in various combinations of percentages to produce the appearance of flat colours. In the first four columns (**above**), a few of these combinations and the colours they produce are shown. The four columns to the right of these are illustrations of a few of the tints that are available and the combinations that produced them. The process colours are largely used to reproduce full-colour continuous-tone originals, but the huge number of possible colours give tremendous flexibility.

operator keys in the percentage reduction or enlargement and the screen ruling (for example, 133). Before scanning, he or she uses a densitometer to take readings of the colour strength in different parts of the original and adjusts the scanner controls accordingly. The drum then rotates at high speed and the scanning head analyses the image as it moves along the surface of the drum. The signals are sent, via the colour filters, to the computer, which converts the digital information into light signals that are exposed onto the film, carried in a cassette. Scanners can separate all four colours at once, singly or in pairs depending on the size of the original or output of the scanner.

Flat colour artwork is scanned in the same way, but difficulties can occur with fluorescent hues as well as certain strong hues,

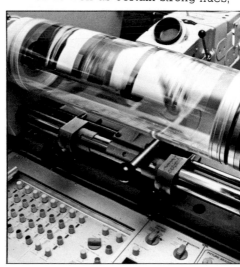

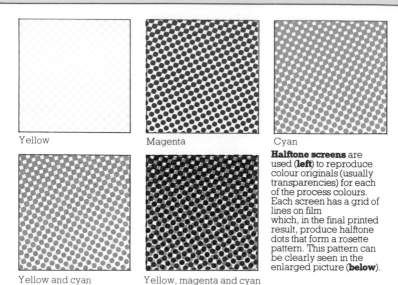

Yellow

Magenta

Cyan

Halftone screens are used (**left**) to reproduce colour originals (usually transparencies) for each of the process colours. Each screen has a grid of lines on film which, in the final printed result, produce halftone dots that form a rosette pattern. This pattern can be clearly seen in the enlarged picture (**below**).

Yellow and cyan

Yellow, magenta and cyan

such as lemon yellow, turquoise and orange. With these, the process can come close to the original colours, but cannot reproduce them exactly.

Depending on the particular make of scanner (Hell, Crosfield and Dai Nippon are three common brands), the film can be produced as: continuous tone (used for gravure cylinder preparation); with dots produced by a contact screen; or with dots burned on to the film by a laser beam. Some scanners produce screened positives with a 'hard dot', others with a 'soft

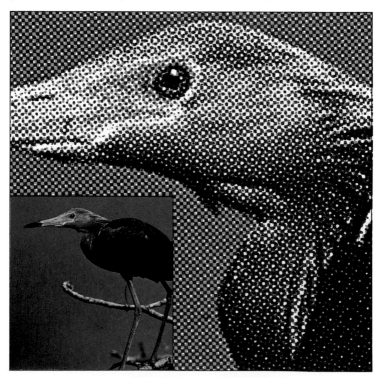

A viewing booth with standard lighting for viewing and correcting proofs. The light box on the right is for viewing transparencies and comparing them with colour proofs.

dot'. The difference determines how much colour correction can be carried out by hand (see page 52). Some scanners can be programmed to position images or lay tints and borders without the expense of electronic page planning.

Tints Where a flat area of colour is required, this is normally produced by the reproduction house using tints. A tint is not solid ink, but made up from dots of the three process colours — yellow, magenta and cyan (black can also be used). The solid colours are screened in percentages, usually in increments of ten per cent and each colour is combined with one, or both, of the other colours. In practice, this yields 1,100 combinations and another 300 can be achieved if black is incorporated.

The tint required is selected from a tint chart, which can be obtained from the reproduction house or printer. The client specifies the colour in percentages of yellow, magenta, cyan and black in this order, for example 90Y + 30M + 20C + 10B.

Dot gain The term 'dot gain' describes an increase in the dot-size that can occur when printing takes place. Normally the dot on the film can be reproduced at almost exactly the same size on the metal printing plate, but in the printed version the size may have increased. This is a result of various factors, including the blanket, the machine, the inks and paper being used.

The reproduction house must therefore allow for dot gain in the reproduction and proofing process. This is done by, in effect, purposely making the dot on the film smaller than it 'should' be so as to allow for the gain that will take place at the printing stage.

Under-colour removal This technique is used particularly when the printing is to be by web-offset. Where a subject has a dark area, the four-colour process will normally reproduce this using large dots of all four colours, whereas an identical effect can be achieved using only one or two colours. When heavy dots of all four colours overprint each other, there are drying and other problems, and more ink is used than is necessary. To avoid this situation, the scanner can be set to remove most or all of the magenta and yellow in the dark areas, leaving mainly black, sometimes with some cyan to improve the density.

The printer should inform the repro house of under-colour

This set is out of fit, meaning that the films are not all made to the same size. This gives the same effect as a set which is out of register, but obviously it cannot be corrected on the printing machine as can register.

A colour bar (below) It is used when correcting colour proofs and by the printer to ensure even colour.

removal requirements before reproduction work starts.

Achromatic colour removal This is a recent development of under-colour removal. In conventional reproduction, a grey component is formed when a hue containing a mixture of all three colour primaries is printed on paper. This inherent three-colour grey component is replaced with a corresponding amount of black. This should result in stability during the run, reduced wastage and thus savings, although the technique has still to be proven.

Proofing

Once film has been made, a proof has to be produced so that the client and reproduction house can satisfy themselves that the quality and sizing are correct and the printer, too, will require a proof to refer to when printing the finished job. Proofing can be done either on a press or by using photographic/electrostatic methods.

Press proofs are produced on a special proofing press. This is in essence an offset printing machine, which usually prints one or

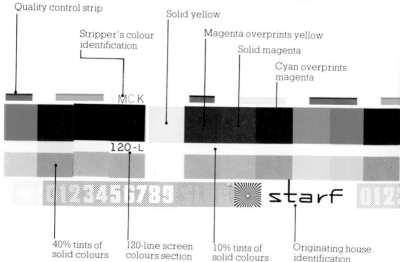

Quality control strip

Stripper's colour identification

Solid yellow

Magenta overprints yellow

Solid magenta

Cyan overprints magenta

MC K

120-L

starf

40% tints of solid colours

120-line screen colours section

10% tints of solid colours

Originating house identification

two colours at a time, with the paper fed in and taken off by hand. Before proofing, an offset plate is produced (see page 63) in the normal way. This may be a plate specially made for proofing, or can be the same plate that will eventually be used for printing (a machine plate).

It is difficult or impossible to simulate on a proofing press all the printing conditions of the production machine, because the mechanics and speed are so different. Also, most colour offset presses print ink wet on wet, whereas on a proofing press the previous colour is usually dry before the next colour is applied (wet on dry). However, if the same paper and inks are used as on the final job, a reasonably close result can be obtained.

Proofs of four-colour process work should include a colour bar (see below); this is used by the reproduction house, client and printer to check the density of colours on the proof. There are various standard colour bars, all of which enable the ink density and other factors to be read by use of a colour reflection densitometer (a device that reads the density of colours). The printer can therefore set the ink density on the press to be the same as on the proof and this can be measured accurately by meter rather than merely judged by eye — or set automatically where suitable press controls are fitted.

'Progressives' are produced when proofing: these are proofs of one, two or three of the four colours and show how the eventual proofing result has been achieved. A set of progressives will typically consist of the following stages: cyan; magenta; cyan and magenta; yellow; cyan, magenta and yellow; black; all four colours. It is essential that the printer has proofs of all these stages if he or she is to obtain the right colour strengths when printing.

An alternative to press proofing is the use of photographic/ electrostatic methods (Dupont Eurostandard Cromalin and 3M Matchprint are two common brands). A Cromalin is made by exposing each separation film on to a sheet of photosensitized clear plastic. This sheet is treated so that dust of one of the four process colours will adhere to the image areas. The four plastic sheets (one for each process colour) are superimposed in register and laminated for protection. These proofs carry colour bars and, although they are obviously not printed on the actual

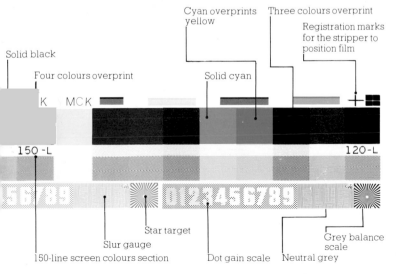

Cyan overprints yellow

Three colours overprint

Registration marks for the stripper to position film

Solid black

Four colours overprint

Solid cyan

K MCK

150 -L

120 -L

Star target

Slur gauge

Grey balance scale

150-line screen colours section

Dot gain scale Neutral grey

job paper, recent improvements in the technique allow simulation of different types of paper and a very precise allowance for dot gain. The results of the process are much less variable than with press proofing, and are generally considered more accurate. This form of proofing is cheaper than press proofing when just one or two proofs are required, but more expensive if more copies are wanted. Cromalins can only be one-sided.

Straightforward black-and-white halftones are normally proofed as ozalids (see page 63) or photographic bromides. However, for high-quality photographic work it is advisable to have press proofs on the correct paper.

The description 'random' or 'scatter' proofs is used to describe a proof of several illustrations laid down in any position to fill up the plate, as opposed to imposed proofs, where the illustrations are in the correct position relative to each other.

Checking colour proofs When the client receives colour proofs they should be checked for sizing (normally done by the designer) and colour quality. As well as the actual colour values,

Colour correction symbols (right) These symbols are commonly used for marking corrections on colour proofs. It is important to write your instructions as neatly as possible and to make further additions to the marks clear (**below**). The instruction 'improve detail and modelling' refers to the highlights and details that need enhancing. Hardness and softness are terms used to describe whether the edges of colour, shape or tone are too sharp or too indistinct respectively. If an image is out of register, the films for one or more of the four colours have been misaligned. If the edges of the image are not in register, the film has been positioned incorrectly on the plate, due to a proofing defect which elongates the halftone dots. The proofs (**far right**) illustrate some of the errors that can occur.

Instruction	Marginal mark
1 Passed for press	✔
2 Reproof	⚠2
3 Reduce contrast	☐
4 Increase contrast	■
5 Improve detail or modelling	◻■
6 Too hard, make softer	U
7 Too soft, make sharper	∧
8 Rectify uneven tint	◑
9 Repair broken type, rule or tint	✕
10 Improve register	⊡
11 Correct slur	⪥

Process colour	Increase	Reduce
Yellow	Y +	Y −
Magenta	M +	M −
Cyan	C +	C −
Black	B +	B −

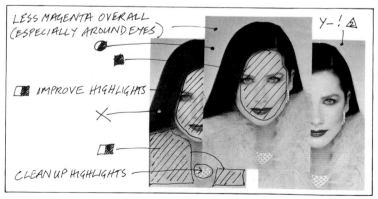

LESS MAGENTA OVERALL (ESPECIALLY AROUND EYES)

Y − ! ⚠

IMPROVE HIGHLIGHTS

CLEAN UP HIGHLIGHTS

it is also important to check for blemishes, scratches, process stains and broken screens (a magnifying glass helps here). Register (the correct positioning of the films, so that the dots are in the correct position relative to each other) must be checked: a subject which is out of register will look fuzzy and slightly out of focus, and the edge of the offending colour will be seen to protrude slightly; this is easy to correct before printing at the imposition stage. A more serious problem is where the colours are 'out of fit'. This means that, during reproduction, the films have become the wrong size relative to each other. Although the edges still appear in register, the picture will appear out of focus and a magnifying glass will show that the dots are out of position. Bad fit can usually be corrected only by rescanning.

Another error which can occur is that the picture is reversed left to right; in this event the picture must be 'flopped'. It is not sufficient simply to turn the film over: the emulsion would be on the wrong side. A new contact film has to be made, so that the emulsion is on the correct side. Which side this is depends on the

The correct version (**1**)

Too much contrast (**3**)

Not enough contrast (**4**)

Loss of detail (**5**)

Detail too hard or sharp (**6**)

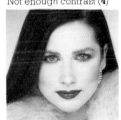
Detail too soft (**7**)

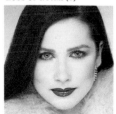
Too much yellow

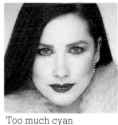
Too much cyan

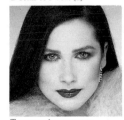
Too much magenta

Too little yellow

Too little cyan

Too little magenta

platemaking process being used; however, the emulsion, whether on negative or positive film, has to come into contact with the surface of the plate.

To check the actual colour values on the proof, it is important to have correct viewing conditions. Ideally, the client will have a viewing booth with standardized lighting which matches that used for viewing at the reproduction house and the printer. This lighting simulates daylight so, if the client does not have a viewing booth, it is best to view the proof in daylight. To compare the proof with the transparency, the transparency should be viewed on a light box, again with standardized lighting.

The purpose of this operation is to assess whether the reproduction house has achieved a result faithful to the original. When marking colour proofs it is much more sensible to tell the reproduction house what result you want to achieve than to instruct them according to how you think they can achieve it. For example, if a darker green is required, it is better to say 'darken green' than 'increase cyan', because it may be that the best way to achieve the darker green is not by increasing the cyan but by reducing the yellow.

Colour separation is probably the most complex area of printing technology, so it is best, when in doubt about colour correction, to get staff from the reproduction house in to discuss the problem.

Colour correction The introduction of scanners has improved the quality of separations to the extent that, very often, the first scan can be used without further correction. However, most batches of separations include a few that need some form of attention. Correction can be achieved in several ways. Most major correction will now be done by starting again — that is, by rescanning with the scanner adjusted to the new requirements.

If the correction can be achieved without rescanning, the four-colour set will be retouched by hand — a highly skilled and expensive process. Here an increase or decrease in the amount of colour is achieved by enlarging or decreasing the size of the halftone dots on the separation film. A colour is strengthened by reducing (etching) the dot size on a negative film, contacted from the scanned set, which means that the dots are larger when converted to positive film. To reduce a colour, dots are etched on the positive film.

Some makes of scanner produce hard-dot film, which can be etched only slightly, whereas soft-dot film allows a greater amount of retouching.

Passing colour on machine The vast majority of printing jobs are produced without the client being present but, where there is a long run of a colour book or packaging or where the colour is critical, the client will be present, either for the first one or two workings or for the complete run.

It is important to approach this job with the right attitude — which is not a question of telling the machine-minder how to do his or her job but more a question of interpretation: for example, does the client want a bright, sparkly result or a more subtle one and which subjects are the most important?

When making ready, whether or not the client is present, the printer should have the marked colour proofs and progressives to refer to, as well as the marked ozalid proof. Before passing the colour, the first sheet off the press should be checked against the ozalid to ensure that any corrections have been carried out, and

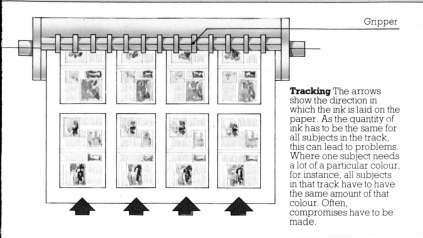

Gripper

Tracking The arrows show the direction in which the ink is laid on the paper. As the quantity of ink has to be the same for all subjects in the track, this can lead to problems. Where one subject needs a lot of a particular colour, for instance, all subjects in that track have to have the same amount of that colour. Often, compromises have to be made.

then the sheet should be checked for spots which can sometimes occur in the platemaking process (if the spots are not in the original film they can usually be deleted from the plate without removing it from the machine). Register should be checked to ensure that all the colour sets are positioned correctly.

Finally, the accuracy of the colour values should be inspected. The colour can be adjusted by regulating the amount of ink released on to the inking rollers and then on to the plate. One major problem in adjusting colour on machine is that it can be done only in 'tracks' (that is, in strips parallel to the direction in which the sheets come off the machine); thus, if you increase the magenta in one picture, the magenta will be increased in all the other subjects in that track. Another particular problem area is where the imposition (see page 65) dictates that the two halves of double page spreads are at opposite corners of the sheet; the two halves must match as nearly as possible, but without upsetting the colour balance of other subjects in the two tracks.

Decisions about colour adjustment need to be made very quickly, either because the press is already running or because it is making ready and productive time is being lost. Checking colour on machine can be an intimidating experience until the person doing it has gained experience. However, the printer will usually advise the novice on how to achieve the best result.

Most printers have standardized lighting, so that the printed sheet can be viewed in the same conditions as at the repro house; and the sheets should carry a colour bar to be checked against the one on the proof to see if the ink used is of the same strength.

Electronic page planning

Recent developments in scanners have produced machines that can scan (see page 42), store the separation information on disk in digital form, and then use this information to create the image of a complete page containing several transparencies, output on to film, in position, so that the page film consists of one complete piece of film for each colour. In addition, these machines can be used to lay tints, produce shapes and cut-outs, airbrushing and other artistic work and carry out colour correction. Most of them have a colour monitor, so the operator can visually assess the layout and colour values before being committed to film.

Some page planners can include type as well as pictures in the

layout, and can even alter typefaces and type sizes at layout stage.

The capital cost of these machines is very high, but their sophistication means that complex publications such as mail-order catalogues can be produced more cheaply and to a higher standard. Makes include Hell, Dai Nippon, Crosfield and Scitex. This is a rapidly developing field, with new machines coming out every few months. The newer systems can go direct to offset plate or gravure cylinder without using film.

CAD drafting and masking systems CAD stands for 'computer-aided design'. Most electronic page planners include facilities for drafting and masking, but many reproduction houses do not want the facilities or the expense of the full electronic page-planning system and so install a CAD system to complement their existing equipment.

Before these machines were developed, masks (to define image areas) had to be cut by hand with a scalpel. CAD machines consist of a keyboard and a digitizer, which can be used to create shapes and masks via a photoplotter and can also lay tints.

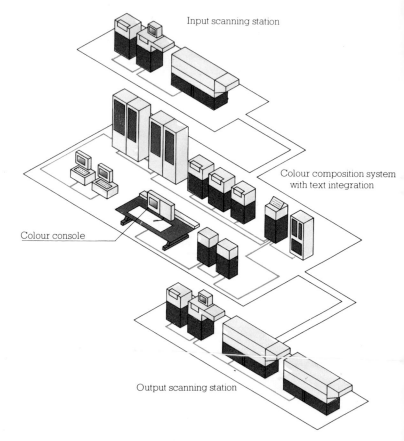

Input scanning station

Colour composition system with text integration

Colour console

Output scanning station

An electronic page planning system
Originals are scanned at the input scanning station and the digitized separations are sized and put in the correct position by the colour composition system. Type can also be put into the page layout here. The output scanning station produces one-piece final film for each colour on a page.

An input scanning station Here the operator is taping originals to the drum of the scanner prior to scanning. The input scanner will convert the originals into separations in digital form to be manipulated by the colour composition system before film is produced.

A colour console The operator has called up two pictures from the system and is sizing and positioning them. He can also use the console to colour correct, lay tints, and produce cut outs.

Specifications

Until recently, there was very little direct communication between the reproduction house and the printer, and so often film would be supplied in a form that was not ideal for the best printing result. With the increasing sophistication of machinery and demands from customers for improved quality, it is now usual for the reproduction house to work to a detailed specification. This can either be supplied by the printer, or it can be a standard specification (for instance, *Specifications for European Offset Printing*, issued by the International Federation of the Periodical Press). These specifications should include information on the following: under-colour removal, screen ruling, screen angles, type of film, colour bars, proofing direction, proofing sequence, inks, ink densities, paper, dot gain, progressives, viewing standards and types of proof.

As the customer acts as the point of contact between the reproduction house and the printer, it is important that he or she makes sure that each is aware of the other's requirements.

Film assembly, imposition and platemaking

Film assembly This is the assembly of all the type and pictorial elements within a page in the correct position. Sometimes, the typesetter will have already assembled the type in page form as camera-ready copy, leaving space for any illustrations; the

Various devices and techniques have been used by artists to make the printed page interesting and innovative. The relatively new electronic page planning systems offer almost limitless scope for the alteration of images — they can overlap pictures, produce montages, as here, change the original colours, retouch and insert border patterns. The operator alters the images, as specified by the client, at a console by pressing control keys and using an electronic cursor while viewing the image and his or her instructions on VDU screens. The systems available can offer very good quality controls and enlarge, reduce and move pictures automatically. This example (**above**) illustrates how three transparencies of a car, a landscape and a plane (**right**) can be montaged together automatically. The resulting image can be further altered if required. The system can certainly produce very high-quality work in a short space of time.

The same subject as above is treated in a different way (**right**). The operator has altered the colour of the car by using the percentage tints specified (**above**). The operator indicates the area of colour to be changed by the use of a cursor on the monitor. The designer's sketch (**above**) shows the operator the desired result.

The enlarged picture (**right**) shows how the system breaks a picture down into squares called 'pixels'. The colour of individual pixels can then be altered.

An example (**above**) of an image employing the system's tint-laying function. An even area of tint can be inserted by the operator keying in the specified percentages of each of the four process colours.

The system can be used to sharpen, or improve the definition, of originals to a certain extent (**left**). This is achieved by the system's computer which modifies the signals from the scanner, increasing the contrast over adjacent areas of detail.

Electronic page planning systems can be used to create various distortion effects. The examples here (**left** and **above**) are achieved by enlarging the height of the image by a greater proportion than the depth or vice versa.

Imposition This term is used to describe the organization of the pages on each side of a printed sheet so that they will be in the correct order when they are cut, folded and trimmed. The illustrations (**below**) show the commonly used imposition schemes and the corresponding folding methods (**right**). Margins of about 3-6mm (⅛-¼in) are left when printing and folding for trimming.

1 4-page work and turn

2 4-page work and tumble

3 8-page work and tumble

4 8-page work and tumble

5 8-page work and turn

6 8-page work and turn

7 4-page work and turn one fold

8 6-page work and turn

9 4-page work and turn one fold

10 8-page work and turn

11 8-page work and turn

12 12-page booklet work and turn

13 12-page booklet three parallel folds

14 16-page oblong booklet

15 16-page booklet

16 32-page section (16 to view)

printer will shoot the camera-ready copy (see Line origination, page 36), make negative or positive film of it; and then insert the illustrations (which usually come from a separate reproduction house in the form of film positives or negatives) in the correct position to make complete film pages. Sometimes, however, the typesetter supplies typesetting in galley form, so that the printer has to do the complete page make up. In either case, the printer works to the designer's layout to get all the elements in the right positions.

The film assembly is normally done with adhesive tape, although electronic methods are starting to be used (see Electronic page planning, page 53).

Imposition Imposition is the positioning of the pages in the right places on the plate, so that they come out in the right order and in the correct positions, with the intended margins, when printed.

Most printing machines print 8, 16 or 32 pages (or multiples of these) at a time, and the printer will work out an imposition scheme that will print the required number of pages in the most economical way on the particular machine being used. The details of the imposition will not normally concern the client if the job is being printed in one, two, three or four colours on every page; however, if the printing is to be planned so that, for example, half the pages are to be in four-colour and half in two-colour, the client must obtain the imposition scheme from the printer or binder. The illustrations and layout can then be planned according to which pages will print in four-colour and which in two.

Normally, jobs are imposed as sheet work (see page 60), but in sheet-fed printing they can be imposed as 'work and turn' (half-sheet work). This means that all the pages in a job are printed on one side of the sheet and the sheet is then turned over to print the other side.

The imposition itself, like film assembly, is normally done with adhesive tape on clear plastic foils, which are positioned on top of

the layout grid. (Accuracy can be aided by using a punch register system.) This is a slow and expensive hand operation and some printers now use electronic imposition devices such as the Opticopy. These are like a camera with a large piece of film, the same size as the printing plate. The pages are photographed one at a time and the machine moves the film so that each page is exposed in the correct position for printing. A microcomputer controls the operation, with different programs for the required imposition schemes. Even more advanced machines can expose directly on to the plate, without the need for a film stage. Some of these photograph the pages on to microfilm.

Once the imposition has been done, the printer makes ozalids (called 'blueprints' in America) from the imposed foils. Ozalid proofs are produced by a process similar to that used for dye-line prints, with the imposed foil placed over the ozalid paper, which is photosensitized. This assemblage is then exposed to light and the ozalid developed to give a white image on black or blue. Ozalids can usually be produced two-sided and are ruled up and folded so that the client can see exactly how the job will be printed.

Platemaking Once the ozalid has been approved by the client, the printer makes any necessary corrections and then produces plates from the imposed foils. The metal plate, which is usually presensitized (that is, the manufacturer has coated it with a chemical which reacts to light), is put in a vacuum frame and the imposed foil placed over it. Light from an artificial source is shone through the clear parts of the film, and this has the effect of hardening the image area. Exposure is critical and can be checked with an exposure control step wedge. When the plate is developed and washed (normally on automatic machines), the image area will attract ink and repel water while the non-image (background) area will repel ink and attract water (see The lithography process, page 19). Plates can be baked to give longer life.

The Opticopy machine (**left**), showing the page of camera-ready copy on the copy board. This is photographed on to film in the darkroom in the correct position. A plate being made in a vacuum frame (**right**). The sensitized plate is put in the frame and the imposed film placed on top in position. Vacuum holds the film tightly to the plate and the lamps expose it.

Origination for letterpress

In letterpress, pictures are printed from letterpress 'blocks' or plates which have a raised surface for the image area. Original (as opposed to duplicate — see below) plates are produced by etching. First, exactly as for offset origination, the original is photographed on a process camera and a negative is produced. The same basic principles of line, halftone and four-colour origination for offset lithography apply for letterpress up to the film stage, except for the fact that letterpress plates are made from negatives rather than positives.

A metal plate (usually zinc or copper) is coated with a light-sensitive emulsion; the negative is placed over it and the whole is exposed to light. The image area, which is clear on the negative, is hardened by the light and therefore becomes resistant to corrosion by acid. When the plate is etched, the acid therefore has the effect of bringing the non-image areas down below the level of the image area, so that they do not print. For flat-bed letterpress printing, the thin plate is mounted on a base of wood or metal to bring it up to the height of the type.

A letterpress block
(**right**) The image is the raised area and the background (non-printing) area is below the printing height and therefore does not pick up ink. The block is produced by an etching process where the background (non-printing) area is eaten away (etched) by acid.

Rubber duplicate plates are shown (**left**) imposed on a plastic sheet, or foil, for paperback printing. Each page is a separate rubber plate.

A photopolymer plate A flexible plate for printing by letterpress or flexography. The plate is made photographically from a negative and the image area is in relief.

It is also possible to have a letterpress plate that has the text as part of the plate rather than as separate type, so that the whole 'forme' consists of one plate rather than mixed type and blocks. However, this process is quite expensive and normally used only in rotary letterpress, where a curved plate is required. It is, however, the only way to make an original metal letterpress printing surface from filmset type.

Duplicate plates for letterpress Duplicate plates are made by making a mould from the original relief surface, which can be in the form of type, blocks or a mixture of both. A 'stereo' plate is made by placing a 'flong' (sheet made of paper mâché) on the original relief surface and using a press to make an indented impression in the flong. Molten metal alloy (similar to that used for metal type) is poured into the flong, and when the metal solidifies it has a relief printing surface that is a duplicate of the original.

This method first came into use in the eighteenth century when all printing was from the original metal type. Long runs meant that the type wore out, so that the whole job had to be completely reset. By contrast, when stereos wore out, new plates could easily be made from the flongs.

Alternatively, stereos can be made from rubber or flexible plastic. Here the moulding material is usually thermosetting plastic (bakelite) and the plates are made from the moulds by the application of heat and pressure. These flexible rubber or plastic plates are still used for printing paperbacks on web-fed rotary presses, although offset is now taking over. They are also used for flexography, although most of this is now done using photopolymer plates (see below).

Another form of duplicate plate is called an 'electro'. The technique was developed particularly for fine-screen halftones, where a stereo cannot give a sufficiently precise result. The mould is made of plastic and its surface is sprayed with silver compound to make it electrically conductive; the mould is then placed in an electrolytic bath, so that a film of copper 'grows' on the recessed surface of the mould. This film is then removed from the mould and filled with molten metal alloy to strengthen it.

As a result of the demise of letterpress in most areas, there are now very few companies left making letterpress original or

duplicate plates, and then only for specialized applications such as stereos for national newspapers.

Photopolymer plates

Photopolymer plates are made from a flexible plastic material and so can be curved around the cylinders of rotary presses. Unlike the other forms of relief plate described above, photopolymer plates are a 'growth area', particularly in book production, newspapers and flexography.

They are made from negatives, much in the same way as letterpress blocks. The plate material is given a light-sensitive coating that is exposed through the negative. The light hardens the image area, while the background (non-image) area remains soft and can be dissolved away to leave the image area in relief. The developed plate is then hardened by being exposed again.

In book production, photopolymer plates are used on belt presses (see page 17) as well as on web-fed rotary letterpress machines used for printing paperbacks. They are also popular for producing newspapers, as the newspaper can be filmset, yet printed on letterpress machines, with photopolymer instead of the previously used metal plates. Photopolymer plates are now the main printing surface used in the flexographic process.

Origination for gravure

The image in gravure is intaglio (see page 25). Most gravure printing surfaces are cylinders made of solid steel electroplated with a thin, highly-polished metal skin which forms the printing surface. For sheet-fed gravure, a thin copper plate is wrapped around the plate cylinder of the press.

In conventional gravure origination, the starting point is to make a continuous-tone film positive (that is, one that is

A photopolymer platemaking machine A negative is exposed to the sensitized photopolymer material. The light hardens the image area while the background remains soft and is dissolved away, leaving the image area in relief. Here, the operator is removing the exposed plate prior to processing.

unscreened) of the picture to be printed. In the case of colour, the same four-colour process is used as described in detail on page 41, but the resulting film has continuous tone. Where type is required, a line negative of the type is made and printed down with a continuous-tone negative of the pictures to make a combined positive. In this process, the film does not print down directly on to the plate, but is first transferred to a gelatin transfer medium, called 'carbon tissue', which has been screened by exposing it to light in contact with a 150-line glass screen. The lines on this screen are transparent and surround small opaque squares; the purpose, in conventional gravure, is to provide the walls around the cells which hold the ink. They do not create 'tone' as in offset or halftone gravure (see below).

Once the carbon tissue has been screened, it is exposed to the positive carrying the image. Light passes freely through the pale areas of the positive, and the gelatin in the carbon tissue hardens accordingly. The carbon tissue is then laid around the cylinder and developed to wash away any unhardened gelatin, so that gelatin of varying thickness is left on the cylinder. This is then etched using ferric chloride; the rate of penetration depends on the thickness of gelatin resisting the corrosive chemical. The result is the production of cells of differing depths, the deepest ones representing the darker areas of the subject, and carrying the most ink, and the shallower ones corresponding to the lighter areas of the subject.

A more modern technique uses the halftone principle (as in offset), in that both the size of the cells varies, as well as their depth. This technique can be combined with 'litho to gravure conversion'. The initial stages of origination are the same as they would be for the making of an offset plate but the positives are

Gravure printing (below) is suited to the printing of long runs as the plates used are very durable. A conventional gravure plate (**A**) has cells that vary in depth but which have equal surface areas. A variable surface variable depth gravure plate (**B**) has cells that vary in size as well as depth. The enlarged details above the illustrations of the surfaces of the plates show the printed results.

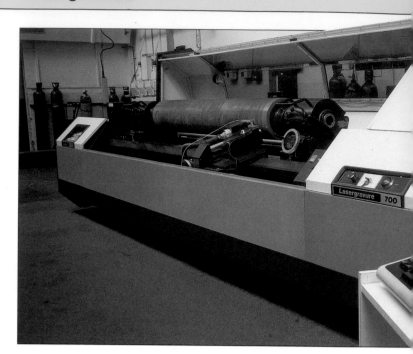

then used instead to make a gravure printing surface.

However, both the above methods are slow and expensive compared with engraving the cylinder electro-magnetically with a diamond engraving head that cuts out the cells (a laser beam can be used instead). In both cases, the cutting is controlled by a scanning head, which 'reads' the image to be reproduced. The image is a negative of one of the four process colours, and the scanning head moves across the surface of the negative in tandem with the engraving head moving across the cylinder. The darker areas of the negative are read so as to create shallower cells on the cylinder, and so forth. In some of these systems the cylinder's surface is plastic, which facilitates engraving by laser.

Electronic engraving is cheaper and more accurate than the chemical methods discussed above, and is helping to bring down gravure origination costs and so enable the process to compete at shorter run-lengths than previously.

Often gravure cylinders are chromium-plated to prevent wear on long runs. Proofing is carried out on a small-scale version of a gravure press. Colour correction, which is difficult and expensive, is done by localized etching by hand on the cylinder.

Origination for screen printing

In screen printing the image is achieved by use of a stencil which can be produced either by hand or photographically.

Hand-cut stencils are made using film that has two layers. The stencil is cut on the top layer, following a layout; those areas representing the image areas are cut out with a sharp knife, leaving the backing film behind. The film is then transferred to the screen and the backing film peeled away to leave the film blocking the openings of the mesh in the non-printing areas.

Obviously, hand-cut stencils cannot be used for small type, photographs or fine drawings and so for these a photographic process is used. Photostencils can be produced either by the

A gravure laser cylinder engraving machine The image, which is in digital form, activates the laser which evaporates the plastic surface of the cylinder. The pages already engraved can be seen to the left of the engraving head.

'indirect' or by the 'direct' method. In the indirect method, a photographic positive is produced (using the halftone and four colour processes where necessary), and this is placed in contact with the stencil film and exposed to light. Light passes through the clearer areas of the film, hardening the light-sensitive coating, while the darker areas of the film leave the coating soft, so it can be washed away chemically. The stencil is then transferred to the screen and the backing film is removed. This leaves the mesh blocked by the light-hardened areas of coating on the non-image areas.

In the direct method, light-sensitive solution is applied directly to the screen. A film positive is exposed to the coated screen and, after exposure, the soft (image) areas of the coating are washed away with chemical solution.

A screen printing stencil being cut by hand. The required shape is cut out of the top layer of the film, leaving the backing film intact.

3
TYPESETTING

Typesetting in metal/strike-on systems
and typewriters/Photocomposition/The
phototypesetting unit/Page make up
systems/Proofs and corrections/
Interfacing computers and word
processors to phototypesetters/
Type measurement/Typefaces

This century has seen dramatic changes in the ways in which type is set and in the speed and sophistication of the typesetting process. At the end of the nineteenth century, type was still being set by hand, at a speed of around 2,000 characters an hour, whereas now computerized filmsetters can produce more than two million characters per hour.

New developments in typesetting occur every few months mainly because typesetting is probably the part of the printing industry that most lends itself to computerization, so that its speed of development is linked to the rapid developments in the computer industry itself. All of this has brought down the cost of typesetting in real terms and aided the growth of publishing and printing.

Typesetting in metal

Although it is only some 30 years since photocomposition was first used commercially, setting in metal has already all but disappeared. Its demise is linked to the decreasing use of letterpress printing, because photocomposition is most suitable for the offset process, producing film that can be used directly for making a litho plate. Moreover, photocomposition is a much cleaner process and does not demand the investment of large sums of money in type metal.

It was probably Gutenberg who invented movable type in the middle of the fifteenth century: pieces of metal were cast to carry a letter of the alphabet on their face, and were assembled in lines with metal spaces. These spaces were used to 'justify' the lines — that is, to create straight left and right edges on a page of type by inserting sufficient and equal space between each word of a single line so that the last letter of every line aligns with those above and below. (In unjustified setting the spaces between the words of every line are equal and the right (or left) edge is ragged. This form of typesetting is used often in publicity and magazine work, whereas most book typesetting is still justified.) Once a job had been printed, the metal type had to be distributed by hand into the correct boxes in the case for reuse. The whole process was therefore slow and expensive.

At the end of the nineteenth century, two methods of mechanical typesetting were invented, which speeded the process of setting in metal.

The Monotype system consists of a keyboard which perforates a

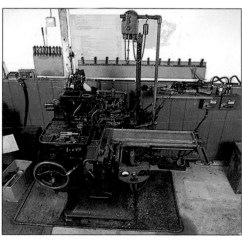

Above, metal type being set by hand. The individual letters are picked up from the wooden 'case' and placed in order so that they form the line with appropriate spaces between the words.

The Monotype keyboard (**left**) showing the banks of keys for the different alphabets (capitals, lower case, italic and so on). The white drum shows the operator how much space to put in to justify each line. At the top is the spool of paper which is perforated as the typesetter presses the keys. This paper tape drives the caster.

The Monotype caster (**right**) The spool of paper has perforations that instruct the machine to position moulds of the characters above a nozzle. The nozzle injects molten metal into the moulds to form the individual characters. The finished type is assembled one letter at a time and emerges on to the galley (**bottom right**).

paper tape that is then used to 'drive' a separate machine called a 'caster'. This squirts molten metal into a mould to form each individual character and automatically puts the right space between each word to justify the line. Corrections to Monotype setting can be done by hand, by removing the incorrect character, inserting the new one, and adjusting the spaces accordingly.

The second system of setting mechanically in hot metal is linecasting. The two (very similar) machines using this principle are the Linotype and the Intertype. Here the keyboard and the caster are combined in one machine. When the operator depresses the appropriate keys, brass matrices are fed into a holder until the line is complete; hot metal is then forced into the matrices to form a solid line of type. This system was used until recently for newspapers and cheaper books such as paperbacks.

Metal type is still used, either to print from directly in the letterpress process or to be converted for use in offset lithography, by taking a reproduction proof on smooth paper, which is then photographed to produce litho film.

Strike-on systems and typewriters

Before filmsetting systems became as cheap and available as they are now, strike-on systems were popular as a cheap typesetting method. The best known of these is the IBM Composer, which in essence is a sophisticated electronic typewriter with interchangeable typing heads ('golf balls') for the different typefaces. Unlike ordinary typewriters, however, this machine has variable character spacing with up to four different widths. The more sophisticated of these machines are computerized to

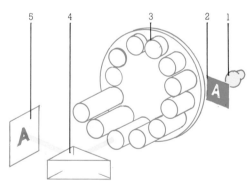

Photosetting (left) utilizes simple physics. In many systems, a high intensity light (**1**) is flashed through negatives of the type images which move on a spinning disc (**2**). The characters are projected through a lens turret (**3**) — there are several of them so that the size of the projected characters can be varied. The projected characters then pass through a moving prism (**4**), which positions them on the photosensitive film or paper.

Typesetting systems often include in their range of typefaces faces that are well known but which have been designed specifically for a manufacturer — thus producing a variety of results, as these examples of Times Roman (**right**) clearly illustrate. It is necessary, therefore, to see some sample setting on the machine that will actually be used for the whole job before choosing a face.

abcdefghijklmnopqrstuvwxyz
Photon

abcdefghijklmnopqrstuvwxyz
APS 4

abcdefghijklmnopqrstuvwxyz
Bobst Eurocast

abcdefghijklmnopqrstuvwxyz
Linotron 202

abcdefghijklmnopqrstuvwxyz
Monophoto 2000

abcdefghijklmnopqrstuvwxyz
Linocomp

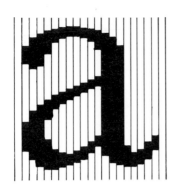

A CRT (cathode ray tube) typesetter
was used to set this character. CRT typesetters work in two ways: one type stores the data in the computer and the type is generated electronically (using a digital fount) on to a video display unit. It is then transferred to photosensitive paper or film. A second type of CRT typesetter scans a photographic fount to produce the characters. Both generate characters by means of dots or lines (**left**).

achieve automatic justification.

The typographic quality of these systems leaves something to be desired, but, before photocomposition systems became cheaper, these systems were an effective method of low-cost typesetting.

Photocomposition

Nearly all typesetting is now done by photocomposition (also known as filmsetting or photosetting). Although the term 'photocomposition' means setting type by photographic methods, it is used also to cover electronic composition methods that are not strictly photographic.

Within the boundaries of photocomposition, there are three main methods of image formation; the names for these come from the different types of photocomposition machines. The three

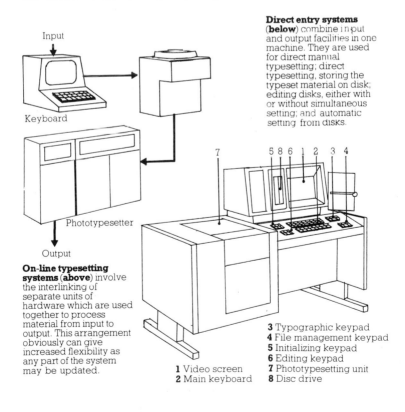

Input

Keyboard

Phototypesetter

Output

Direct entry systems (**below**) combine input and output facilities in one machine. They are used for direct manual typesetting; direct typesetting, storing the typeset material on disk; editing disks, either with or without simultaneous setting; and automatic setting from disks.

On-line typesetting systems (above) involve the interlinking of separate units of hardware which are used together to process material from input to output. This arrangement obviously can give increased flexibility as any part of the system may be updated.

1 Video screen
2 Main keyboard
3 Typographic keypad
4 File management keypad
5 Initializing keypad
6 Editing keypad
7 Phototypesetting unit
8 Disc drive

Photomechanical typesetting A cathode ray tube (CRT) or index tube (**1**) generates scan lines by directing a beam of light through a lens (**2**) which focuses it though the negative of the desired character on the matrix grid (**3**). The character is sized by a condenser lens (**4**) and the image passes into the photomultiplier (**5**). The scan lines create a video signal which is amplified by the video amplifier (**6**) and these signals then activate the write-out CRT (**7**) which travels along its carriage (**8**), aligning the characters horizontally on the photographic paper or film (**9**).

methods are photomechanical, digitized cathode ray tube (CRT) and digitized laser.

The photomechanical method produces type images by the shining of light through a glass or film negative of the character onto photographic film or paper.

In digitized CRT, the character is produced either by a contact process, where the film or paper is placed over the front of the CRT itself (onto which the image is projected), or by optical transmission of the tube beams directly onto the film or paper.

The digitized laser method uses a laser instead of a CRT to produce the image. This last method is very fast. However, early models had poor character resolution. Current machines have overcome this problem, and digitized laser is the method in use on the newer generation of machines.

The methods described above relate to the output device. In addition, all modern photocomposition systems have a keyboard and a computer

The keyboard The keyboard normally consists of an ordinary typewriter keyboard with extra keys for special typographic commands. Keyboards can be 'counting' or 'non-counting'. A counting keyboard will allow for the widths of the characters being set and permit the operator to make the end-of-line decisions on justification and hyphenation. A non-counting keyboard will produce only a continuous string of characters, so that the decisions about hyphenation and justification have to be performed by the computer. Most keyboards have a VDU, so that the operator can see what he or she is keying; this VDU can also be used to correct errors. The keyboard can be connected directly to the computer (on-line), or it can produce a disk or magnetic or paper tape which will 'drive' the computer and photosetting device. A floppy disk allows 'random access', which

means it is possible to access instantly any part of the matter that has been keyed in, so that correcting and editing are much easier

The computer The computer is used to convert signals from the keyboard into signals that will instruct the photosetting device to set characters in the correct typeface and size and to the correct measure. It is also used for hyphenation and justification where copy has been keyed on a non-counting keyboard.

Computers achieve hyphenation in various ways. A 'discretionary' program is one that uses a hyphen only if it is in a word that falls at the end of a line, all other hyphens having been inserted by the operator. 'Logical' hyphenation works by having a set of rules governing hyphenation — covering all words ending in 'ing', for example. Although this system will cope with a large percentage of hyphenation decisions correctly, it will still produce a significant number of errors; for example, it might break sing as 's-ing'.

These errors in 'logical' hyphenation have to be corrected by the operator at a later stage, so, in order to avoid this, the larger and more sophisticated machines have hyphenation systems that use an 'exception dictionary', whereby all the words that are not subject to 'logical' hyphenation are listed. Even this can leave a few errors, so a 'true dictionary' is sometimes used, which hyphenates words of six or more letters according to correct English usage. These dictionaries (also available for other languages) are stored in the memory of the computer. The rate of their success depends on the number of words that can be stored, and this can vary considerably.

A more recent development is the use of computer dictionaries to check spelling and indicate misspelt words for the operator.

The computer — or, sometimes, the combination of keyboards and computer — is described as the 'front end' system, the back end being the phototypesetting device itself.

The phototypesetting unit

This device actually outputs the final typeset product on to film or photographic paper. As described earlier, there are three methods of image formation. In machines using the photomechanical method, the founts of type (the whole alphabet and numerals in various styles, upper and lower case, bold, italic) are carried in the form of negative images through which a light is shone on to photographic film or paper. Founts can be in the form of film strips or disks, and most machines allow more than one fount to be carried, so that the bold and italic of a face can be set at the same time as the roman. More sophisticated machines carry several typefaces, so a job can be set in its entirety, without having to combine galleys of different faces at the make up stage. Different sizes are achieved by photographic enlargement or reduction.

In digital CRT or laser machines, the characters are stored in digital form on a disk or in the computer's memory. Some of the CRT machines recreate a photographic image on the tube by a process of scanning. In both methods, the character is generated as a series of lines drawn by a scanner at high speed to fill in the outline of the character and of such a high resolution that the lines are imperceptible in the finished setting.

Most machines can distort the appearance of type by using prisms; these can condense the type, expand it, or slant it to create an italic (however, the italic version created in this way is typographically inferior to a true italic).

Page make up systems

Earlier photocomposition systems produce type in galley form and the subsequent page make up is achieved by cutting the galley film or paper and sticking it in position with adhesive or wax. This is a time-consuming process, and page make up systems have now been developed in which all the positioning is done by computer and the final output is in page form ready to go

The visual display unit (VDU) of a page make up system. The operator has called up the type and decided its size and position. The green rectangle represents the area of a picture that will be stripped in later. The operator can manipulate the size and position of the type to achieve the desired result.

to the printer. These systems, often known as 'area composition' systems, consist essentially of an input terminal with a VDU showing the made up page. The raw copy (previously keyed on a non-counting keyboard) is fed in from a disk and manipulated by the operator to the typeface, size and measure required. Spaces are left for the illustrations, although the latest machines will even incorporate halftones that have been previously scanned and stored in digital form (the very latest machines can do this with colour illustrations).

As prices of these systems fall and they become simpler to operate, it is likely that they will eventually be operated by designers rather than by staff at the typesetter. This will cut out the layout stage, since it will be possible to produce layouts, in effect, directly on the screen.

Another method used for simpler work is automatic page make up. Here the parameters of the page, such as number of lines, instructions for headings and folios (page numbers), and so on, are fed into the computer and page make up is achieved 'blind' — that is, without being visually checked on a VDU.

Storage and updating Nearly all modern photocomposition systems allow for the text to be stored on disk or magnetic tape and subsequently edited and/or set in a different typeface for another publication. For example, a hardback book can be set to a large format and the publisher can later reissue the book as a smaller paperback using the same original keyboarding but with the type set to a different measure and in a different typeface and size. Likewise, where a database has been produced for a large dictionary or encyclopedia, this can then be reused for other publications by pulling out certain subject areas, or a 'concise' version of the dictionary can be prepared from the database compiled for the 'complete' version.

Proofs and corrections

Galley and page proofs (usually photocopies of the original) are produced as in hot metal setting, although the galley stage is omitted when page make up systems are used. Here the keyboarding may be checked on a line printer proof before page make up.

In more traditional photocomposition systems, corrections are made by resetting the affected line(s) and stripping them in by hand. In modern systems, corrections are keyed in to produce an updated disk, and this is run through the system again to produce clean output for the whole job. The disadvantage of this, from the editor's point of view, is that the rerunning may produce different end-of-line decisions which have to be checked again.

Interfacing computers and word processors to phototypesetters

'Interfacing' is the name generally given to the methods of connecting up two different types of computer, and in the field of typesetting refers specifically to any such operation designed to eliminate the rekeying of text for typesetting when it is already stored on a word processor or other computerized system. As well as posing certain technical problems, there may also be questions of trade union resistance to be considered.

Interfacing is usually worth undertaking only when there is a substantial volume of work, or where the particular *combination* of machines involved is so well known that all the problems have

already been eliminated. Unless you have very good reasons, it is usually not worth setting up an interface to undertake very complex tabulations — although this is quite possible.

In everyday life there are many interfaces. Mostly they cause no problems at all or we adapt to them over time and in the end cease to notice them. The most obvious example in the field of text-creation is the standard QWERTY keyboard. This is near impossible for the uninitiated to comprehend but, once you are accustomed to it, it poses no problems.

Unlike a 'human-to-machine' interface, the 'machine-to-machine' interface usually has to be perfectly matched in all respects for it to work at all. The problems of interfacing are in some ways similar to those encountered in colour correction. In colour correction, beginners should not say how corrections are to be undertaken but should confine themselves, first, to ensuring that the conditions for good reproduction exist and then, if the results are unsatisfactory, so say what is wrong rather than how the corrections should be made. Therefore, when it comes to inferfacing computers — by whatever means — it is particularly important whenever possible to consult the typesetter in advance of preparing magnetic tapes or disks to ensure that suitable conditions exist for interfacing.

All interfacing is divided into two main areas. The first is concerned with ensuring that the text is readable by the phototypesetter; the second is concerned with ensuring that it can understand what it has read. There may also be a third stage — adding the codes needed by the photosetter (to select the correct fount, size, measure) — although this may be included in the second stage.

The three main methods of interfacing available are telecommunications, text-retrieval terminals and multidisk readers.

Telecommunications This involves the text creator and the typesetter both being equipped with a modem. Modems (which must be of a model approved by the local telecommunications authority) convert the signals generated by a computer or word processor at one end and the phototypesetter at the other into a form that the telephone lines can carry. The advantage of this method is that you do not have to worry about your disks being the same kind as the typesetter, or having the same interface plugs on your machine. On the other hand, you will normally need to have a modem of a similar type to that of your supplier, and the telephone charges usually increase dramatically with both time and distance.

Text-retrieval terminals TRTs are also known as 'milking machines', which describes their function well. They are designed to plug into a wide variety of text-generating equipment — usually by its RS-232-C interface, although many can also be plugged in in place of a printer if there is no proper communications interface. Once connected, all these devices record the data from the user's machine onto a diskette, tape or cartridge, and the TRT is then taken back to the typesetting house. TRTs have the advantage that, once the data has been recorded, the typesetter *knows* that there is a copy that he or she can read and that any problems can be dealt with at leisure — that he or she need only trouble the client if the bill is too great. The disadvantage is that the typesetter will normally have to travel to the client every time there is a job to be done, and this may involve greater expense than can be saved by cutting out one set of keystrokes.

A multidisk reader A microcomputer programmed to transfer information on word processor disks on to disks that will drive typesetting machines.

A modem (right) This converts output from a microcomputer into a form suitable for transmission via a telephone line and back again.

A text-retrieval terminal (TRT) (left) This is connected to the word processor and records the data onto a disk, tape, or cartridge. It is taken back to the typesetting house and the data is fed into the typesetting machine.

Multidisk readers The third method is to use a multidisk reader. These are devices that can read a large number of different kinds of disk — different both in size (from little over 3in up to 8in across) and varying also in the number of 'tracks' of data it contains and its recording 'density'. While these are relatively expensive machines for the typesetter to buy, they may not involve the customer in any investment and may make it possible for the client simply to mail a disk to the typesetter for him or her to read, just so long as it is in a format that the MDR recognizes.

Further coding With few exceptions, once a typesetter has read in the text data it will be necessary to remove from it many of the codes used by the word processor, or to convert them to typesetting codes, or to add further typesetting codes. A multidisk reader will usually be programmable to carry out these 'protocol' conversions, but, if not, the task will have to be done on the front end, using some sort of search and replace facility.

While it may be relatively easy for a typesetter to turn an underscore code into a fount change for italic (and the 'off' code to a return to roman), many other codes, such as for fixed tabs, size and measure changes and justification pose a greater problem. There are now a good number of 'mark up languages', which involve the text creator in typing special codes in place of, or in addition to, those generated automatically by their word processors, and these are relatively easily converted into typesetting commands.

It is important, however, to emphasize that these codes should not be used without prior discussion with your typesetter. It is also vital that, whatever method you do agree to, you should not deviate from it in any way without again consulting your typesetter. Few interfacing problems are insoluble, but there is no benefit in using these techniques if sorting out the problems costs more than conventional double-keying would have cost.

Most suppliers who are seriously involved in this relatively new sort of work will be able to provide comprehensive instruction manuals and advice.

Type measurement

Type is measured in points, picas and units. These measurements can be confusing, in that the Anglo-American system is different from the European one, although both use the term 'point'. The reason for these different systems lies in the fact that metal type foundries in Europe were casting type that was incompatible in size with that from other foundries. It was not until the early eighteenth century that an attempt was made to standardize a system of type measurement. This happened in France, when Pierre Fournier proposed a standard unit of measurement which he called the 'point'. The innovations made by Fournier were developed by another Frenchman, Firmin Didot, to produce a European standard, but neither the UK nor the USA adopted this, although their system was based on points.

The Anglo-American system is based on the division of one inch into 72 parts, called 'points' — each point is therefore 0·013837 of an inch (0·35146 mm). A pica (or pica em) is made up from 12 points and is $1/6$ an inch (4mm). Although this system is still universal in the USA, in the UK it has been complicated by the introduction of metrication when type is specified in millimetres.

The European point measures 0·37592mm (0.0148in), and 12 of

Point sizes Characters in typeset copy are measured in units called 'points'. This system, was first developed in France but the European, or Didot, point is slightly larger than the point used in the US and the UK. An inch contains approximately 67.5 European points and 72 Anglo-American points. Letters are measured from the top of the ascenders to the bottom of the descenders of the lower case letters. The point size is thus based on a 'strip' holding all the letters in a sentence. In the metric system, type size is described by the height of the capital letters, or 'cap height' (CH). The spaces between lines of type is called 'line feed' (LF) — both are in millimetres.

The spaces between lines are also measured in points. A line of, say, 12 point type directly followed by another line of 12 point type said to be 12 point solid, or 12 'on' 12 point. Point spaces inserted between the lines make type more legible.

Line length is measured using a unit called a 'pica em', which is 12 points long (approximately 4mm or $^1/6$in). The pica is an Anglo-American unit, in France and Germany the 12 point unit is called a *cicero*, in Italy a *riga*, in Holland, an *aug*.

inches

centimetres

picas

ciceros

72pt em divided into 18 units

36pt em divided into 18 units

18 units 10 units 6 units

The characters in a line of type each have their own qualities. The terminology for the different parts of typeset characters forms a significant body of commonly used words.

Some of these are illustrated (**above**): apex (**1**), counter (**2**), bar (**3**), serif (**4**), arm (**5**), beak (**6**), ascender (**7**), ear (**8**), bowl (**9**), spine (**10**), cross-stroke (**11**), hairline (**12**), spur (**13**), bracket (**14**), tail (**15**), link (**16**), loop (**17**), descender (**18**), ascender line (**19**), capital (**20**), x-height (or mean line) (**21**), base line (**22**), descender line (**23**).

The point or body size of type is the distance from the top of the ascender to the bottom of the descender. This distance varies from typeface to typeface as well as from one point size to another. If there is no leading, type can be measured from base line to base line to establish the point size, as illustrated (**right**).

48 points

48 points

The examples here are all 36pt. A face with a large x-height is called a large appearing face and one with a small x-height a small appearing face.

abc *abc* **abc**

Bembo Times Rockwell

Loose
The form typography is to take

Normal
The form typography is to take

Tight
The form typography is to take

Very tight
The form typography is to take

Overlapping
The form typography is to take

Letterspacing defines the space between letters, which can be adjusted depending on the designer's requirements. The type of spacing required is normally specified as normal, loose, tight and very tight. In phototypesetting, these instructions are translated into units or half units, depending on the system. The results are extremely flexible up to a fraction of a millimetre.

The height of small caps is the same as that of lowercase characters. Designed small caps are of even weight. Photographically reduced small caps tend to look lighter when set with normal type.

Designed SMALL CAPS

Reduced SMALL CAPS

A variation on SMALL CAPS

When two or more characters are joined and set as a single unit, they are termed ligatures. Common examples are ff, fi, fl and ffl. They should not be used when letterspacing is tight, as the result may look gappy.

fi fl ff ffi ffl

fi fl ff ffi ffl

When the spacing between specified characters is deliberately reduced, leaving the rest of the setting the same, the result is called kerning. The technique is frequently used with certain letter combinations, such as Yo, Te, LY and la. When these are set, there is often too much space between them, compared to the rest of the setting. Kerning solves this problem. If used properly, it can greatly improve letter-fit, legibility and the evenness of a line of typesetting — it is particularly useful with large display type.

VAULT VAULT

AT	AY	AV	AW	Ay	Av	Aw
FA	TO	TA	Ta	Te	To	Ti
Tr	Tu	Ty	Tw	Ts	Tc	LT
LY	LV	LW	Ly	PA	VA	Va
Ve	Vo	Vi	Vr	Vu	Vy	RT
RV	RW	RY	Ry	WA	Wa	We
Wo	Wi	Wr	Wu	Wy	YA	Ya
Ye	Yo	Yi	Yp	Yq	Yu	Yv

these form a unit of 4·511mm (0.1776in). This 12 point unit is called a 'cicero' in France and Germany, a 'riga tipografica' (riga) in Italy, and an 'augustijn' (aug) in Holland. There is no easy mathematical relationship between the Anglo-American point and the Didot point, and neither of them relate to the metric system. Thus in Europe, including the UK, typographic measurement in points coexists with metric measurements, which are used in virtually every other allied trade. For this reason, type measurements are gradually being metricated and eventually all type sizes will be defined in millimetres.

Set width Although many designers refer to a pica em simply as an 'em', technically this is incorrect: a pica em is the square of the body of a 12 point piece of type; an em (so called because the letter 'M' originally occupied the full unit width of a piece of type) is the square of any point size. A 36 point em, for instance, measures 36 points in width, whereas a pica em can only measure 12 points. The most important measurement in controlling line length is that of each character's width. This measurement is determined by dividing an em into vertical 'slices'. These are called set points or, more commonly in phototypesetting, units. The number of units in an em varies from one typesetting system to another, but probably the most popular is 18; the more units there are in an em, the greater the possibility of refinement. Units not only control the widths of characters but also the spaces between them. Although the actual size of the unit varies according to the size of type,

PROOF CORRECTION MARKS

When galley proofs are being corrected, marks should be made in the margin as well as in the text. This enables the typesetter to simply glance down the margin to locate corrections rather than necessitating scanning of the text. The proof correction marks given here are the more recent standard marks but many people still use the old systems.

Instruction to printer	Textual mark	Marginal mark
Correction is concluded	None	
Leave unchanged	typeface groups	STET
Remove unwanted marks	typeface groups	✕
Push down risen spacing material	typeface groups	lower
Refer to appropriate authority	typeface groups	?
Insert new matter	groups	typeface
Insert additional matter	type groups	Ⓐ
Delete	typeface groups	ℓ
Delete and close up	typeface grooups	℮
Substitute character or part of one or more words	typeface grooups	y ℓ u
Wrong fount, replace with correct fount	typeface groups	wf/fix
Correct damaged characters	typeface groups	✕

Instruction to printer	Textual mark	Marginal mark
Set in or change to italics	typeface groups	(ital)
Set in or change to capitals	typeface groups	(cap)
Set in or change to small capitals	typeface groups	(sc)
Capitals for initials small caps for rest of word	typeface groups	(cap+sc)
Set in or change to bold type	typeface groups	(bf)
Set in or change to bold italic type	typeface groups	(bf+ital)
Change capitals to lower case	typeFACE groups	(lc)
Change small capitals to lower case	typeFACE groups	(lc)
Change italic to roman	(typeface) groups	(rom)
Invert type	typeface groups	9
Insert ligature	filmsetter	ﬁ
Substitute separate letters for ligature	filmsetter	fi
Insert full point	typeface groups ⊙	⌒ ⊙
Insert colon	typeface groups :	⌒ :
Insert semi-colon	typeface groups ;	⌒ ;
Insert comma	typeface groups ,	⌒ ,
Insert quotation marks	'typeface groups '	⌒ '/'
Insert double quotation marks	"typeface groups "	⌒ "/"
Substitute character in superior position	typeface groups	(sup)
Substitute character in inferior position	typeface groups	(sub)
Insert apostrophe	typeface groups '	⌒ '
Insert ellipsis	typeface groups ...	⌒ ⊃000
Insert leader dots	...typeface groups	⌒ 000⊃
Substitute or insert hyphen	typeface groups	⌒ =
Insert rule	typeface groups	⌒ (2pt rule)
Insert oblique	typeface groups	⌒ ≠
Start new paragraph	are called set points. The dimension of	⌒ ¶
No fresh paragraph, run on	are called set points The dimension of	⌒ (no ¶)

Instruction to printer	Textual mark	Marginal mark
Transpose characters or word	groups typeface	tr.
Transpose characters (2)	tpeyface groups	tr.
Transpose lines	The dimensions of are called set points.	tr.
Transpose lines (2)	The dimension of are called set points.	tr.
Centre type	typeface groups	center
Indent 1 em	typeface groups	indent 1em
Delete indent	typeface groups	flush left
Set line justified	typeface groups ‖	Justify
Set column justified	‖	Justify col.
Move matter to right	typeface groups	
Move matter to left	typeface groups	
Take over to next line	typeface groups	break
Take back to previous line	typeface groups	move up
Raise matter	typeface groups	
Lower matter	typeface groups	
Correct vertical alignment	typeface groups	‖
Correct horizontal alignment	typeface groups	Align
Close up space	type face groups	
Insert space between words	typeface groups	#
Reduce space between words	typeface groups reduce #	reduce #
Reduce or insert space between letters	type face groups	#
Make space appear equal	typeface groups	equal #
Close up to normal line spacing	typeface groups	normal spacing
Insert space between paragraphs	are called set points. The dimension of	#
Reduce space between paragraphs	are called set points. The dimension of	reduce #
Insert parentheses or square brackets	typeface groups	{ } or []
Figure or abbreviation to be spelt out in full	12 point twelve pt.	sp. out
Move matter to position indicated	are called The set points. dimensional	tr.

because there are always the same number of units to any one em regardless of size, the proportions remain the same.

In the design of typefaces, each character is given a fixed amount of space known as the set width or set, which is measured in units. The set width of a character controls the amount of space between itself and the next character, and can be varied for special purposes — either increased, to allow greater space, or decreased, to allow less. The latter is possible only in phototypesetting systems and obviously has limited scope. Beyond a certain stage, characters lose legibility.

Since different founts vary considerably in their characteristics, the set widths of characters will also vary from typeface to typeface so that a condensed typeface, for instance, will have a narrow set width relative to its body size.

Typefaces

Before the advent of phototypesetting, there was a relatively small number of typefaces, because of the labour involved in cutting punches to the precise form required. In phototypesetting, however, the typeface can be reproduced from artwork, and this has resulted in the proliferation of typefaces now available.

It is important to realize that typefaces with the same name are not identical if set on different machines. For example, Baskerville set on a Linotron will not match Baskerville set on a Monophoto. As well as the characters themselves having a slightly different design, the set widths and the heights of the characters on the body may be different.

Typeface name comparisons			
Typeface	**Alphatype**	**Compugraphic**	**Dymo**
Caledonia	Caledo	California	Highland
Century Expanded	Century X	Century Light	Century Expanded
Clarendon	Clarendon	Clarendon	Clarendon
Futura Book	Alpha Futura	Futura Book	Photura Book
Futura Light	Futura Light	Futura Light	Techno Light
Futura Medium	Futura Medium	Futura Medium	Techno Medium
Futura Bold	Futura Bold	Futura Bold	Techno Bold
Garamond	Garamond	Garamond	Garamond
Helvetica	Claro	Helios II	Newton
Melior	Uranus	Mallard	Ballardvale
News Gothic	Alpha Gothic	News Gothic	News Gothic
Optima	Musica	Oracle	Chelmsford
Palatino	Patina	Paladium	Andover
Stymie	Stymie	Stymie	Stymie
Times Roman	English	English Times	Times New Roman
Univers 55	Versatile	Univers Medium II	Univers Medium

An example of proof-read copy. The proof-reader reads the typeset text against the text that was sent to be set line for line, checking that what has been set is what was asked for. If the proof-reader finds that the typesetter has made an error, he or she, using the proof-reading marks (**see left and previous page**), writes clearly in red pen the correction that needs to be made. If he or she wishes to add in an author's or editor's alteration, the change is marked in black or blue pen using the same marks. The typesetter's reader (if there is one) will have marked in green typographical and literal errors, such as transposition of letters. The different colours are used as an aid to allocation of correction costs.

Typefaces (below) are given different names by different manufacturers of typesetting systems, although they look very similar.

Typeface name comparisons

Harris	Mergenthaler Linotype	Monotype/ Monophoto	Varityper
Laurel	Caledonia	Caledonia	Highland
Century Expanded	Century Expanded	Century Exanded 658	Century Expanded
Clarique	Clarendon	Clarendon	Clarendon
Futura Book	Spartan Book		
Futura Light	Spartan Light		Techno Light
Futura Medium	Spartan Medium		Techno Medium
Futura Bold	Spartan Black		Techno Extra Bold
Garamond	Garamond	Garamond	Garamond
Vega	Helvetica	Helvetica	Megaron
Medallion	Melior	Melior	Hanover
News Gothic	Trade Gothic	News Gothic	News Gothic
Zenith	Optima	Optima	Chelmsford
Elegante	Palatino		Andover
Cairo	Memphis		Stymie
Times Roman	Times Roman	Times	Times Roman
Galaxy Medium	Univers	Univers 689	Univers Medium

4
PAPER AND INK

Ink/Paper/How paper is made/Pulp/The paper
machine/Types of paper/Specifying papers

I nk and paper are the two raw materials used in the printing
process. Both have been continually refined and improved by
succeeding generations. So many combinations of ink, paper
and process are now available that it is therefore increasingly
important for the printer to choose the right one.

Ink

In the fifteenth century, when Gutenberg first printed from
movable type, the ink he used was made of boiled linseed oil
with resin, soap and lampblack. Modern inks are made of
pigments and binding materials (like resins) combined in a
varnish with solvents. The ingredients can be varied to give
certain desirable characteristics to the ink, such as improved
drying or good rub-resistance. Apart from all the different
colours available, there are many different types of ink,

**Stages in the manufacture of
ink Above**, formulating a sample.
Centre, computer colour matching.
Right, the ink mill, which breaks down
the ingredients until they are of a smooth
consistency.

corresponding to different printing processes, finishing requirements, toxicity restraints (as in food packaging) and drying methods.

Drying ink There are four main methods of drying ink: evaporation, chemical curing, penetration and oxidation.

Evaporation is used when inks contain volatile solvents such as paraffin. Evaporation is a very fast and effective method of drying, and is used for 'liquid' inks such as those used for gravure or flexography.

Chemical curing 'dries' ink by linking the pigment molecules in the ink thereby solidifying it. This is done by adding a catalyst immediately before printing to start the solidification process. A similar method uses ultraviolet light to 'cure' the ink.

Penetration is used with paper and board, where the ink dries by being soaked down into the paper, rather like blotting-paper. It obviously cannot be used on plastic or foil, which are nonabsorbent.

Oxidation is a method of drying where the ingredients absorb oxygen from the air. This causes the ink molecules to join together, so that the ink film slowly solidifies. It is a slow process and, when the printing is on paper or board, is used in conjunction with penetration.

Specifying ink Unlike paper, the type of ink is not normally specified by the client, but is chosen by the printer after consideration of the process being used, the machine, the paper and whether any special finishing operations such as varnishing or laminating are involved.

Four-colour process inks are normally made to a standard within a particular country, so that a four-colour set will give the same result regardless of the printer. It is vital that the repro house works to the same ink standard as the printer.

Special colours used to be mixed by hand by the printer to match a swatch supplied by the client. Now a more exact method

is available in the form of the Pantone Matching System (PMS), a proprietary system consisting of a book of colour swatches with reference numbers which relate to inks that the printer buys ready-made or can mix to exact instructions. This has made the matching of colours a much more exact process.

Metallic inks contain fine metallic powders such as aluminium, copper or bronze to give a gold or silver effect, or produce metallic blues, reds, greens and so on.

Paper
Nearly all printing is done on paper. Its importance in the production cost equation has increased dramatically over the last fifteen years or so as prices have risen sharply and certain qualities of paper have been in short supply. For some printed items such as magazines, more than half the production cost is accounted for by the price of paper. This has resulted in buyers of printed materials considering changes to lighter weight and lower quality papers.

There are several reasons for the big increases in paper costs. The rising price of oil and a shortage of raw materials have increased the actual production costs of paper making, so raising its selling price. This, together with the increased demand for paper, accounts for its importance in publisher's budgets.

How paper is made
Pulp
Paper basically consists of vegetable (cellulose) fibres with various additives to control the physical characteristics, print-ability and aesthetics of the finished product. The choice of fibre is important. High-quality papers, which may still be made by hand, might utilize cotton, linen or hemp fibres — all of which are high strength yielding and very durable materials. These raw materials give strength and stiffness. Straw and esparto grass are other materials used to produce fibres which, due to their shape and lack of flexibility, yield a weaker paper but one with even texture, softness, elasticity, good opacity and bulk. Book papers were usually made from esparto but this has now been replaced by the bulky hardwood, eucalyptus. Most paper is now made from wood pulp, largely from softwood coniferous trees such as spruce, pine or eucalyptus.

Chemical pulping The object of all chemical pulping is to dissolve away the lignin and other glutinous materials so that the fibre within the wood can be extracted.

After the initial de-barking, wood is cut into small chips (16 × 3·18mm/⅝ × ⅛in) and these are then cooked at a high temperature and pressure using a variety of pulping liquors depending on the source of the wood and the process available. Caustic soda and sodium suphide have formed the basis of the 'kraft' pulping process since the late 1800s whereas sulphite pulping technology relies principally on the use of sodium, calcium or magnesium sulphite and sulphurous acid for pulping, and is often used for woods with a low resin content. The extracted fibres are washed and bleached before being further processed.

Mechanical pulping Mechanical or groundwood pulp is different from chemical pulps. Chemical pulps are essentially separated, whole cellulose wood fibres from which the lignin

and other bonding material has been removed. The fibre length of these pulps is the full fibre length of the source from which the pulp is made. In the mechanical pulping process, bundles of fibres are torn from the de-barked pulping log and therefore contain a mixture of whole fibres, broken fibres, lignin and various other wood gums. The groundwood pulp, made into paper is soft, bulky, absorbent and opaque, but it is weak and will deteriorate over time, especially if it is exposed to sunlight, as the lignin decays.

Papers for different uses need to have different properties and the properties of groundwood are desirable in many grades where permanence is not essential. Among these grades are newsprint, tissue, towelling, wallpaper and some printing paper, both coated and uncoated.

Other processes exist that combine both mechanical and chemical pulping technology. These processes are covered by the general terms, semi-chemical or chemi-wood.

Pulp processing The characteristics of a paper can vary tremendously, not only as a result of the choice of pulp but the way in which the fibre is subsequently processed.

An average fibre is 3·5mm (0·1378in) in length and 30/40 microns in diameter, it has smooth sides and is fairly rigid. The pulp must be rendered in such a form that it can be manufactured into paper that will exhibit the desired properties. To achieve this, the absorbency, strength or plasticity characteristics of the individual fibre may have to be increased. This is achieved by a process referred to as 'beating' or 'refining'. A refiner consists of a bladed cone rotating in an outer shell between which the fibrous suspension is passed. By controlling the consistency of the fibre suspension, the speed with which it passes through the refiner and the pressure of the cone within that shell, it is possible by a process of fibre rubbing, bruising, crushing, cutting, plasticizing and fibrillation to render the fibres suitable for the manufacture of a wide variety of papers of chosen characteristics. This is a key process in the paper making cycle. It can control strength characteristics, sheet density, tensile strength, tear resistance, folding characteristics, sheet formation, opacity, dimensional stability and physical characteristics, such as air porosity and even oil resistance.

Prior to refining, or immediately afterwards, certain additives may be mixed into the fibre furnish. These might include titanium dioxide, clay or calcium carbonate to control opacity, whiteness, smoothness and other printing characteristics, optical bleaching agents to develop brightness, sizing with starch or similar substances to control oil and water absorbency, anti-foaming agents, retention and sheet formation aids.

The pulp is normally refined at a consistency of about 2/3 per cent before being further diluted and fed to the machine chests, to which colouring pigments or dye stuffs may be added prior to the 'stock' being advanced to the paper machine.

The paper machine
A paper machine has to produce from this very dilute aqueous fibrous suspension a uniform 'mat' of fibres exhibiting uniform dimensional, physical and visual characteristics. The magnitude of this task, can be illustrated by considering a fibre 2 – 3mm (0·787 – 0·1181in) in length and 40 microns wide in a 0·3 per cent aqueous suspension being presented to a machine of up to 6

Wet end

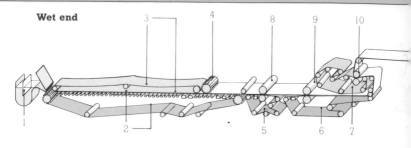

Fourdrinier part Press part

Paper making (above) In the Fourdrinier part of the machine the paper pulp is fed out of the flow box (**1**) on to the Fourdrinier wire screen belt (**2**). Deckle straps (**3**) ensure that the paper pulp does not slide off the wire screen belt. In the press part of the machine, the dandy roll (**4**) forms the web of paper. The paper, conveyed by belts (**5, 6** and **7**), is pressed between sets of rollers (**8, 9** and **10**) that extract excess moisture. The paper is then conveyed to the dryer where it is passed between the upper and lower felts (belts covered with felt) (**11** and **12**). The felts themselves are dried by passing over a number of felt driers (**13**). In the calender part of the machine the now dry paper is fed through a calender stack (**14**), which polishes the paper to give it a good finish, then on to a winding reel (**15**). When this reel is full, the machine feeds the paper onto another reel (**16**). The paper from the full reel is then unwound and fed by rollers on to a further winding reel. The pictures show the wet end (**right**) and the dry end (**below**).

Dry end

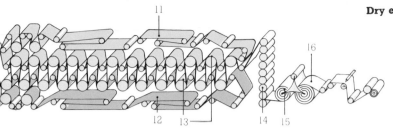

Dryer part Calender part

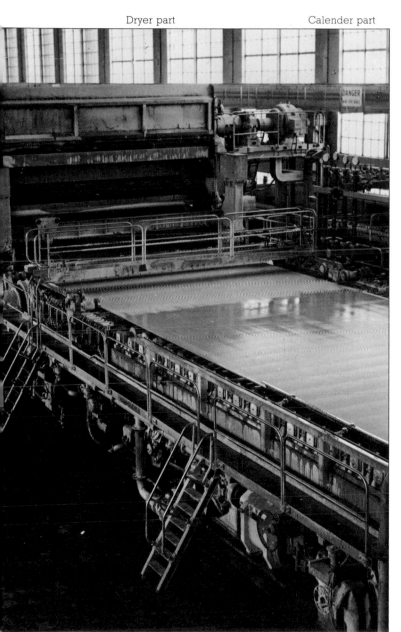

Dandy rolls (right) with proprietary watermarks. The dandy roll is a hollow wire-covered roller which is used on the wet end of the papermaking machine to compress the pulp and squeeze out water. The watermark's surface is raised above the wire roller and presses into the paper to form a translucent area, so the watermark is visible when held up to the light. Watermarks are used on high-quality stationery and banknotes for security against forgery.

A dandy roll (right) being adjusted by the machine minder.

metres (approximately 20 feet) in width and weighing thousands of tons and producing paper at a speed of 1,000 metres (approximately 3,280ft) per minute.

The pulp is fed from a 'head box' through a slice aperture on to a continuous moving wire (a wire mesh), at what is called 'the wet end' of the paper making machine. Slice setting, consistency of stock and the rate of flow of the furnish on to the wire, controls the 'substance' (unit weight) of the paper. The wire may vibrate from side to side in order to help maintain random fibre orientation. Water drains through the mesh, aided by foils and vacuum boxes beneath the wire. Sheet consolidation and watermarking may be achieved by the use of a 'dandy roll'. A dandy is a mesh covered roll, which rotates on the partially formed paper sheet. It carries wire marks called 'electros' and/or 'embossings' which compress the sheet and produce areas of light and shade due to changes in sheet density. These watermarks can be used to identify branded papers or be used as security features.

During the Fourdrinier manufacturing process, one side of the sheet is in contact with the wire. As a result a very fine impression of this wire may be detectable on this side of the final product — it is called 'the wire side of the sheet' and its characteristics may be slightly different to those of the top side, particularly in relation to print quality. Twin wire papers overcome this characteristic by effectively laminating two sheets together immediately after the sheet formation stage to leave the smoother top sides (the 'felt') available for printing.

At the end of the wire section, the fibrous web is still 92/93 per cent water, but it has matted together sufficiently for it to 'jump' into the press section where it is transported by felt through a series of granite and rubber composition presses. The press section removes more water by its 'mangle action' and also imparts polish to the wet sheet.

The remaining water is removed by passing the paper around several large, metal drying cylinders heated by super-heated steam. Before the paper making process is complete, however, the web may pass through a size press and/or coating station in order to further control or alter the final characteristics of the sheet. Size, in the form of starch solution, gelatin or other surface sealants may be applied, usually by roll coating, to both sides of the sheet, the added weight being only a few grammes per square metre (fractions of an ounce per ten square feet). This application supplements any earlier 'internal sizing' and helps to seal off loose fibres in the surface, controls ink receptivity, any tendency to feather at the touch of pen and ink, or adds a specific characteristic to the sheet such as colour, slip, release properties, moisture/vapour permeability or security features.

After further drying by a second group of cylinders the paper may be 'calendered' on the machine. Calendering imparts a smooth finish by passing the paper through a vertical stack of polished steel rolls, the temperatures and pressure of which may be varied. Finally, the paper is wound to form a very large 'jumbo' reel, which on wide modern machines may weigh up to 10 tonnes (11 short tons) or more.

Handmade paper Small amounts of paper are still made by hand for prestigious applications such as letterheads, limited edition books and artists' paper where completely random orientation of fibres is important, particularly for watercolour paintings.

Raised crowns

Frame

Wire screen

A mould used for making paper by hand The mould is dipped into a vat containing the pulp. The frame is then shaken to drain off the water, leaving the fibres in the mould. The watermark is raised and creates a translucent area in the paper.

A close up of the raised areas on a wire mesh screen (**left**) for watermarking handmade paper. The lettering indicates the paper maker. The vertical and horizontal lines give the familiar texture to laid paper.

The process is very slow and expensive as each sheet has to be hand produced. Pulp is fed into a small vat fitted with an agitator. A mould of fine mesh wire surrounded by a frame is dipped into the vat. The paper maker withdraws the mould gently shaking the frame as water drains away leaving the fibrous mat to be extracted and dried on felt sheets by pressure and hanging in a warm atmosphere.

Off machine processes The conversion of paper into functional, decorative or protective products is normally acheived by different basic operations: mechanical processing application of coatings or by impregnation. Although some of these operations may be accomplished on the paper machine, the great majority are performed by 'off machine' secondary techniques.

Off machine processes can be used to improve and enhance the characteristics of a printing paper or produce a completely new product, such as carbonless, release or gummed papers, photographic, pressure sensitive or thermal reactive products.

The most common form of 'after processing' involves coating with a pigment dispersed within an adhesive system. This is applied uniformly, usually from an aqueous mix, to the paper web by a roll application system. A flexible blade is then used to spread and monitor the thickness of the applied layer by adjusting its pressure and angle of application.

For the production of coated art papers, a coat weight of between 12 and 30gsm may be applied. For higher quality papers, a higher coat weight is normally necessary and this may be achieved by a double coating operation.

After coating, a surface finish is applied to the paper by a process of super calendering which produces the very high gloss effect characteristic of art papers.

If the paper is to be web printed, the jumbo reel is split into smaller reels of the specified size of the press otherwise it is 'sheeted' (made into sheets) and precision trimmed before being bulk-packed or ream-wrapped for mill or merchant stock, or despatched directly to a customer's premises.

Types of paper

Newsprint Newsprint is a machine finished paper, made mostly from groundwood pulp and used for printing newspapers and cheap handbills. It discolours readily when it is exposed to light, due to the impurities (lignin) contained in and around the fibre.

Mechanical Papers described as mechanical contain a large proportion of mechanical wood pulp, but also some chemical pulp to increase strength. The mechanical element may be bleached. Paper can be produced with a smooth surface by super calendering (SC), machine finishing (calendering on machine, MF), or machine glazing (MG). In recent years a grade called WSOP (web sized offset printing) has been introduced, where size is applied at the paper making stage to give an improved printing surface for offset printing. These papers are used for cheaper leaflets and magazines. halftones and colours up to 100 lines per inch screen can be printed satisfactorily.

Woodfree This description is misleading as the paper is still made from wood pulp, but it is produced by the chemical, rather than the mechanical process. Strong sheets with good whiteness are produced for use as general printing and writing papers, continuous stationery, copying papers and magazine papers. These grades will take colour, but with not such good results as

coated qualities. This category includes 'bond' paper with a fine formation (used for stationery) and 'bank', which is a lighter weight (70gsm or less) version of bond, used for carbon copies.

Cartridge papers These are tough, hard sized papers that were originally used in the production of cartridges. The quality has been extended to most rough-surfaced heavy papers.

Board Board is normally used for covers to catalogues and paperback books and for the production of cartons. It may be uncoated or supplied coated on one or two sides. Board weights normally start at 160gsm. The thicker boards may be made by laminating two or more plys of material together.

Antique This normally relates to a bulky paper with a naturally rough finish (antique wove), similar to that of an uncalendered handmade paper. It is mainly used in the production of books.

Antique laid has a different surface characteristic as it shows the laid lines and chain marks of the dandy roll within its surface. This paper is not suitable for halftones or line work with large solid areas of colour or fine detail.

Coated papers Art paper is coated on both sides with china clay (the best clay is British) and calendered to give a very high smoothness and gloss. It is used for the printing of halftones and colour and high-quality magazines and promotional material.

Matt art is produced in a similar way to art paper by coating with china clay, but the calendering process is only used to consolidate the surface rather than to produce a high gloss. As a result, the surface has a matt appearance but still gives good reproduction of halftone colour prints without gloss interfering with print definition. An alternative way of producing a similar effect is to calender in the conventional manner but with a micro embossed roll.

Blade coated cartridge paper is midway between being an uncoated and a matt art paper. It has a lighter coating than art or matt art, but reproduces halftones well. It is used for some magazine work and illustrated books like this one.

Chromo is coated on only one side and is used for posters, proofing work, printing of book jackets and labels.

Cast coated papers are characterized by exceptionally high gloss. Cast coated papers are used in the production of prestigious cartons or covers for presentation material.

Plastic papers are made completely from plastic or with a plastic coating over a base paper. Although expensive, these products are ideal for the production of some maps, workshop manuals and books for young children. They are very tough and washable.

Carbonless copying papers Carbonless copying papers are produced by employing a coating of micro capsules that rupture under the pressure of a stylus or printer key, releasing a solution of colourless dye. This transfers to the reactive surface on the sheet below where the dye is converted to its coloured form.

Technical papers Many types of highly specialized papers are manufactured either through modification to the basic paper making process, blend of pulps, use of additives or after processing. These include papers for currency, photography, filters, electrical cable winding, decorative laminates, security applications, and postage stamps.

Specifying papers
When purchasing paper great care must be exercised in specifying the quality and quantity required. The following are a few of the most important considerations.

Substance This refers to the weight of the paper and in the UK and most of Europe, the metric system is used where paper substance is described in grammes per square metre (gsm) — the weight in grammes of a sheet of the paper having an area of one square metre. In the USA and certain parts of the Far East, substance is described as the weight of a ream (500 sheets) of paper in a certain standard size. For example, a book paper might be described in the USA as having a substance of 60 pounds. This means that a ream (500 sheets) of the basic size of 25 × 38 inches weighs 60 pounds. The conversion table on page 154 enables substances of both systems to be compared.

Size In the metric system, sheet sizes are given in millimetres, as are reel widths. In the USA, sizes are given in inches. For large jobs, such as long runs of books or magazines, the paper may be made specially for each job and (depending on the width of the paper making machine) can be made to virtually any size. Smaller jobs have to be printed using standard sheet sizes and in the metric system, these are the 'A' and 'B' series of sizes (see page 152). Most books are produced in sizes related to the system in use before metrication, so have sizes in millimetres for trimmed page size and sheet size (see page 152).

Grain direction (for sheet-fed paper) Grain direction is the direction in which the web of paper runs through the paper making machine with the result that the fibres tend to lie in this direction. When specifying paper it is important to state the grain direction for two reasons. In binding, pages open more easily and the book handles better if the grain direction of the paper runs parallel to the spine, also there is less strain in the binding edge. In printing, the printer normally prefers the grain to run across the printing direction as this helps to prevent stretching through pressure or change in moisture content.

Sometimes these two requirements conflict with each other and usually the printing requirement takes precedence. To specify grain, state whether the sheet is long grain (LG) or short grain (SG), depending on whether the longer or shorter dimension of the sheet runs with the grain. When filling out an order form, the machine or grain direction should be the second dimension. Obviously, in web-fed printing, the grain always runs round rather than across the reel.

Bulk This is used to describe the thickness (caliper) of the paper and is mainly used in book production (for example, volume controlled papers). To achieve bulk, it is not always necessary to increase the substance (weight) of a paper. Certain papers such as antique wove can be made bulkier by being manufactured with more 'air' in the paper without increasing the weight. It is therefore possible to have paper of a common substance but with several different bulks.

The metric system used in the UK and Europe describes bulk with a volume figure which gives the bulk in millimetres of 200 pages of a 100gsm paper. Therefore the thickness of the sheet in microns is the weight multiplied by its volume divided by 10, so 80gsm vol 18 gives a sheet with a thickness of $80 \times 18 \div 10 = 144$ microns.

In the USA, bulk is expressed as a 'bulk factor', which is the number of pages that make a thickness of one inch.

Shade Shade or tint must be specified. Paper manufacturers will offer their standard shades but when a special one is required, it

is advisable to submit large samples for colour matching. Beware that some papers are 'metameric' — that is, they exhibit different shades under different lighting conditions. White is, in fact, the most difficult shade to specify and match.

Special instructions All special instructions relating to packet and bulk packing, reel wrapping, lorry loading and delivery times and dates must be given concisely and clearly.

Potential problems with paper

Paper is not inert, it reacts to its environment and this may cause printing and processing problems. The manufacturing process itself can result in minor defects, leading to production problems. Some of these are outlined below.

Curl stability Paper is affected dramatically by temperature and changes in humidity. Perhaps the one most important factor is RH (relative humidity) since this alone will determine whether or not the sheet will lie flat or expand/contract and even curl. This will have a considerable effect on the end result, particularly if the printing involved requires a high degree of colour registration accuracy.

In an ideal situation, the print room should be RH controlled to match that of the paper conditioning environment. This will ensure that the moisture content within the paper remains constant and so the sheet will not move. Remember, however, that lithography is a 'wet' process and the machine minder must allow for this.

Linting/picking A common problem with both coated and uncoated paper is that of linting, or 'pick'. Usually, this is a problem of debris that is either loose on the surface (bad paper to begin with or cutter dust) or that lifts as a result of the printing process (ink tack pulling particles away from the surface). The overall effect would be white spots appearing on the printed surface. Modern paper making technology has minimized this problem.

Squareness Obviously, to achieve a good print result the sheet must be square. Modern precision cutting technology can produce very accurately cut sheets and 'out of squareness' is rare.

Long edge This is usually a problem associated with lighter weight papers of 60gsm or below and manifests itself as a slackness on one edge of the reel, caused by differing profiles across the paper web during manufacture. This may prove a particular problem if different webs are to be matched as in multi-part continuous stationery.

Bulk after printing Paper is specified prior to printing and the characteristics may change during the print process. This is particularly true with high bulking book papers where the pressures encountered during printing tend to flatten the sheet and cause a three to five per cent reduction in bulk.

Binding problems As previously mentioned, the printer and binder often require opposing grain directions with paper stock. It is worth remembering that with certain types of format, grain direction can cause serious binding problems. Probably the best example of this is using a heavy, coated paper on a large, landscape format. The wrong grain direction (across paper) will cause tremendous strain in the spine and no matter how well the book is bound it will eventually begin to break the binding.

Obviously, choice of binding material is equally important. It should be remembered that publisher, printer and binder should liaise very closely on all the above points.

5
FINISHING AND BINDING

Cutting / Scoring and perforation /
Folding / Paperback binding /
Hardback bookbinding / Other
methods of finishing / Addressing
and mailing / Packing

The finishing and binding processes can either ensure that a book lasts well and is a pleasure to read or, produce one that is difficult to handle and disintegrates after a couple of months' use. A good understanding between publisher, printer and binder must be established if the end result is to please all those involved in the project.

Finishing

Cutting Most printed items have to be cut at some stage in the finishing process — either before folding or after binding or stitching — to give a clean edge. Cutting is done on a guillotine, which consists of a large steel bed; a movable piece of steel at the back (back-gauge) used to position the paper correctly; a clamp to hold the paper firm at the point of cutting; and a very sharp, electrically-driven blade. Although guillotines are essentially very simple pieces of equipment, they can have sophisticated extras: photo-electric guards to prevent the blade coming down if the operator's hands are in the cutting area; and facilities to make them programmable by a small computer or respond to a program recorded on paper tape or magnetic cassette. In either case, the program automatically moves the back-gauge to the required position for the next cut and can save a great deal of time where there is a complex sequence of cuts to be done.

Scoring and perforating Scoring is done on board or thicker grades of paper to facilitate folding. In letterpress printing a scoring rule can be part of the printing forme on the press. In offset, perforating rules can be stuck around or across the cylinder or scoring wheels can be brought into the operation between the printing unit and delivery of the sheets or done on a scoring machine.

Perforating can be carried out similarly, using a perforating rule in the forme on a letterpress machine or a perforating rule or wheel on an offset machine. The same separate machine used for scoring will also perforate.

Both scoring and perforating can also be done while die-cutting (see page 108).

Folding Where an item has been produced on a web-fed press, the press will usually produce folded sections of 8, 16 or 32 pages. However, with sheet-fed printing, the sheet has to be folded after printing on a folding machine. The flat sheets are fed in at one end and the machine delivers the sections folded in accordance with the imposition scheme used (see page 60). Most folding machines process 10,000 sheets an hour or more.

Folding machines fold the sheets using either a knife fold or a buckle fold (see below), or a combination of both; most modern high-speed folders use buckle folding. Various special folds are

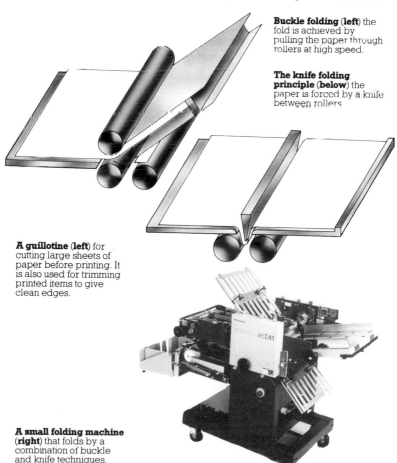

Buckle folding (left) the fold is achieved by pulling the paper through rollers at high speed.

The knife folding principle (below) the paper is forced by a knife between rollers

A guillotine (left) for cutting large sheets of paper before printing. It is also used for trimming printed items to give clean edges.

A small folding machine (right) that folds by a combination of buckle and knife techniques.

Bookbinding methods vary according to the nature of the job and the materials used. The various elements involved in the binding of a conventional jacketed hardback (**right**) are endpapers (**1**), headbands (**2**), dustjacket (**3**), spine (**4**), case (**5**), metallic foil stamping (**6**) and tailbands (**7**). This form of binding is known as cased binding: paperbacks are perfect bound, a preprinted cover being glued to the spine.

Cased binding and perfect binding are the conventional forms of binding for hardbacks and paperbacks respectively (**left**). In cased binding, the sheets are folded into 16 or 32 page signatures to be collated and sewn by machine. The edges are trimmed and the sewn back edge is coated with glue (**1**). This is then rounded and a strip of gauze glued to the spine to overlap on both sides. (**2**). Finally book and cloth cover (**3**) are placed on a casing-in machine, which pastes the endpapers and fits the cover. In perfect binding, the folded and collated pages have the spine edge trimmed off and roughened, so that the binding glue adheres strongly (**4**). The cover is glued firmly in place (**5**). **Quarter binding and half binding** (**below**) are more luxurious versions of cased binding. In both, leather — or a similar substitute — is used to strengthen the spine; in half binding patches are also used to reinforce the corners.

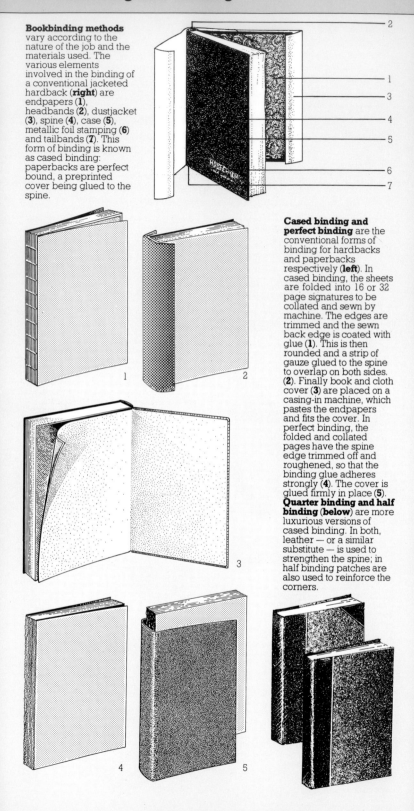

There are four main methods of holding pages together (**above**) In saddle-stitching (**1**), the booklet is opened over a 'saddle' and stapled along the back fold. In side-stitching with wire (**2**), wire staples are inserted from the front, about 6mm (¼in) from the back edge, and then clinched at the back, not unlike a stapler. In unsewn (perfect) binding (**3**), the gathered signatures are trimmed along the back edge, roughened and bound with adhesive. In thread-sewn binding (**4**), the gathered signatures are sewn individually and then joined to each other by thread.

Ring binders (left) enable the opened book to lie absolutely flat. A loose leaf post or ring binder (**1**) can have two to four rings rivetted to a stiff or soft cover. It can then be sprung open and paper with the requisite number of holes can be inserted. Multiple ring binders (**2**) use the same principle but have a larger number of rings.

Mechanical binding can take several forms (**above**). A plastic gripper may be fitted tightly over the spine to hold the covers and pages together (**1**). In open-flat mechanical binding, holes are drilled through the covers and pages and a wire or plastic coil is inserted through them to hold the pages together. Examples of this method are wiro (**2**), spiral (**3**) and plastic comb (**4**). Unlike (**1**), these latter methods allow the pages to lie flat when the book is opened and so they are perfect for reference manuals and notebooks.

A french fold (right)
Often used for greetings cards. Only one side of the sheet has to be printed.

A concertina fold (far right) Used for publicity leaflets.

used for pamphlets — such as the concertina fold and the french fold (see page 104).

For book production the sheet should be folded so that the grain of the paper runs parallel to the spine of the end product, so that the pages will open more easily. However, on occasion the printer will want the grain running in the other direction in order to avoid paper stretch on printing — particularly in four-colour printing.

Paperback binding
Brochures and magazines A common method of binding brochures and magazines is wire-stitching — which can be saddle-stitching or side-stitching (also called stab-stitching).

In saddle-stitching, the folded section is positioned on a metal 'saddle' under a head that inserts wire staples (cut from a continuous coil of wire) through the spine.

Side-stitching is used for thicker publications with more than one section. Here the folded sections are gathered in order and the staples are forced through the side about 6mm (¼ inch) in from the spine. Obviously a side-stitched publication will not open flat easily, and the designer should allow a wider back, or centre, margin (or gutter).

Perfect binding Most paperbacks (and many magazines and hardbacks) are 'perfect' bound; the method is known also as 'unsewn binding'. After folding, the folded sections are loaded on to a perfect binding line, which first gathers the sections in the right order and then removes the back fold, trimming off about 3mm (¼in), and grinds the cut spine to roughen it. The book block (which now consists of individual leaves) is then glued at the spine, both to hold the leaves together and to attach the book block to the cover. The books are then trimmed using a three-knife trimmer or guillotine to give a smooth edge all round and are ready for packing.

A variation of this technique is known as 'burst', or 'notch' or 'slot', binding. With this technique the spine of the section is perforated (in effect, slashed across its width) on the folding machine and the sections then go through a perfect binding machine, but do not have their spines removed. Instead, glue is forced into the perforations to hold the sections together. This is stronger than unsewn binding and cheaper than sewn.

Sewn book binding Some paperbacks are sewn. After gathering, the sewing machine inserts threads through the spine of each section and then uses further thread to join the sections to each other to form the book block. In a separate operation, the cover is

then glued to the spine and the books are trimmed.

Spiral, wiro and plastic-comb binding These methods are used for manuals and shorter-run publications, or where the ability for the result to lie flat is important (computer manuals for example).

In spiral binding, holes are drilled through the cover and pages, which are then joined together using a wire or plastic spiral coil. Wiro binding is similar but instead of a coil has a construct the 'fingers' of which go through slots in the sheets. Plastic-comb binding is the plastic equivalent of wiro binding.

Hardback (cased) bookbinding

As in paperback binding, the process starts with the sections being folded and collated. Then the endpapers are glued on to the first and last sections. Where the paper is strong enough, 'self-endpapers' (usually known as 'self-ends') are used; in other words, the first page of the first section and the last page of the last section act as endpapers and are glued down to the case.

If the book has plates printed on a different paper to the text, these can be incorporated either as sections of 8, 16 or 32 pages, or as 'wraps and inserts', where four or more pages are wrapped around the outside or inserted into the centre of a section. This latter process is more expensive, but spreads the plates more evenly through the book. More expensive still, and consequently, little used today, is 'tipping in' where a plate is printed on a single separate leaf and fixed to a text page by pasting along one edge.

The books are then sewn, as described above. The next operation is 'lining', where a strip of paper or linen (mull) is glued to the spine to help reinforce the joint when the case is applied. Head- and tailbands (folded strips of plain or striped cloth inserted at the top and bottom of the spine beneath the lining) can

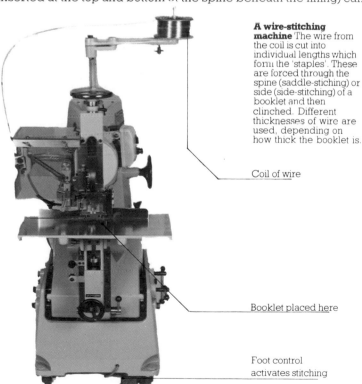

A wire-stitching machine The wire from the coil is cut into individual lengths which form the 'staples'. These are forced through the spine (saddle-stiching) or side (side-stitching) of a booklet and then clinched. Different thicknesses of wire are used, depending on how thick the booklet is.

Coil of wire

Booklet placed here

Foot control activates stitching

Insert (**above**) A method of placing colour plates in books. The four page unit of colour is inserted in the middle of a section of black-and-white.

Wrap (**above**) Alternatively, the four pages of colour are wrapped around the black-and-white sections. Sometimes these two methods are combined in one book.

be applied at this stage; these do not really add any strength to the book, but look attractive and cover up the tops of the sections. The book block can then be left with a flat spine ('flat back' or 'square back') or can be rounded and backed. The rounding and backing operation gives a firm grip to the sections and helps to prevent the middles of the sections dropping forward.

The book block is then cased-in; that is, it is glued into the case and pressed to make it firm and flat. Jackets, if required, are then wrapped around the book; this can be done by hand or machine.

Although many hardback books are still sewn, an increasing number are perfect or burst bound, as the strength of these techniques improves. Another technique used is 'thread-sealing', where, instead of sewing, plastic threads are inserted through the

These brasses are used to block the spine of a book in imitation gold or silver. The image area is raised and the brass is heated and pressed through foil to block the case.

spines of the sections to hold the pages together and then the book block is glued at the spine to hold the sections together.

Casemaking and blocking For hardback books, the cases are made separately on a casemaking machine. This wraps cloth or imitation cloth around the three pieces of board (front, spine and back) and glues it to make the case. Often the cloth is plain in colour, but it can also have a design printed on it.

Blocking is the method used to stamp such things as the title and publisher's imprint on the spine and sometimes the front of the case. A 'brass' is made — very often reproducing part of the jacket artwork. The brass (there is a cheaper version called a Chemac) has the image area raised above the background rather like a letterpress block. On the blocking machine, the brass is heated and pressed through metallic or coloured foil on to the case.

Hand binding De luxe or very limited editions are bound by hand, using leather or real cloth (as opposed to imitation). Here, all the operations described above for cased binding are carried out by hand, even down to the title on the spine being blocked one letter at a time. There is a shortage of skilled labour in this area and good craft binders are much in demand.

Other methods of finishing
Finishing on web presses Web presses can be fitted with a variety of attachments to produce a finished product without further off-the-press operations being necessary. These facilities can include sheeting, scoring, perforating, wire-stitching, gluing and envelope making.

Collating As well as the collating done in bookbinding in the gathering process, there are also collating machines for assembling individual sheets (A4 size, for example) to produce reports and manuals.

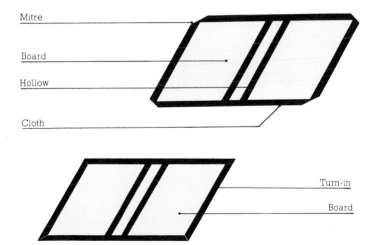

Casemaking The boards for the spine, front and back are placed in position on the previously glued binding material (**1**) which is folded over on all edges to produce the finished case (**2**). This is now carried out automatically on high speed casemaking machines.

Loose-leaf binding A growth area is the loose-leaf binding of reports and computer manuals. Plastic ring binders are popular; they are made by specialist suppliers. Other methods include plastic-slide or post binders.

Embossing This is normally carried out on letterpress printing machines or die-stamping machines (see Die stamping, page 31). 'Blind-embossing', the creation of a raised image without ink, is often used for letterheads. Paper or board can also be embossed overall before or after printing on special roller-embossing machines.

Die-cutting This is known also as 'cutting and creasing'. A forme is made consisting of knives — blunt for creasing and sharp for cutting — and placed in the bed of a converted letterpress machine or a special cutting-and-creasing machine. The process is used mainly for cartons, where irregular shapes have to be cut out and the box corners scored.

Round cornering This can be done on a cutting-and-creasing machine or on a special 'round-cornering machine', which has a tool shaped like a chisel with a curved cutting edge. This technique is often used for bibles.

Box making Cartons are made up on special machines that glue the joints together.

Varnishing A gloss finish can be achieved by applying lacquer or varnish after printing. This can be done by printing a varnish on the normal printing machine or by 'spirit varnishing' on a special machine. Very high gloss can be achieved using an ultraviolet (UV) cured lacquer. In this process, the lacquer is applied by a roller and then dried with UV lamps. Most paperback books and many cartons have this finish.

Laminating Here gloss and protection are achieved by applying a sheet of clear film to the printed matter. Cellulose acetate is used for very high gloss, and oriented polypropylene (OPP) where the laminate needs to fold without cracking.

Addressing and mailing

Although not strictly part of the finishing process, many finishing departments include facilities for addressing and mailing; this particularly applies with magazines and journals, where the publisher asks the printer/finisher to address and mail subscription copies.

Addressing machines can range from those that simply apply a preprinted address label to sophisticated computers that print out the labels while the copies are running through the machine. The more sophisticated machines can also batch the copies for different postal regions or countries. The labels here are often produced by ink-jet or laser printing (see page 32).

Packing

This is an often neglected but vital area of the whole production process. Excellent printed products can be produced on sophisticated machinery and yet arrive damaged at their destination due to inadequate packing. If delivery is by the printer's own transport, the parcels can be shrink-wrapped on special machines, or work can be stacked on pallets and the whole pallet shrink-wrapped for protection.

Where transport is being arranged by third parties, it is safer to pack the items in stout cartons, particularly if the work is being exported.

6
WORKING WITH THE PRINTER

Buying print / Typesetting /
Reproduction / Printing abroad /
Specifications / Printer's estimates /
Quality control / Scheduling / Buying
paper / Working with the designer /
Microcomputers in production

How do we select the right printer for the job and work with him
or her to get a result with which both parties are happy? The
client wants the job delivered on time, at the right price and to the
quality required. The printer wants all these things as well, and
yet a printing job can often be unsatisfactory to one or both
parties. Although almost all printing is 'bespoke' and each job
will raise its own special problems, with good planning by the
client, especially early on, most problems can be avoided.

Buying print
When choosing a printer, what is required is a balance between
price, quality and service. Before considering these areas in
detail, the area of choice of suppliers must be narrowed to those
capable of effectively producing the job required. Printers
specialize in particular areas of printing, and there is obviously no
advantage in sending the printer a specification that his or her
machinery cannot deal with. The printer's plant list will show the
buyer if he or she is equipped to produce the job.

Having chosen a group of suitable potential suppliers, the
buyer will normally choose the one which quotes the cheapest
price, as long as the quality and service are as good as those of
the competitors: there is no point in saving a few per cent on the
price if the job is likely to be of poor quality or delivered late.

Some buyers consider only the first price and do not give
printers a chance to requote. Although this is the more ethical
approach, many successful buyers negotiate prices down after
the first quote; they may, for example, get a printer whose service
and quality are good down to the price of a printer whose price is
lower. There is obviously a limit to how far this process can go, as
the printer is in business to make a profit, but, nevertheless, such
negotiations can achieve big savings, particularly if a job is
placed at a time when the printer has relatively little work, or if
several jobs are placed together, so that the buyer is in effect
getting a discount for volume.

Service means meeting all the schedule dates and the final
delivery dates and, if possible, making up time if the job runs late
at any stage. It also means fast answers to queries and good
attention to detail. Service is obviously of paramount importance
on dated items such as magazines, reports, accounts and so on.
Where very fast results are required, one has to pay extra for the

service as the printer has to have sufficient staff (sometimes on night-shift) and equipment to be able to respond rapidly to the customer's requirements.

Quality in printing really means fitness for purpose. A glossy promotional brochure needs to be of higher quality than a simple handbill. Most printers can achieve an acceptable quality level on more straightforward jobs, but colour printing is an area where results can vary enormously — even when printers are working from the same set of films. The best way to establish a printer's quality level without any risk is by the recommendation of other customers. You can also see samples of work, and a visit to the factory is usually instructive.

Print buying does not lend itself to the application of hard and fast rules, and a good print buyer is one who has learned from experience and has an instinct for the right supplier for a particular job. The real key to effective print buying, however, is to develop a good relationship with the printer. This can be achieved by continuity — in other words, by using a small group of suppliers which each get a reasonable amount of work, rather than spreading the work thinly among a large number of suppliers. It is also important to develop 'give and take' — so that, for example, a printer may ask if a job can be delivered a couple of days late. If the customer can permit this, there is obviously a better chance of the printer returning the favour on a future job.

The printer's salesman Printers' salesmen, or 'reps', vary enormously — from the superb to the appalling. A good salesman or saleswoman will start with a letter outlining his or her company's facilities, follow up with a telephone call to make an appointment, visit to explain how the company can help the buyer, provide production advice if so requested, estimate promptly and follow up with a telephone call to check how the estimate compared with those of the competitors. Once working for the customer, the salesman will act as the customer's representative in the factory and follow jobs through to completion. The bad salesman will drop in without an appointment, be badly briefed on what the company can do, take a long time to give an estimate or sometimes not give one at all, and then either not follow up or, perhaps worse, pester the buyer daily.

Where there is a good salesman working for a good printer there is clearly no problem; similarly, a bad salesman working for a bad printer creates no difficulties — for obvious reasons! However, there is the situation of the bad salesman working for the good printer and here, if possible, buyers should try to ignore the quality of the salesman if they feel the particular printer concerned is the right one for the job. When the customer is giving a fair amount of work to a particular printer, the buyer will develop good contacts at the factory with a production controller or order clerk. It is also advisable to visit the factory from time to time, as 'putting a face to a name' is always worthwhile.

The above remarks may seem rather critical of some printers' salesmen. It is worth pointing out that the quality of buyers can vary just as much.

Outwork A printer will sometimes quote for the whole operation but place part of the work with another supplier (that is, subcontract). This applies particularly to specialist finishing and binding operations, for which the printer may not have the necessary equipment. This 'outwork' is not usually a problem, as long as the printer takes complete responsibility for the outwork

supplier. Some buyers may want to know with whom outwork is being placed, possibly to avoid inadvertently using a supplier who has given problems before.

Typesetting

In buying typesetting, the same principles apply as in buying print, but the following additional points should be watched.

Some typesetters will check copy very carefully before setting, raising queries with the customer, and will also supply a marked set of proofs drawing attention to any errors they know they have made. If there are a lot of these, they may re-run the corrected text to give the customer a cleaner set of galleys at the first proof stage. If these typesetters are no more expensive than those who do not provide these services, then they obviously represent better value.

'Author's corrections' is a contentious area, as it is always difficult to judge if the charge for corrections is fair and some less scrupulous typesetters will put in a low quote for the job but then overcharge for the corrections in order to make a good profit. Some typesetters have a standard charge for corrections of so much per line, and here it is comparatively easy to check the correction bill. Failing this, it becomes a matter of trust between the customer and typesetter.

Typesetters based in the centres of cities can give a very fast overnight service, but because they have high overheads and staff costs (including night-shifts and overtime) they can be more expensive — sometimes by a factor of four times the price of an out of-town typesetter who might take a little longer, but who can show dramatic savings if the customer can wait another day or two for the typesetting.

Reproduction

As with typesetting, there can be difficulties over the charges made for changes and extras. These can be partially avoided by a clear specification at the time of quoting, particularly when dealing with tint-laying and flat artwork. If the first proof is not a good reproduction of the subject, the reproduction house should correct it and show an additional proof without extra charge. Again, trust must enter the relationship between customer and reproduction house, as there are often corrections which are too small to make a second proof worthwhile; if the reproduction house does not bother to carry these out, the customer will not know until the job is on machine, which is obviously too late.

Printing abroad

Communication problems and transport costs mean that it is usually only high-volume work which goes abroad. Printing abroad attracts extra costs in terms of telephone, telex, couriers and transport, as well as considerable 'nuisance' value, so it should not be considered unless there are big price savings or significantly better quality or service. However, in certain areas, the buyer may be forced to print overseas.

When printing abroad, the telex is a very useful means of communication, as it gives a written record instantly and is not affected by time differences between different countries. There are fast courier services available at reasonable prices which can get packages to most parts of Europe and the east coast of the USA within 24 hours and to anywhere else in the world within 48

hours. Transport of the finished job will take from two days to a week from Europe, but up to six weeks from the Far East.

The specification
Getting the specification right is the most important part of any print buyer's or production manager's job. Before drawing up the specification, the following questions need to be asked:
- How durable is the job supposed to be?
- Who will be using the printed item and under what conditions?
- What is the quantity of the first printing, and are reprints likely?
- When and where will delivery be required?

All these points need to be resolved by the client and his or her company before the printer is contacted. On occasion, the printer may be asked to quote on alternative specifications, but this should be done only if there are good reasons for doing so, rather than because the client and company cannot make up their minds or are trying to postpone a decision.

Let us assume that all the necessary questions have been answered and the point has been reached where a specification can be drawn up and sent to suppliers for quotation. The first considerations are typesetting and reproduction. These might be done by the printer or by separate trade houses.

Typesetting specification If the typesetter is not quoting from actual copy (manuscript) he or she needs to know the number of words, number of pages, typeface, type size, type measure, layout, number and type of proofs and what final product is required. The proofs can be galley and/or page proofs, and the final product can be camera-ready copy or negative or positive film, depending on what the printer requires. Although a typesetter will give a price without seeing the copy, he or she will usually reserve the right to requote on seeing the manuscript.

Reproduction specification The specification for reproduction should include the number of originals, whether they are transparencies or flat artwork, their appearing size, whether or not some or all of the originals are in pro (in proportion — see Glossary, page 136), the page size, whether illustrations bleed, whether proofs are to be imposed in page form or at random, and the number and type of proofs required (that is, whether they should be proofs from a proofing press or photographic proofs such as Cromalins). Black-and-white pictures should be described as halftones or line. The final product required should be given, whether it is scanned sets or final hard-dot positives, and the repro house should always be asked to supply progressives for the printer. The repro house may wish to requote when its staff have seen the originals.

Printing and finishing An example of an enquiry form is on page 114; detailed below are some of the items on it.

The items under 'origination' are described to tell the printer all he or she needs to know to give an accurate estimate for planning and platemaking. This includes the type of intermediate (CRC or negative or positive film) that will come from the typesetter or reproduction house; whether the film will be imposed or will have to be made up into page by the printer; and what further proofs the printer should supply before printing.

A simple job like a letterhead may not require any proofs; a booklet, magazine or book will normally require galleys, a set of imposed ozalids and, in some cases, the client might require a complete colour proof, fully finished as the final job. This is very

A reproduction specification that is sent out to a number of companies for quotation.

REPRODUCTION SPECIFICATION

From: A Publisher

Date: 10 October 1985

To: A Repro House

Title: A Book

Please quote for reproduction and proofing to the following specification:

Trimmed Page Size: 246 x 189 mm (full bleeds)

25 mono half-tones (x half page) out of pro, random sizes

25 mono line (x half page) to a common reduction

50 transparencies (x half page) out of pro, butted rules, no cut-outs

Please allow for 12 sets of scatter proofs. The final requirement is random, finalized and corrected film positives and progressives.

Please make prices valid to December 1985.

TYPESETTING QUOTATION

From: A Publisher

Date: 10 October 1985

To: A Printer

Title: A Book

Please quote for setting and page make up of this title as follows:

Trimmed Page Size: 246 mm x 189 mm

Extent: 208 pages

70,000 words set single column as attached layout and setting instructions. Spaces to be left for 100 illustrations occupying a total of 40 pages.

Please allow for 6 sets of galley proofs and 6 sets of page proofs including a typesetter's marked set of each. Final requirement is for clean one-piece film positives. Please show reduction if the final requirement is camera ready copy or film negatives.

Please make prices valid to December 1985.

A book typesetting specification to be sent out to various firms for quotation.

expensive, as the printer has to make plates and make-ready exactly as he or she would have to do to produce the final job – and they may not be reusable. Nevertheless, this sort of proof might be required if, for example, a promotional item were planned for distribution nationwide and several people in the client's company had to approve it in its final form before the printing of the main run. The quantity of such proofs dictates whether they are produced on a proofing press or printed on a printing press. Usually, any quantity more than 50 copies will be printed rather than proofed.

The trimmed page size (TPS) is probably the most important single item in the specification, because this determines the type of printing and binding machines on to which the job will fit, and therefore has a direct bearing on the price. The chart here shows the economical page sizes one can get out of a printing press with a sheet size of $1,100 \times 1,600$mm (43×63in), depending on how many pages are printed to view (that is on one side of the sheet). To make the best use of the machine, the job should be printed as near to the maximum sheet size as possible; the price of the job will increase considerably if you ask for a size that is just slightly bigger than the page size given. For example, a page size of 266×195mm ($10\frac{1}{2} \times 7^{11}/_{16}$in) will fit 32 pages to view. However, should you opt for a size of, say, 271×200mm ($10^{11}/_{16} \times 7\frac{7}{8}$in), only 24 pages can be printed to view, requiring a third more plates and make-readies and a third greater number of sheets to be printed: all this will add greatly to the cost, even though the size is only a few millimetres bigger than the more suitable one. Exactly the same principles apply with smaller machines. The printer will be happy to give you relevant information about the presses.

The number of pages printed at a time will also affect the

ENQUIRY FORM		
From:	To:	
Date:	Job:	
Specification:		
Trimmed Page Size	mm (Portrait/landscape)	
Extent:	pp printed in	colours on
	Paper supplied by client/printer	
Cover: printed in	colours on	laminated/varnished
Binding/Finishing:		
Origination: supplied by client as random/imposed film of illustrations and galley/page film		
positives/negatives/crc of typematter		
Proofs required:		
Packing:		
Delivery to:		by:
Quantity:	and 1,000 run on	
Validity: to		
Extras:		

A typical **enquiry form** for printing and finishing.

binding or finishing. For example, if you print 24 pages to view, it is more economical to bind in 24s than 16s, there being fewer sections to fold, gather and sew. If you are using a large size (above A4) then check with the supplier the maximum size that can be finished or bound.

After the size should come the description 'portrait' or 'landscape' (see below). In the UK, this is always indicated by the height being given first, but in the USA and most European countries the width is given first, so it is always best both to state whether the job is portrait or landscape *and* show it by the order of the dimensions. It is also important to state here whether the job bleeds, as this requires a larger sheet size to accommodate the trimming of the illustrations.

The extent (number of pages) obviously depends on how the designer can fit in the copy and pictures but, in order for it to be economical to manufacture, it should be divisible by 4, 8, 12, 16, 24 or 32 pages, depending upon what sheet size is being used; the printer can advise you on this. An example might be a booklet whose extent could be either 16 or 20 pages. It might well be that 16 pages fit exactly on to the particular machine being used, and that the extra four pages will need a separate working involving new plates and make-ready. This means that certain operations nearly double in cost for only a 25 per cent increase in extent. This is the area where the designer and the print buyer need to work closely together to give the job an economical extent.

Next, as well as stating the printing process, the number of colours to be used is given. The shorthand for this is:

4/4 Four colours both sides of the sheet
2/2 Two colours both sides of the sheet
1/1 One colour (normally black) both sides of the sheet.

Maximum trimmed page sizes
obtainable from a press size
1,100 × 1,600mm (43 × 63in
approximately). These sizes allow for
bleeds. (Inch equivalents are
approximate.)

pages to view	maximum page size in mm	maximum page sizes in in*
8	538 × 394	21⅛ × 15½
12	522 × 269	20½ × 10½
16	392 × 269	15⅜ × 10½
20	309 × 266	12³/₁₆ × 10½
24	266 × 261	10½ × 10¼
32	195 × 266	7⅝ × 10½
48	193 × 178	7⅝ × 7
64	193 × 133	7⅝ × 5¼

Landscape

Portrait

Portrait (an upright rectangular format) and landscape (a horizontal rectangular format). These terms originate in painting and drawing where portraits are commonly executed on upright rectangles and landscapes are commonly painted or drawn on horizontal rectangles.

It is possible to have any combination of the above, for example, 4/1, 4/2.or 2/1. Although it is possible to print in three colours, this is unusual because most printing machines for multi-colour work are two-colour or four-colour, so that to print in three colours is not to make the most economical use of the equipment.

Unless the customer specifically requires a particular brand of paper, it is best to describe the type of paper (for instance, 'matt blade-coated cartridge') and the desired weight, leaving the printer to choose the brand, as he or she may stock a particular brand or have an arrangement to buy it at an advantageous price. In this case, you should ask for a sample with the estimate — or, better still, a blank dummy (a book made up in the size, extent, type and weight of paper required but unprinted). If the client is supplying paper, the printer should be asked to state the sheet or reel size and quantity required (including wastage) and the grain direction, if sheet-fed.

When stating the quantity, always ask for a 'run-on rate' (the cost of an extra number of copies run at the same time as the main quantity). The purpose of this is twofold: if the client decides to print slightly more or fewer copies, it saves getting a new estimate; secondly, the final delivered quantity is hardly ever exactly the number ordered and a quoted run-on rate enables the invoice to be checked. However, calculations based on the run-on rate (up or down) must be done with care, as they can be misleading if the total quantity has changed markedly in either direction. For example, if a job is increased from 40,000 to 80,000 copies, a calculation based on the run-on rate could be seriously wrong, as the printer may switch from sheet-fed to web-fed offset at 50,000 copies, giving a much lower run-on rate above this quantity. As a rule of thumb, the run-on rate can be run up or down by a quarter of the original quantity, but outside this range it is best to check with the printer.

'Validity' is important, as there are periodic increases in labour and paper prices. If a price is required for a job to be delivered in six months' time, it is best to ask the printer for a firm price for this period. It is rarely possible for him or her to do this with paper, as increases can be frequent and unpredictable.

Finally, the delivery date and delivery address should be given, as well as full details of the method of packing.

Book production specifications An example of a specification for a book is shown on page 118. Here all the above general points on specifications apply, but there are some additional considerations.

Endpapers are normally on uncoated cartridge paper, which adheres better to the case than does coated. Sometimes, however, the endpapers may have been printed in a four-colour process, and they will normally then be coated, as the printability takes precedence over the adhesion qualities. Self-endpapers (see page 105) can save money, but some strength is lost.

Printing 4/1 (four colours one side of the sheet and one colour the other) can give a good spread of colour throughout the book at a lower cost than printing 4/4 (four colours throughout), and can also save in origination costs. Another way of achieving colour scattered throughout the book is by the use of wraps and inserts (see page 106); this practice saves money on printing, but it does add to the binding cost.

Cover-board for paperbacks is normally one-sided, meaning that the inside has a rougher surface which helps the glue to adhere to it and the book block; cover-board with a smooth or coated inside surface can cause binding problems. Jacket paper normally has a rough inside surface so that the jacket does not slide around on the case as much as it otherwise might.

The boards from which the case is made should be dutch grey boards for all but the cheapest books, where strawboard can be used. The reason for this is that strawboard can warp in extremes of temperature and humidity. This consideration is important, because at least some copies of most titles are exported.

Giving detailed packing instructions is even more vital in bookwork than in commercial work, as many publishers' warehouses are highly automated and give very precise instructions on labelling, type and size of cartons, type and size of pallets, and maximum height of books on a pallet. Failure to follow these instructions can lead to charges for repalletizing — sometimes the load can even be turned away from the warehouse for the printer to repack or repalletize.

Shipping is another important area. Where the printer is responsible for shipping it must be made clear whether the shipping is CIF (carriage, insurance and freight to a specified port), FOB (free on board at the specified location) or FDW (free delivery to the customer's warehouse).

When asking for the basic printing price, it is useful to ask about the costs of various extras. Although these extras may not in the event be required, it will save you having to ask for the prices separately should they become so. These extras can include the cost of duplicate film (state whether wrong- (mirror image) or right-reading (as this page) on the emulsion side, and whether negative or positive), the cost of a complete language change for printing a foreign edition at the same time as the English-language run and the cost of an imprint change (the cover/jacket, title page and title-verso (imprint page)) for another English-language publisher or a book club. If a reprint is expected fairly soon after the first printing, it is worth asking the printer to quote a reprint price at the same time and to keep the plates.

The printer's estimate

Having sent out the specification to one (or more) printers, you should carefully check the estimate on its arrival. The printer may have changed some of the details of the specification to suit his or her equipment better. In particular, he or she may have changed the size — although, if so, the customer should have been alerted to this separately rather than simply by a different size appearing in the estimate. Other things to watch for are that the weight and type of paper are identically as given in the specification, and that the paper sample or dummy (if supplied) is acceptable. The validity should also be checked against the specification. If the printer breaks the price down into component parts, the client cannot thereby assume that he or she can use the printer for some parts of the job and another supplier for other parts, as the prices may be based on the printer getting the whole job.

The order Once the printer has been selected, he or she should be given a written order for the work, detailing the complete specification, the price and the delivery date.

A printing and binding specification for bookwork, to be sent out to printers and binders for competitive quotation.

BOOK SPECIFICATION

From: A Publisher
Date: 10 October, 1985

To: A Printer
Title: A Book

ORIGINATION
Text: type supplied as film made up into page (1 piece per page) and random positives of 75 colour illustrations, 25 2-colour diagrams and 50 b/w halftones to be stripped and imposed by printer.
Supply 2 sets of imposed ozalids.
Jacket/cover: complete 4-colour film supplied, no imposing required. Supply 2 ozalids.

TRIMMED PAGE SIZE
255mm x 248mm bleeds (portrait).

EXTENT
96 pages.

PRINTING
Text: printed 4/1 throughout.
Jacket/cover: printed 4/0. Laminated.

MATERIALS
Text: 120gsm matt blade coated cartridge.
Endpapers: 135gsm offset cartridge.
Jacket: 135gsm 1-sided coated art, laminated.
Cover: 260gsm 1-sided coated board.

BINDING - CASED
Cased flat back, board hollow, bound sewn in 12 page sections, 3mm grey board imitation cloth, blocked on spine only, jacketed.

BINDING - PAPERBACK
Limp, sewn in 12 page sections. Cover glued to spine and crease mark 5mm from spine. Cut flush.

PACKING
In cartons of 20 on pallets.

QUANTITY
10,000 hardback and 10,000 paperback and 1,000 run on of each.

DELIVERY
CIF London.

EXTRAS
Quote extra for complete change of black plates for language on text, cover and jacket.
Quote extra for duplicate positive film of text, jacket and cover, right reading emulsion side down.

Quality control

The print buyer's control of quality is mainly that of checking material going to and from the printer. In typesetting, the camera-ready copy or film should be checked for density, scratches and blemishes before being sent to the printer. Checking colour reproduction should be done in the correct viewing conditions (see page 52), and it is just as important to check the quality of the originals before they are sent for reproduction and point out any problems. Where a job is very critical or has a very long run, it may be passed on machine (see page 52).

When the job has been completed, the buyer should ask for advance copies to approve before despatch so that, if there are any queries, checking and, if possible, correction can be done. There are particular points to look for (see next page).

QUALITY CONTROL CHECKLIST

• **Set off** This is where the ink from one sheet smudges on to the underside of the following sheet during printing, and is particularly noticeable on covers where the inside is blank. It is caused by not using sufficient anti-set off spray or sufficiently quick-drying inks or problems with the paper.

• **Colour variation** This occurs where the printer does not maintain consistent colour throughout the run and can be avoided by the use of colour bars and regular measurements with a densitometer (see page 43).

• **Hickies** These are small areas of unwanted solid colour surrounded by an unprinted 'halo' area, and are caused by specks of dirt, paper debris

or ink skin on the plate or blanket cylinders. These can be avoided by regular washing of the blanket.

• **Bad register** This is easy to spot as normally the colour(s) out of register protrude beyond the edge of the four-colour set. As well as this, the subject will look out of focus.

• **Binding faults** These are often the most expensive to put right, as very often a problem here means the job has to be started again completely from scratch. Perfect binding always has to be monitored closely, particularly on heavy, coated papers.

Scheduling

All but the simplest print jobs should have a schedule drawn up giving the deadlines for the various stages. Before drawing up the schedule, the buyer should check with his or her colleagues that the in-house dates are feasible and with the printer as to how much time will be needed for the various stages. Where possible, contingency time should be built in to allow for any second proofs that are required or other unforseen problems that may occur.

Buying paper

There can be advantages in the customer buying paper and supplying it to the printer, but in general it should only be considered for high-volume work such as books or magazines. The disadvantages are: the paper has to be paid for at a time based on the delivery date of the paper, rather than on the delivery date for the job as a whole, so that cash flow is affected; if there is a problem with printing on the paper you may end up with an unresolved dispute between the printer and paper maker, with the customer picking up the bill; the customer will not be able to buy the paper for less than the printer unless he or she is buying a very large quantity. Moreover, the customer can end up with excess stock which has to be stored and paid for.

However, if a customer is buying a large tonnage of a limited range of papers, he or she can very often obtain a better price direct than by buying it through the printer, and he or she can have better control and knowledge of likely price increases and availability problems.

Working with the designer

There are sometimes problems in the relationship between the print buyer or production manager and the designer, as the two people may have different priorities. The designer considers the final look of the job to be the most important criterion, while the buyer is primarily concerned with costs and dates. In a well run company, the relationship between the two will be balanced to give a reasonable compromise between these opposing requirements: a job winning a design award loses some of its glory if it costs far more than planned and is delivered late

because it has been 'over-designed'. A good designer is one who can achieve a good visual result within the budgetary and other restraints his or her company may impose.

Just one example of where a designer can particularly affect the work of the production department is in the choice of an exotic typeface not held by the typesetter the production manager had in mind. Here, the production manager may be able to use another typesetter who holds the face and can offer a similar price and service, or the designer may have to select another typeface. Another example is the use of small type reversed out of four colours, where the planned process is incapable of register precise enough to keep the type clean.

There need not be conflict if both parties try to understand and appreciate the other's point of view.

Microcomputers in the production department
The availability of cheaper and more powerful microcomputers represents an opportunity for the production department to get the computer to take over some of the more repetitive clerical tasks and to do estimating work that involves calculation. Word-processing software can be applied to specifications and orders, and spreadsheet software to estimating and stock control. The microcomputer can be linked via electronic mail with similar machines at suppliers, and can be used to communicate directly with them, replacing post and telex.

A large proportion of the software now available is designed so that the user can write his or her own programs, and this is much easier than most non-users believe. The microcomputer can free production people from most of the routine tasks, leaving them free to use their time more effectively.

The microcomputer in the photograph is typical of the simple inexpensive micros suitable for estimating and progress control applications in the production department.

7
GLOSSARY
by Colin Cohen

Disk is used for the magnetic and optical media for computer systems and disc for the optical founts used in phototypesetters. Terms which have their own entry are written in SMALL CAPS.

A note on American and British spelling and terminology The spelling generally follows the British model. Where a single meaning is covered by more than one word it is normally defined at its first occurrence, be it British or American, and cross-referenced.

A

A sizes Series of finished trimmed sizes in the ISO INTERNATIONAL PAPER SIZES range. See also International Paper Sizes on page 152.

AA/AC *(US/UK)* see Author's Alterations/ Corrections.

Abrasion resistance The ability of a surface such as a printing PLATE to resist rubbing or other frictional forces without being worn away.

Access To recall data from a computer storage area. Access time is the time taken for a computer system to retrieve data from its memory or from MAGNETIC MEDIA. Access may be either random (on disks, where the reading head goes straight to the point required) or serial (on tapes where the head has to pass along the whole tape until the desired point is reached).

Accordion fold *(US)* A series of parallel folds in which the paper is 'pleated' by making each fold in the opposite direction. *(UK)* Concertina fold.

Achromatic A method of COLOUR CORRECTION used on a colour SCANNER by which an extended degree of UNDERCOLOUR REMOVAL can take place. In conventional UCR most of the colour and tone is still contributed by the three PRIMARY COLOURS, with the black lending only deeper shadow tones. In achromatic REPRODUCTION the very minimum amount of each colour required is computed and the black added to produce the required depth of colour.

Acoustic coupler A cheap, slow, MODEM that does not need to be directly wired to the telephone system as the telephone handset clips into its 'cups'. It converts the electronic impulses into sounds so they can be transmitted down the phone at 300 BAUD or sometimes 1,200 baud.

Adhesive binding Style of unsewn binding in which the backs of GATHERED SECTIONS are cut off and the LEAVES are held together at the binding edge by glue or synthetic adhesive and (in a CASE BINDING) a suitable lining. See also HOT or COLD MELT ADHESIVES.

Airbrush A pneumatic tool with a small reservoir of liquid ink arranged so that a controlled current of air is blown over the ink's surface which is thus broken into an atomized spray and ejected through a nozzle. Artists use them to obtain gradated effects on drawings, photographs and the same effect can be obtained on ELECTRONIC PAGE COMPOSITION and computer graphics systems.

Aligning numerals see MODERN NUMERALS.

Alignment In typesetting the ability of the output device to ensure that each character is perfectly aligned on the BASE LINE. In JUSTIFICATION the variable spaces inserted between words so that left and/or right hand margins of the type are vertically aligned to form a straight line.

Alphabet length Usually the length of a LOWER CASE alphabet in a particular FOUNT and used in CAST OFFS.

Ampersand The symbol '&' for 'and'.

Angle bar *(US)* see TURNER BAR.

Aniline A class of liquid inks used in FLEXOGRAPHY.

Anilox see FLEXOGRAPHY.

Antique (1) A rough, uncalendered, finish on book paper, when bulk and light weight are required. **(2)** Typefaces — Old Style, see MODERN TYPEFACES.

APR Asahi Photopolymer Resin. A LETTERPRESS or FLEXOGRAPHIC PLATE made from a clear and flexible PHOTOPOLYMER liquid.

Apron *(US)* Extra space left at the edge of a page for a fold-out.

Arabesque see PRINTER'S FLOWER.

Archiving Storing of information off-line from a computer, WORD PROCESSOR or typesetting FRONT END SYSTEM. This can be on any MAGNETIC MEDIA such as a FLOPPY DISK, magnetic tape, cassette, cartridge or removable rigid disk.

Art *(US)* Abbreviation of ARTWORK, or more usually a Mechanical.

Art paper Paper that has received a coating of china clay and SIZE. It has a very smooth surface, which may be matt, but is usually shiny.

Artwork *(UK)* Usually material (other than text

only) for reproduction. Finished artwork or mechanicals (US) are usually completely camera ready and include any type matter in position, as well as HALFTONES in the form of pre-SCREENED PRINTS.

ASCII More accurately US ASCII, USA Standard Code for Information Interchange. A more or less standard interpretation of the ISO data codes, it gives 128 seven-bit codes and is used by almost all electronic equipment not made by IBM, who use EBCDIC.

Ascender Top part of the LOWER CASE letter stretching above the X-HEIGHT of the character, as in d, h, k.

ASPIC (UK) Authors' Symbolic Pre-press Interfacing Codes, a hierarchical set of codes used for indicating to typesetting equipment the typographic commands intended by a computer/WORD PROCESSOR user. Sponsored by the BPIF.

Assembly (1) Bringing together all the items required to make a complete printing PLATE — either in film or on paper. **(2)** see also FLAT.

Asynchronous Method of transmitting information over data circuits with a start and stop BIT at the end of each BYTE. While it is less efficient in terms of speed than synchronous, it does not require the equipments' internal clock cycles to be synchronized.

Author's alterations/corrections (US/UK) Corrections, made by the author on proofs, that alter it from the original copy. The cost of making them is charged, in contrast to printer's errors or house corrections.

Author's proof The proofs sent to the customer. Traditionally this set should have a copy of any PROOF CORRECTION MARKS.

Automatic transfer press A WEB-FED press in which separate jobs are run without a stop to change over. While one is running the second set of PLATES are being put on a second UNIT and MAKE READY carried out.

Autopaster A FLYING PASTER.

A/W see ARTWORK.

Azure A grey colour

usually found in ledger papers.

B

B sizes The ISO INTERNATIONAL PAPER SIZES intended primarily for posters, wall charts and similar items where the difference between each A size represents too large a jump. See page 152.

Back/spine The binding edge of a book or booklet. Traditionally backing a book is done by placing it in a vice and hammering the spine, which has already been rounded, so as to make a shoulder on either side against which the front and back covers fit closely. CASED books are backed by machine.

Back margin The white area of page between the spine and the printed image. See also GUTTER.

Back step (collation) marks Black marks (which may have letters or numbers on them) printed where the final fold falls on book SECTIONS. Once folded and GATHERED the marks appear in a stepped sequence that shows if any are out of order.

Back to back/back up (US/UK) **(1)** The process of backing a printed sheet, otherwise known as PERFECTING. **(2)** To make a security copy of MAGNETIC MEDIA.

Background The ability of a computer to carry out one task while the operator does something else: JUSTIFYING a line while the next is keyed, making up a page while another is corrected or receiving data over the telephone while the operator is sending text for setting. See also CONCURRENT.

Backing/release paper The component of a self-adhesive material that acts as the carrier for that material. The silicone-backing readily separates from the adhesive prior to the application of the self-adhesive material to its final surface.

Backmatter (US) The final pages of a book, such as the index. (UK) Endmatter.

Backslant A typeface that can be made to slant backwards, in the opposite way to ITALIC. Either effect can be obtained optically or electronically in PHOTOTYPESETTING.

Bad break Poor HYPHENATION, usually carried out automatically where words are broken in the wrong place in JUSTIFIED typesetting.

Band aid (US) Corrections added to a PROGRAM to make it work better (or at all). (UK) A patch.

Bank A thin writing or typing paper, white or tinted, made in a range of weights from 45 g/m² to 63 g/m². Heavier weights of otherwise similar material are termed BONDS, the lighter weights were called manifolds.

Bar code Bar codes are used on packaging and book covers and carry information relating to their contents. The many different types are designed to be easily read by computerized systems such as cash registers or for stock control and need to be accurately printed. The two most common types are the American UPC (Universal Product Code) and the EAN (European Article Number) — both are used over a wide geographical area.

Baryta paper A very smooth matt-COATED paper used to make REPRO PULLS of type or BLOCKS required for subsequent REPRODUCTION.

Base alignment Traditionally the designs of metal types were centred on the face of the type, so that the point at which any design would align depended on the relative length of its ASCENDERS and DESCENDERS. This made it very difficult to mix faces, so that most types are now output to align at the foot of the X-HEIGHT in PHOTOTYPESETTING.

Base line The notional line at the foot of the X-HEIGHT on which different type designs align.

BASIC Beginners All-purpose Symbolic Instruction Code. Still the most popular language used on microcomputers. A high-level language that is more or less within the reach of non-specialists.

Basis weight (US) The weight (SUBSTANCE) of a REAM (usually 500 sheets) of a paper or board in the base size. See page 98.

Batch processing Most computer operations (including PHOTOTYPESETTING) are

processed in batches, rather than in 'real time'. From the user's point of view the difference is that in batch processing data being input is not processed until a final instruction is given, while in real time each BYTE is processed as it is entered. This means that the effects are immediately evident, and that it should be faster.

Batter A damaged letter, from the days of hot metal when the characters could be dented physically.

Baud The rate at which data can be transmitted. It is not safe to equate it with BITS per second as extra bits may be added during transmission. Apart from Prestel, little data is transmitted slower than at 300 baud, or 30 characters per second. Standard telex is only 50 baud while the new teletex is 2,400 baud.

Baudot The limited five-BIT code used in telex transmissions that only allows for capitals, numerals and a few symbols.

Beard (US) see BEVEL.

Bearoff (US) Adjusting the spacing in typematter to correct JUSTIFICATION and COMPOSITION of the COPY.

Bed The moving or stationary table of a LETTERPRESS printing machine, on which the FORME is locked in preparation for printing.

Belt press A letterpress machine used for printing books and lottery tickets. Flexible printing plates are fixed to a pair of belts in such a way that books of almost infinitely varied EXTENT and page size can be produced.

Bevel (1) The outside edges of a LETTERPRESS BLOCK, below the printing surface, by which the block is pinned to its mount. May be trimmed off if the plate is adhesive mounted. (2) The sloping surface of HOT METAL type running up from the shoulder of the face.

BF Bold Face – see BOLD.

Bible paper see INDIA PAPER.

Bicycling (US) Moving duplicate film, ARTWORK or COPY to different trade houses and printers where simultaneous production so requires.

Bi-directional Computer printers that print alternate lines in the opposite direction to save the time that would be lost in the non-printing movement.

Binary A number system based on only two values — 0 and 1. All computer operations work on the binary system regardless of how the information is presented, with the 0 and 1 being represented by on or off electrical charges.

Binder's brass/die (UK/US) Brass or other metal carrying the design to be impressed into a book binding. (US) Also Stamping brass. See also CHEMAC.

Binding Traditionally applied to books, but now many similar processes carried out on other printed material.

Bit From BInary digiT the basic unit of information in computing and computer PHOTOTYPESETTING; it represents a pulse or charge or its absence — or one hole or no hole in a paper tape. Each bit stands for one BINARY digit, 0 or 1.

Bit density The density at which data is encoded in a linear measure on MAGNETIC MEDIA. May be stated in bits per inch (typically 1,600 bpi for magnetic tape) or as single, double, quad density on DISKS. The amount of data contained will also depend on the number of TRACKS.

BL British Library.

Black box Slang for a PROTOCOL CONVERTER or other automatic device without a keyboard attached.

Black printer In the FOUR-COLOUR PROCESS the black printing films and plates, which may have to be altered to allow for language changes.

Blad A booklet used in book publishing and usually made up of the intended cover and three to eight printed sample pages. Used to promote new titles at book fairs, sales conferences, etc.

Blank A partly printed sheet held in stock to be subsequently printed with up-dated information, or a different language for an overseas edition.

Blanket A fabric coated or laminated with a rubber or synthetic compound of an appropriate SHORE HARDNESS on the BLANKET CYLINDER of an OFFSET press.

Blanket cylinder The cylinder on an OFFSET machine on which the BLANKET is carried and by means of which the printing image is taken from the PLATE and transferred to the paper or other material.

Blanket to blanket press An OFFSET press that PERFECTS and on which the BLANKET CYLINDER of each unit doubles as the IMPRESSION CYLINDER for the other unit.

Bleed (1) Printed matter designed to run off the edge of the paper. Also used by bookbinders to describe over-cut margins. (2) An ink that changes colour or mixes with other colours, sometimes caused by LAMINATION.

Blind (1) Book CASES or covers that are blocked/embossed (UK), or stamped (US), without the use of ink or FOIL. (2) Term applied to a LITHO plate that has lost its image.

Blister card/pack (US/UK) A bubble of clear plastic, laminated to a backing board, that stretches round and encloses small retail goods.

Block (UK) (1) In binding, to impress or stamp a design upon the cover. The design can be blocked in coloured inks, gold leaf, metal FOIL, etc, (see also BLIND). (2) In printing, a LETTERPRESS BLOCK (CUT US) is the etched copper or zinc plate, mounted on wood or metal, from which an illustration or text is printed.

Block pull A proof of a BLOCK.

Blocking (UK) To make an impression on paper or board from a BLOCK which may be specially hardened and heated if a FOIL is used or may be used BLIND.

Blow up A photographic enlargement.

Blue print/blues (US) A cheap proof made by contacting film in a VACUUM FRAME with a coated paper which is then developed in an ammonia vapour. May be blue, black, red or brown; one or two sided; negative or positive. Also known as browns or Vandykes (US) and Ozalids, diazos or dyelines (UK).

Blurb Promotional text on

the flap of a book jacket or the outside back cover of a paperback.

Board A cellulose-based material, which is usually above 200 g/m² (UK), 10 POINTS (US).

Boards/binders (US) The best quality of board used for CASE binding and made from a solid sheet of fibre. (UK) Grey board. There are different types of board: **bristol** A fine quality of cardboard that may be made stiff by pasting two or more sheets together — used for business cards; **chip** A cheap quality board made from MECHANICAL WOOD PULP/ground wood and/or waste materials. Used, unlined, for binding cases, rigid boxes, etc, and white lined, for cartons and showcards; **cloth centered** A TRIPLEX BOARD in which the centre sheet is cloth for additional strength; **duplex** Paper of two qualities or colours that have been brought together and combined, usually by lamination, but sometimes while the paper is still in the wet state on the papermaking machine; **grey** (UK) see BOARD/BINDERS (US); **ivory** High grade board of one or more laminations of identical quality and having characteristic features of translucency and rigidity; **mill** A high grade board, brown in colour, traditionally made from rope and other materials. Very hard, tough, with a good finish. It is used for covers of better books, as it is less liable to warp than a straw BOARD; **paste** (UK) Two or more laminations of paper, for visiting cards, etc; **pasted** (US) Two or more layers of CHIP BOARD used in CASED bindings; **pulp** Manufactured from pulp as a single homogeneous sheet on a FOURDRINIER or a CYLINDER machine; **straw** Traditionally made from straw, and now from pulp or waste. Used principally for making the covers of CASED books. Cheaper and more prone to warping than a BINDER'S BOARD.

Body (1) The main metal shank in metal type. **(2)** The text pages of a book.

Body copy/body type The main text matter, as distinct from the DISPLAY matter.

Body paper Paper or board forming the base from which a COATED paper is made.

Bold A FOUNT that is heavier than standard weight, available in most typeface FAMILIES.

Bolt Any folded edge of a section other than the binding fold.

Bond Similar to bank paper but heavier, usually supplied in weights from 63 g/m² to 120 g/m².

Book block In ADHESIVE BINDING or in a CASED book the trimmed and sewn, or glued, SECTIONS which are ready to have the case added.

Book cover/jacket Printed board or paper wrapper used to cover a paperback or CASED book.

Book paper An uncoated paper, often with an ANTIQUE finish, used in non-illustrated hardback books.

Book proof A LIMP BOUND proof, not always on the correct paper, showing a book in page form and frequently lacking the illustrations.

Boot/strap A program used to set up a series of computer operations. 'To boot' is to start a computer.

Bottom out (US) To arrange the type on a page so that there are no WIDOWS.

Bound book A book in which the boards of the cover have first been attached to the book, with the covering of leather, cloth, or other material only then being attached to the boards. Traditional bound books are much stronger, but more expensive, than CASED books by which they have almost entirely been replaced.

BPI Bits Per Inch, the BIT DENSITY at which data is recorded.

BPIF British Printing Industries Federation — the employers' body for general printing in England, Wales and Northern Ireland.

BPOP Bulk Packed On Palettes.

Brace A curly bracket , sometimes joining several lines of type.

Brass (UK) see BINDERS' BRASS/DIE.

Broadside/broadsheet Any sheet in its basic size (ie not folded or cut). In newspapers the large format equivalent to THE TIMES (UK) and USA TODAY (US) and double the size of tabloids like the DAILY MIRROR (UK) or THE NATIONAL ENQUIRER of Florida (US).

Bromide A photosensitive paper coated with silver bromide, used in general photography, graphic REPRODUCTION and PHOTOTYPESETTING, on which an image is created. Also used loosely to refer to other photographic materials such as PMT (Photomechanical Transfer), DT (Diffusion Transfer), CT (Chemical Transfer), RC (Resin Coated). See PHOTOMECHANICAL TRANSFER.

Bronzing A process for obtaining a metallic finish to printed matter. It is first printed with an adhesive ink and the bronzing powder is then dusted on by hand, or more generally, by a bronzing machine. Gives a better result than printing with a metallic ink.

Brown line/print (US) see BLUE PRINT/BLUES.

Bubble memory An electro-magnetic computer memory that can be used either as a substitute for DISKS or for RANDOM ACCESS MEMORY. Its main advantage as a substitute for RAM is that it is non-volatile and thus retains its contents when the power is off.

Buckram A heavy binders' cloth made from coarse thread and used for legal and library bindings.

Built fraction Unlike a CASE fraction a built or made fraction consists of separate SUPERIOR and INFERIOR numerals and a horizontal or oblique stroke.

Bulk Relative thickness of a sheet or sheets, for example, a BULKY paper and a thin paper may both have the same weight.

Bulk factor (US) The number of pages of a paper that make up a thickness of an inch. (UK) Volume.

Bulking dummy see DUMMY.

Bulky Lightweight ANTIQUE papers that have a fibrous surface which may stick to the rollers, BLANKET and PLATES and cause loss of time in the repeated cleaning of a printing

plate this necessitates.

Bull's eye/hickie
Printing defect caused by dust (usually from the paper or board's surface) or ink skin holding the paper away from the printing surface.

Bundle (**1**) *(US)* Two REAMS, 1,000 sheets (**2**) Bundled software *(UK/US)* is software supplied 'free' with a computer.

Burn out An opaque mask used in platemaking to clean up areas of a printing plate where there might be unwanted images when a plate is made from more than one exposure.

Burst binding Method of UNSEWN BINDING in which the back fold is burst through (nicked) in short lengths during folding so that the glue can reach each LEAF, without having to remove the usual 3mm or ⅛ inch.

Buyout *(US)* Any work that a printer does not undertake in house, such as typesetting or binding.

Byte In computing and PHOTOTYPESETTING, effectively a character which is usually made up of eight BITS, but can vary from five to ten depending on the system.

C

C sizes The C series within the ISO INTERNATIONAL PAPER SIZE range, used for making envelopes or folders to take the A SIZES.

C type Proprietary photographic process for producing CONTONE colour prints.

Calender Steel rollers between which the paper passes under pressure after it is made, to give it a smooth finish. The calender is found at the 'dry end' of a paper machine. A super-calender, which gives a smoother finish, is 'off machine'. A smooth paper may thus be called SC.

Caliper The thickness of a SUBSTRATE, or the device used to measure it.

Camera paste up/ready copy see ARTWORK.

Cancel A page TIPPED in to replace one on which there is an error.

Cap height The vertical space taken up by a capital letter from top to bottom. The top may be below the top of the ASCENDERS, while the foot will align with the BASE

LINE.

Caps Capitals as opposed to LOWER CASE.

Caption *(UK/US)* Descriptive text for an illustration.

Carbon tissue A thin paper used to transfer the photographic image from film to a GRAVURE plate or cylinder.

Carbonless paper A sheet coated on one or two sides with microscopic capsules containing chemicals that mix and react with each other when they are burst by the pressure of a pen, typewriter or computer printer to give a blue or black image. Normally the top sheet is coated on the back, the middle sheets on both sides and the bottom on the front only. Types are also available in which the two capsules are found in one sheet so that they can be used with normal BANK and BOND papers as top sheets.

Caret Proof readers' insertion mark.

Carriage return Key on a keyboard used to indicate the end of a paragraph on a WORD PROCESSOR and to 'enter' information in some computers.

Cartridge (**1**) A tough, opaque paper, typically off-white in shade and with a roughish surface. A coated cartridge is a matt-COATED sheet (normally a FREESHEET/WOOD FREE). (**2**) A program stored on a CHIP and designed for easy slotting in and out of a computer.

Case (**1**) In binding, a cover of a book prepared separately from the BOOK BLOCK using cloth and paper or synthetic covering materials. (**2**) In hand COMPOSING, the sectioned trays in which the type is kept.

Case binding The normal style for the binding of printed books for hardback editions.

Case fraction A fraction that comes 'ready built' as opposed to a BUILT FRACTION.

Cast coating A high-gloss finish on both or, more usually, one side of paper or board. Made by drying its coating in contact with a heated drum with a chromed surface.

Cast off Calculating the length of copy or the amount of space it will fill when set in a specific typeface, size and

MEASURE.

Cataloguing in publication (CIP) A program operated by the British Library and the Library of Congress that prepares classified entries which are inserted in the imprint pages of books ahead of their publication and compiled in national bibliographies.

Catchline A temporary heading by which GALLEY PROOFS and so on are identified.

Catch-up Image in what should be non-image areas of a PLATE due to a water/ink imbalance in LITHOGRAPHIC printing.

Cathode ray tube Output device, similar to that used in a television set, which may be used either as the display screen on a VISUAL DISPLAY UNIT or as the imaging device in a PHOTOTYPESETTER. In the latter case the image produced on the face of the tube is transferred to a photographic emulsion by fibre optics or a lens system.

CCD Charge Coupled Device. Light-sensitive arrays used in flat-bed input SCANNERS for digital imaging systems.

CCITT Comité Consultatif Internationale Téléphonique et Télégraphique. A United Nations body setting standards for telecommunications.

Cell Indentation in the surface of a GRAVURE cylinder that holds the ink.

Cellulose The basic fibres used in papermaking. Originally only extractable from cotton or linen, but now obtained almost exclusively from wood in PULP production.

Centre Line of type with an equal space at each end, as opposed to RANGED LEFT, RIGHT or JUSTIFIED.

Centre fold/spread see SPREAD.

Centre notes Notes placed between columns on a page.

Centre point A full point/period centered on the x-HEIGHT.

Centronics A brand of computer printer that by its popularity set a standard for PARALLEL interfaces, the other being the IEEE-488 which is much less used in text generation.

Chain line See LAID PAPER.

Chain printer A high speed computer printer.

Chalking Drying problem which, with some ink/paper combinations, leaves loose pigment on the surface.

Character Any letter, figure or symbol in typesetting.

Character generation The projection of typographic images onto the face of a cathode ray tube for typesetting or onto the face of a VISUAL DISPLAY UNIT.

Character set The complete repertoire of letters, figures and other symbols in a FOUNT.

Chase A rectangular metal frame holding the type and illustrations before it is put on the bed of a LETTERPRESS machine. See also FORME.

Check bit see PARITY.

Check digit Used in BAR CODES and other numeric data for automatic reading, which enables a computer to check that all the numbers have been correctly interpreted.

Chemac A proprietary binders' BRASS. Because it is made from a cheaper metal, it can only be used for shorter runs.

Chemical transfer see PHOTOMECHANICAL TRANSFER.

Chemical wood pulp Pulp that is prepared from chipped wood by treating with chemicals to remove the non-cellulose material. Used in the better grades of FREESHEET, or WOODFREE, paper and to improve mechanical pulps when the two are mixed. See also SULPHATE and SULPHITE pulps.

Cheque paper A paper sensitized chemically for security work to prevent fraudulent usage.

China clay Material used for LOADING and COATING in most papers.

Chip The basic building block for computers. ROMs, RAMs and EPROMs are all forms of chip made by a complex process from silicon SEMI-CONDUCTOR. A typical ROM is about 40×10mm ($11/16 \times 6/16$ of an inch, approximately) and has 28 pins or 'legs' that plug into the computer.

Choke see SPREAD.

Chromo A smooth paper, usually only coated on one side, often used for the printing of labels.

Cicero The European equivalent of the PICA em. The basis of the European system of type measurement equal to $4 \cdot 511$mm or $3/16$ inch or 12 DIDOT points. See pages 80-86.

CIP see CATALOGUING IN PUBLICATION.

Close (US) see BOLT (UK).

Club line The short line at the start of a paragraph (sometimes known as an orphan) that looks unsightly at the foot of a page. Page composition systems should avoid them automatically. See also WIDOW.

Coarse screen A HALFTONE SCREEN of up to 35 lines per cm (85 lines per inch) used in illustrations printed on NEWSPRINT and other cheap papers.

Coated paper Paper that has received a coating on one or both sides, such as ART PAPER and CAST COATED papers. Coatings are not usually applied on the FOURDRINIER paper making machine itself. Coated papers can be used for non-printing purposes, such as for security work or packaging.

Cockling A wavy or rippled effect on the surface of paper caused by humidity changes.

Code conversion/translation When typesetting direct from computer or WORD PROCESSOR generated material, many of the codes used will be different on the two systems and need to be converted or translated by specialist HARDWARE or SOFTWARE.

Codet (US) A COLOUR CONTROL bar.

Cold melt An adhesive used in binding (like PVA) that does not need heat to melt it, as does a HOT MELT.

Cold set (1) WEB OFFSET LITHO printing that does not use heat (as in HEAT SET) to dry the ink. This usually limits the HALFTONE SCREEN that can be used as well as the type of paper and the speed of the web. (2) See COLD TYPE.

Cold type Methods of typesetting other than by HOT METAL, such as PHOTOTYPESETTING or strike-on typewriter-like systems, which produce ARTWORK suitable for REPRODUCTION or act directly onto paper plates for SMALL OFFSET.

Collate To check through the SECTIONS or pagination of a book after GATHERING to ensure that it is complete and in correct sequence for binding. (US) Conflate.

Collating marks see BACK STEP MARKS.

Collotype A planographic process using gelatine as the sensitized plate coating onto which the image is exposed photographically and without a screen. Now very rare, but used for high-fidelity reproduction, particularly of art subjects of very short runs.

Colophon Printed details of a publisher in a book (once in the END MATTER, but now more often on the title page VERSO) which may include the publisher's and printer's addresses (their IMPRINT) and their emblem, DEVICE, or LOGO.

Colour bank/blank see BLANK.

Colour control bar A coloured strip in various DENSITIES on the back edge of the sheet which enables the platemaker and printer to check by eye or instrument the nature of each ink film — or the specially prepared strips of film from which they are made.

Colour correction Alteration to the colour values of an illustration either by the original photographer using colour balancing FILTERS, or by adjusting the colour SCANNER to produce the correct result. Subsequently correction can be done on the COLOUR SEPARATIONS or on an ELECTRONIC PAGE COMPOSITION SYSTEM.

Colour fast see LIGHT FAST.

Colour filters A sheet of glass, plastic or gelatin used for COLOUR CORRECTION, in COLOUR SEPARATION or for special effects.

Colour guide Sample of a colour or instructions for TINT LAYING given to a SCANNER operator or printer to match.

Colour matching system (1) See Pantone Matching System. (2) Sometimes used as a synonym for a DRY PROOF.

Colour rotation/sequence (US/UK) The order in which the FOUR COLOUR PROCESS is printed.

Colour scanner See SCANNER.

Colour separation In colour REPRODUCTION, the process of separating the various original colours of an image by COLOUR FILTERS in a camera or electronic SCANNER so that the COLOUR SEPARATION FILM and then printing PLATES can be produced.

Colour separation film The NEGATIVE or POSITIVE film produced by a PROCESS CAMERA or SCANNER.

Colour separator *(US)* A repro house (UK).

Colour swatch A series of COLOUR GUIDES, which may be graded in a standardized fashion as in the PANTONE matching system.

COM Computer Output (on) Microfilm.

Combination line and halftone work HALFTONE and LINE work combined on one set of films, PLATES or ARTWORK.

Coming and going A specialized IMPOSITION, frequently used in paperback printing, in which the pages are printed HEAD TO HEAD so that two copies can be obtained from one set of plates.

Command A computer instruction specifying an operation to be performed.

Comp See COMPOSITOR/ COMPREHENSIVE.

Compatible (1) IBM-PC compatible A microcomputer which claims to be compatible with the IBM-PC. Some are fully compatible some only work with certain software and some are totally incompatible. **(2) Plug compatible** Add-on computer components such as a DISK DRIVE or PRINTER which can be plugged into another manufacturer's computer.

Compose To set type.

Composition sizes Traditionally (in HOT METAL) the sizes that can be set on a compositing machine and thus below 12 or 14 POINTS in size.

Compositor *(UK/US)*, also typographer *(US)* . The individual who sets type; originally by hand, but now by all methods.

Comprehensive *(US)* A layout of type and illustration, not to the standard of a finished rough.

Computer (assisted)

composition PHOTOTYPESETTING where the copy keyboarded is continuous copy (and suitably coded) but in which HYPHENATION and/or JUSTIFICATION are effected by the computer to produce a paper or magnetic tape or disk or direct input for the PHOTOTYPESETTER.

Concertina fold See ACCORDION FOLD.

Concurrent Two separate computer operations or PROGRAMS that can run at the same time, unlike BACKGROUND operations where the computer carries out one operation while permitting the operator to continue keying.

Concurrent CP/M See CP/M.

Conflate *(US)* See COLLATE.

Contact frame See VACUUM FRAME.

Contact screen Used to produce a HALFTONE from CONTONE film or ARTWORK in a PROCESS CAMERA, VACUUM FRAME or in SCANNERs.

Continuous tone As opposed to HALFTONE screened, or LINE work.

Contone See CONTINUOUS TONE.

Contrast The level of variation in tone or DENSITY between the HIGHLIGHT and SHADOW areas.

Control character/code A computer signal that in COMPUTER ASSISTED COMPOSITION sets functions such as FOUNT, MEASURE and type size.

Control strip A COLOUR CONTROL BAR.

Control tape Magnetic or paper tape with control information such as FORMATS, SET WIDTHS, and separate from text tapes. More modern machines will use a BOOT or FORMAT disk in place of the tape.

Converter See PROTOCOL CONVERTER.

Convertible A press that can print either a single colour on both sides of a sheet of paper or board, or two colours on only one side.

Copy Manuscript, typescript, transparency or ARTWORK from which a printed image is to be prepared. May also be supplied in electronic form.

Copy board The part of a graphic arts camera on which the COPY is fixed during photography.

Copy preparation Marking on COPY of the appropriate instructions for the COMPOSITOR or for REPRODUCTION.

Copyfitting See CASTING OFF.

Copyright The right of an author or artist to control the use of their original work. While broadly controlled by international agreement there are substantial differences between countries. In the UK copyright on intellectual property generally exists by virtue of the creation of an original work, while in the US it is more often by registration.

CORA V Merganthaler Linotype's typesetting language — Computer Orientated Reproducer Assembly, version 5.

Corner marks These may be on the original ARTWORK, film or printed sheet and can also serve as REGISTER MARKS during printing or as CUT/TRIM MARKS for use in the finishing operations.

Corrigenda A list of corrections printed in a book, as opposed to an erratum slip which is a separate list of corrections, TIPPED IN or loose.

Counting keyboard An input keyboard that calculates character width and the spaces used and indicates to the system how much space is still left in a line of a particular measure.

Counting program A typesetting program used on computers that enable it to carry out the functions of a COUNTING KEYBOARD.

Covering The process by which a cover is fixed to the spine and sometimes also for 3mm or ¼ inch to both sides of a book in LIMP BINDING to strengthen the spine.

CPI Characters Per Inch in a CAST OFF.

CPL Characters Per Line in a CAST OFF.

CP/M Control Program for Microcomputers. One of the oldest and most successful OPERATING SYSTEMS for MICROCOMPUTERS, which was introduced in 1976. It has become a standard operating system, though it is now by no means the best available. More PROGRAMS are probably available for it and its developments than any other system, so it is a

very useful feature for a microcomputer, WORD PROCESSOR or front end system. Variations exist for different MICROPROCESSORS such as CP/M80 and CP/M86.
CPS Characters Per Second – refers to the output speed of a computer printer or PHOTOTYPESETTER.
CPU Central Processing Unit or, in a MICROCOMPUTER, a single MICROPROCESSOR.
Crash (1) A more-or-less serious breakdown of an electronic system caused by the failure of a component or by a reading head damaging the surface of a disk. **(2)** To number a multi-part set of forms on CARBONLESS PAPER, by LETTERPRESS printing the top only of a made up set with a heavy IMPRESSION so that the number appears on the other sheets in the set. (The effect can also be achieved by interleaving carbon paper into a set of ordinary paper). **(3)** A muslin cloth used for lining the spine of a book during binding. **(4)** A finish to paper with a coarse, linen-like, surface.
Crease See SCORE.
Cromalin A DRY PROOFING system.
Cropping Trimming or MASKING a photograph or ARTWORK so that a detail, its proportions or size are in line with those required.
Crown See Paper Sizes on pages 152-153.
CRT See CATHODE RAY TUBE.
CT Chemical Transfer, see PHOTOMECHANICAL TRANSFER.
C/T A colour transparency.
Cursor The moveable light spot on a VDU which allows the operator to identify his or her current position on the display.
Cut (US) See BLOCK.
Cut flush A binding where the cover is trimmed to the same size as the pages with a GUILLOTINE or THREE-KNIFE TRIMMER.
Cut in index An index in which the divisions are cut into the edge of the book in steps.
Cut line (US) See CAPTION.
Cut marks (US) Marks printed on a sheet to indicate the edge of a page to be trimmed. (UK) Trim marks.

Cutoff The maximum length of sheet that can be printed on a WEB-FED press and equivalent to the circumference of its IMPRESSION CYLINDER.
Cut-out (1) An illustration from which the background has been removed to provide a silhouette. **(2)** A display card or book cover with a pattern DIE CUT in it.
Cutting and creasing LETTERPRESS operation carried out on a CYLINDER PRESS or a specially built machine when special shapes need to be cut in packaging or when book covers need to be creased so that they fit neatly at the spine. For each job a FORME is made up to just above the TYPE-HEIGHT with cutting and/or creasing rules to the required design.
Cyan The special blue used in the FOUR-COLOUR PROCESS.
Cylinder machine A paper machine, mostly used for making boards, in which a gauze-covered cylinder revolves in a vat of pulp which is then deposited on its surface. Also called a vat machine, see also FOURDRINIER MACHINE.
Cylinder press A LETTERPRESS machine in which the sheet to be printed is carried on a cylinder and brought into contact with the raised printing surface. Mainly used for CUTTING AND CREASING.
Cyrillic See LATIN.

D

D plug A more-or-less 'D'-shaped plug with a variable number of pins used to connect MODEMS, PRINTERS, etc to computer systems.
Dahlgren A proprietary DAMPING system fitted to some LITHO presses to reduce the amount of moisture used.
Daisy wheel The IMPACT PRINTING head used on some typewriters and computer printers. Made of metal or plastic it has the individual characters at the ends of the 'petals'. See also DOT MATRIX and GOLF BALL.
Damper Rollers on a LITHO PRESS which bring water or damper solution to the printing plate, sometimes by way of the inking rollers.
Dandy roll (LAID, WOVE or spiral), a cylinder of

wire gauze on the FOURDRINIER paper machine that comes into contact with the paper while it is still wet. The dandy impresses the WATERMARK and the laid lines into its surface when required.
Data Any information, but in computing and typesetting usually used to distinguish text and figures from the PROGRAMS that control the operation.
Data phone/set (US) A MODEM or device that connects computer systems to the telephone by direct wiring (hard wired) or by inserting its hand set into special 'cups' (an ACOUSTIC COUPLER). It converts the computer's signals into tones that the telephone system can accommodate and of an appropriate speed. (UK) Modem.
Database Virtually any information stored on a computer in a systematic fashion and thus retrievable.
DCE Data Circuit-terminating Equipment — usually a MODEM.
Debugging To correct an error in any computerized system.
Deckle The machine width (and thus the width of WEB) on a FOURDRINIER papermaking machine. Formerly limited by the leather 'deckle straps', and before that by the movable wooden frame (deckle) on a hand mould, now by the width of the wire.
Deckle edge The feathery edge occurring round the borders of a sheet of handmade (and some mouldmade) paper due to the DECKLE.
Dedicated A system designed to carry out a specific task. For instance word processing can be carried out on a dedicated WORD PROCESSOR or on an undedicated microcomputer running a word processing PROGRAM.
Deep etched block A letterpress block on which the non-printing areas have been etched slightly lower than normal.
—etched plate A long-run LITHOGRAPHIC printing plate on which the image printing areas are actually slightly below the surface of the plate: as distinct from a PRE-SENSITIZED or WIPE-ON PLATE.

Delivery On a SHEET-FED press the mechanism that takes the sheet from the printing unit and stacks it in an orderly fashion.

Demy See Paper Sizes on pages 152-153.

Densitometer An optical instrument used to measure the intensity of tone on film or reflection copy as well as of printed images. Special instruments are required for colour and are included in automatic press controls.

Density The weight of tone or colour in any image, measurable by a densitometer. The printed highlight can be no brighter than the base paper or board, while the shadow can be no darker than the quality of the ink and the volume of ink the printing process will permit. A greater range is possible on film and colour transparencies than in printing.

Descender The part of the lower case letter falling below the x-HEIGHT of the character as in 'g', 'q' and 'p'.

Device A printer's or publisher's graphic emblem that may form part of the COLOPHON.

Device independent In computing many programs are 'device dependent' — a FOUNT will only run on the machine for which it was designed. Device independent PROGRAMS and LANGUAGES can be run on a variety of machines.

Di litho See DIRECT LITHO.

Diagnostics, remote When a fault develops on some computer systems it is possible to connect them via a MODEM or DATA PHONE to the vendor's support base. This enables the engineers to 'enter' the system and diagnose HARDWARE faults and even rectify SOFTWARE errors.

Diazo See BLUEPRINT.

Didot The European POINT, see CICERO.

Die See BINDERS' BRASS/DIE.

Die cutting Using a DIE to cut holes or irregular outlines in display work or book covers.

Die stamping An INTAGLIO printing process in which the image is in relief on the surface of the material, either in colour or blind (without ink).

Diffusion transfer See PHOTOMECHANICAL TRANSFER.

Digital fount An electronically-stored FOUNT with characters stored as a series of digital signals for the PHOTOTYPESETTER, rather than in a visible form.

Digitizing pad/tablet See GRAPHICS TABLET.

DIN See Paper Sizes, pages 152-153.

Dingbat A modern form of PRINTERS' FLOWER.

Direct entry A small PHOTOTYPESETTING system in which the keyboard is directly connected to the output device.

Direct image plate A SMALL OFFSET printing plate made of coated paper on which the image is produced by a typewriter with a special ribbon or by suitable pens or pencils.

Direct screening A method of REPRODUCTION, usually working via a camera/enlarger, in which the colour original is reproduced as SCREENED SEPARATIONS in one step without producing CONTONE separations.

Directory The list or catalogue of all the files, jobs or documents stored on MAGNETIC MEDIA.

Dirty proof A proof with many corrections marked on it.

Dis/tribute In LETTERPRESS, once printed, the individual letters may be returned to the TYPE CASE for re-use.

Disc See DISK/ETTE.

Discretionary hyphen Keyboarded hyphens that override the hyphenation rules program on the computer, so that if a hyphen is required it will be inserted there, rather than where a logic rule dictates.

Disk/ette Like a gramophone record, but coated with a magnetic material; may be rigid or floppy, single- or double-sided, single-, double- or quad-DENSITY, soft- or hard-sectored and in size from a little over 3" (77mm) in diameter to 12" (315mm). Storage capacity ranges from under 100KB to over 300MB.

Disk converter See MULTIDISK READER.

Disk drive/reader

Device attached to a computer or PHOTOTYPESETTER that can 'read' (or 'write') a DISK.

Display matter Type for title pages, headings and advertising work, as distinct from the smaller type used for text and so on.

Display sizes Traditionally sizes of type above the COMPOSITION SIZES (or 14 POINT) and used mainly for DISPLAY MATTER.

Distribute See DIS.

Distributing rollers The rollers on a printing machine that distribute the ink from the ink DUCT to the printing plate or FORME inking rollers. They smooth the ink film and are arranged to prevent repeats or GHOSTING.

Doctor blade A flexible metal blade on a GRAVURE press that removes surplus ink from the surface of the printing cylinder before the IMPRESSION is made.

Dongle Part of a computer or PHOTOTYPESETTER that prevents SOFTWARE or DIGITAL FOUNTS from other machines working. An anti-MUMPING and piracy device.

DOS A Disk OPERATING SYSTEM, the CHIPS and circuits in a computer that control its access and use of its disks.

Dot See HALFTONE.

Dot etching The process by which tone correction is carried out for HALFTONE negatives or positives.

Dot for dot (1) (UK) The use of pre-SCREENED PRINTS on ARTWORK so that they can be reproduced without the photographs needing to be screened. (2) (US) Printing colour work in perfect REGISTER.

Dot gain During the REPRODUCTION chain from original to printed image there is a tendency for the size of HALFTONE dots to grow. This leads to inaccurate results, but if a particular press's dot gain characteristics are known it can be compensated for during REPRODUCTION.

Dot matrix Method of creating an image on some computer printers (or on the screen of a VDU). Each letter is made up from a grid of pins — typically of 9×7 dots — with hammers hitting the

correct combination of pins for each letter, in the case of a printer.

Dotless 'i' See FLOATING ACCENTS.

Double burn/print down Multiple printing onto a LITHO plate — often one for line and type and a second for the HALFTONES.

Double case A typical type CASE, for hand setting, which contains an UPPER CASE and LOWER CASE in one tray.

Double coated Better-quality COATED PAPERS receive two (and sometimes more) coatings on each side.

Double page spread See SPREAD.

Double tone ink A printing ink that produces a secondary tone as it dries.

Double truck See SPREAD.

Dow etch See POWDERLESS ETCH.

Draw down A strip of ink spread on a sheet of paper with a pallette-knife and allowed to dry to show the resulting colour.

Drawn on cover A paper or board book cover that is attached to the sewn or ADHESIVE BOUND book by gluing the spine.

Dressing (1) Placing the type FOUNT(s) in a PHOTOTYPESETTER and the loading of a selection of SOFTWARE when a FRONT END system can be configured for different purposes. (**2**) Part of the MAKE READY process when the cylinders are packed to change the degree of impression or (by a small amount) the 'print length' of the final image.

Driers (1) The component in a printing ink or varnish that allows it to dry by reacting with the oxygen in the air, with the paper or by absorption. (**2**) On a printing press the drying mechanism usually fitted near the DELIVERY, or outfeed. Heat may be in the form of electric elements, lazy-flame gas, ULTRAVIOLET or INFRA-RED radiation. See also RADIATION DRYING.

Driver For a FRONT END to control an output PHOTOTYPESETTING device (or any computer printer) a special driver PROGRAM is needed to ACCESS its internal routines.

Drop A gap, usually at the top of a page or column, before the printed image starts, expressed in millimetres, inches, POINTS or lines of type.

Drop out To expose by FILTERS or other means so that an item does not appear on the final result.

Drop out blue/colour Pencil or other marker (yellow is also common) used to write instructions on ARTWORK and which does not reproduce.

Dry litho An OFFSET LITHO PLATE that can be printed on a normal litho press, but which does not need damping to restrict the ink to its image area.

Dry offset See LETTERSET.

Dry proof Processes such as Cromalin or Matchprint that provide a colour proof from film without the need for plate making. They use either toner powders or coloured films and are efficient for producing small numbers of colour proofs rapidly and are especially useful in the control of DOT GAIN.

Dry transfer lettering See TRANSFER LETTERING.

DT See PHOTOMECHANICAL TRANSFER.

DTE Data Terminal Equipment, in other words a computer.

Duct The small reservoir on a printing press that contains the ink or the DAMPER water or solution for transfer to the plate by rollers.

Dummy A sample for a job made up with the actual materials and to the correct size to show bulk, style of binding, and so on. Also a complete mock up of a job showing position of type matter and illustrations, margins and other details.

Duotone Two HALFTONE PLATES made from the same original, but to different tone ranges so that when printed together a greater tone range is produced than is possible in one colour.

Dupe A DUPLICATE.

Duplex Equipment or circuit sending/receiving data in two directions at once. Half-duplex involves data flowing in each direction alternately while simplex transmission involves one direction only.

Duplex halftones Two colour HALFTONE blocks made from a monochrome original, the second plate being used as a tint, not to be confused with a DUOTONE.

Duplicate A film or printing PLATE that is an exact copy. Duplicating film will produce one positive from another without requiring an intervening negative or vice versa.

Dyeline See DIAZO.

E

EAN (European Article Number) See BAR CODE.

EBCDIC Extended Binary Coded Decimal Interchange Code. The IBM eight-BIT character code giving 256 possible character positions.

Edges, sprinkled Book edges coloured with a brush full of liquid ink or an AIR-BRUSH. Used as decoration for books and also on paperbacks to hide the edge discolouration of a cheap paper.

Editing terminal See VDT.

Edition A number of identical copies printed at the same time, either as the first edition, or after some change has been made (revised edition, second edition, revised and expanded edition, for example).

Electro/type A DUPLICATE LETTERPRESS block made by 'growing' a layer of electrolitic copper on a mould taken from the original type or block.

Electronic page composition/make up system A series of interlinked computers based on colour SCANNERS used to assemble and correct colour images. With the most sophisticated it is possible to input a series of transparencies and type and obtain fully assembled one-piece film of each page including COLOUR CORRECTION, electronic AIRBRUSHING and TINT LAYING.

Electronic printer Normally synonymous with ELECTROSTATIC PRINTING.

Electrostatic printing A printing plate, drum or belt is charged overall with electricity, and light is reflected onto them from the non-image areas of the original artwork, destroying the charge in these areas. In a photocopier, toner powder is applied, adhering only in the still-

charged image area, and is then fused to the paper by heat. See also LASER PRINTING.

Elite A typewriter face giving twelve characters to an inch (2·54cm).

Elliptical dot screen A HALFTONE CONTACT SCREEN that produces an elliptical dot giving more even changes in the mid-tones.

Em Traditionally the area taken up by the metal BODY of a capital M. It will be wider or narrower than square, depending on the style of letter. An em space is twice as big as an en space. Sometimes called respectively a 'mutton' and a 'nut'. (See also pages 80-86).

Embossing, blind The process of raising or recessing an image using an un-inked block.

Emulate Usually a terminal which, when connected to another system, can simulate a part of that system.

Emulsion Normally a light-sensitive coating on film or printing PLATE, but may also include ENCAPSULATED odours or flavours in promotional printing.

Emulsion side The matt side of a film that is placed in contact with the EMULSION of another film or PLATE when printing down to ensure a sharp image.

En See EM.

Enamel paper *(US)* A COATED paper.

Encapsulation (1) In printing or papermaking a chemical may be enclosed in a microscopic capsule, perfumes in the case of promotional printing or colouring chemicals for SELF-COPY PAPERS. **(2)** Method of packing — in a BLISTER CARD/PACK.

Encryption See DONGLE.

End matter *(UK)* See BACKMATTER *(US)*.

End of line decisions In typesetting HYPHENATION AND JUSTIFICATION, the decisions made by a keyboard operator or by a computer about where a line should end.

Endpapers Lining sheets used at each end of a book to fasten the CASE to the first and last SECTIONS of a CASE BINDING.

Engraving *(US)* See BLOCK *(UK)*.

EPCS See ELECTRONIC PAGE COMPOSITION SYSTEM.

EPROM Erasable Programmable Read Only Memory. A microCHIP containing instructions or data that cannot be changed by the user.

Erratum slip See CORRIGENDA.

Escapement The movement of a mirror, lens or electronic beam in a PHOTOTYPESETTER to control the movement from one character on to another by the correct amount for that particular character so that the position and LETTER FIT in the resulting typesetting is even.

Etching The MORDANT effect of a chemical on PLATE or film. In LITHOGRAPHY the solutions are applied to the plate after imaging to make the non-image sections both water attractive and ink repellant.

Even working Mainly used in book work — a number of pages fitting into equal SECTIONS without the need to print oddments.

Exception dictionary A PROGRAM that stores words that do not hyphenate in line with the standard rules for a particular language and that may also be used as a SPELLING CHECKER before proof-reading.

Exotic typeface/ language See LATIN.

Extenders See ASCENDERS or DESCENDERS.

Extent The number of pages in a printed work.

F

F&C/F&G Folded and Collated/Gathered. Sheets of a book that have been folded and then GATHERed and/or COLLATED in preparation for binding.

Face/fade out blue *(US)* See DROP OUT BLUE.

Facsimile The electronic transmission of copy, ARTWORK or colour SEPARATIONs from one location to another. The first can be done over ordinary telephone lines while the others may need special communications circuits. Office machines taking A4/QUARTO paper are widely used for copy, while specialized graphic arts machines are used for illustrations or complete pages.

Fade-out halftone *(US)* See VIGNETTE.

False double See SPREAD.

Family A group of related type FOUNTS, perhaps a ROMAN, ITALIC and BOLD of the same design.

Fart box Slang for TEXT RETRIEVAL TERMINAL.

Fax See FACSIMILE.

Feeder That part of a SHEET-FED printing press or folder that transfers the sheets of paper to the printing/folding units.

Feet/foot margin The white area at the bottom of a page between the image and trimmed edge.

Feint Lines, usually ruled horizontally in pale blue by a special machine, on account book pages and in school exercise books.

Felt side The side of a paper away from the wire of the paper machine and on which it is formed. Sometimes called the top or right side.

Fibre optics Thin strands drawn from a pure glass that transmit light and are used in some PHOTOTYPESETTERS to transfer the image from a CRT or LEDs to the film or paper surface without the need for lenses.

Figure (1) An illustration. **(2)** A number, as opposed to a letter.

Film advance Usually equivalent in PHOTOTYPESETTING to the LEADING in HOT METAL — the amount by which the paper or film is moved before the next line is imaged. Extra space is introduced between the lines by making the advance greater than the POINT size of the type being set.

Film assembly/stripping *(UK/US)* The bringing together of all the elements of film on a FOIL or GOLDENROD during IMPOSITION, also the incorporation of correction film/paper.

Film composition See PHOTOTYPESETTING.

Film negative/positive Sheets or rolls of a clear and stable plastic with a monochrome photographic EMULSION and containing LINE and/or TONE REPRODUCTIONS of the image. Used during the making of printing PLATES and cylinders.

Filmsetting See PHOTOTYPESETTING.

Filter See COLOUR FILTER.

Final film The POSITIVE or NEGATIVE used for platemaking, incorporating all

corrections and where there are HALFTONES usually with a HARD DOT.
Finish The smooth (or rough) surface given to paper by COATING or EMBOSSING.
Finishing (**1**) All operations after printing. (**2**) Traditionally the hand operations of lettering and ornamenting the covers of a hand-bound book.
Firmware Programs (SOFTWARE) on a CHIP, which can form an integral part of the system's HARDWARE.
First and third A printed sheet on which the printed matter appears on pages one and three when folded by printing it on both sides, as opposed to a FRENCH FOLD.
First-generation photosetters Essentially adaptations of the old HOT METAL machines, such as the Monophoto, that set the letters by exposing through a grid of photographic negative matrices (see MATRIX) based on the original Monotype layout.
Fit (**1**) See LETTER FIT. (**2**) See REGISTER.
Fixed space Space between words or characters not variable for JUSTIFICATION purposes, used in RANGED left RAGGED right, CENTRED and TABULAR setting.
Flag (**1**) The 'Masthead' or name of a newspaper. (**2**) A computer code, such as a shift/unshift command. (**3**) A tab set into a stack or reel of paper indicating a fault to be examined or a change of EDITION.
Flash (**1**) A secondary exposure sometimes used to produce the required DENSITY range in a HALFTONE. (**2**) In the non-digital PHOTOTYPESETTERS a flash was used to expose individual letters. A no-flash exposure is one that allows the ESCAPEMENT to move by the amount of the particular letter not being exposed.
Flat (**1**) An assembly of IMPOSED film or photographic paper. (**2**) A HALFTONE of insufficient contrast, perhaps lacking in DENSITY.
Flat back Bound sections having a square spine, that is, not ROUNDED AND BACKED; normal in LIMP BINDINGS, but less common in CASE BINDING. Often used for illustrated

children's books.
Flat colour An area of printed colour with no tonal variations.
Flat tint plate A sheet of metal mounted to TYPE-HEIGHT and of the required size for printing a FLAT COLOUR by LETTERPRESS.
Flat wire stitching See STABBING.
Flexiback Reinforcing of the spine in a book binding with a special fabric or paper lining.
Flexo/graphy A relief process using rubber or plastic plates on a WEB-FED press and solvent-based liquid inks. Mainly used for printing packaging films, but also for some newspapers where it is may also be called anilox and can be retro-fitted to LETTERPRESS equipment. So called from the engraved or 'anilox' roller that carries ink to the printing cylinder.
Floating accents Where many languages have to be typeset it is not always possible to have characters available in every possible accented combination. Thus accents can be 'floated' over any character, including a special 'dotless ı'.
Flong A papiermache-like sheet used for making moulds for casting STEREOTYPES for ROTARY LETTERPRESS printing.
Flop To reverse an image from left to right, usually in error.
Floppy disk A small, flexible, plastic disk that stores data magnetically after the computer has been switched off. Made in a variety of sizes (from about 3 inches (7·5cm) in diameter to 8 inches (20·5cm)) and in formats with storage capacity of from about 100,000 to over 1,000,000 characters; random ACCESS allows data to be quickly and easily updated or corrected. See also DISKETTE and MAGNETIC MEDIA.
Floret/flower See PRINTERS' FLOWER.
Flush See CUT FLUSH.
Flush left/right Type lining up vertically, either on the left or right. Also described as ranged left/right. See also RAGGED RIGHT/LEFT.
Fly fold A single fold to give a four-page leaflet.
Flying paster System on a WEB-FED press that joins

a new reel of paper to the nearly exhausted web of the previous reel without the necessity for stopping the press for a change-over.
Foil (**1**) Plastic film with a gold, silver or metalized colouring, used to BLOCK designs in packaging and on book covers. (**2**) Clear, stable film used as a backing during FILM ASSEMBLY.
Fold out A page of a book or magazine IMPOSED so that a fold can be made at the FOREDGE without it being trimmed off during FINISHING and thus allowing a leaf to be folded out to give a three-(or more) page SPREAD.
Folio (**1**) A page number, and so a page. (**2**) A large book in which the full-size sheet only needs to be folded once before binding.
Follow copy Instruction to the COMPOSITOR/typographer to set type exactly as the MANUSCRIPT and not to make any corrections for errors of fact, style, grammar or spelling.
Font US for FOUNT, *(UK)* — both spellings are pronounced 'font'.
Foolscap See Paper Sizes on pages 152-153.
Footer See HEADLINE.
Foredge The edge of a book or pamphlet opposite the BACK, spine, or binding edge.
Foreground Operations on a computer that involve the operator and/or keyboard/screen input/output functions. All but the smallest systems permit the operator to perform foreground operations while the computer continues processing in BACKGROUND.
Formats (**1**) The size of a book or page. (**2**) Instructions included in WORD PROCESSING or PHOTOTYPESETTING that the phototypesetter translates into machine-specific codes to perform a change of FOUNT, MEASURE, LEADING, or a combination of these functions. (**3**) The almost limitless ways in which a DISK can be layed out for a particular computer to be able to read it.
Form/e *(US/UK)* In LETTERPRESS the forme comprises all the type and BLOCKS in a CHASE and ready for printing.
Former On a WEB-FED press that part of the

folding mechanism that makes the first fold, parallel to the MACHINE DIRECTION of the paper.

Forwarding In hand CASE BINDING the stages in book making after sewing but before FINISHING.

Fount (1) A fountain or DUCT. **(2)** *(UK)* A set of type characters of the same design (and, with HOT METAL TYPESETTING, the same size); for example UPPER CASE and LOWER CASE, numerals, punctuation marks, accents, LIGATURES. Part of a FAMILY, which may include ITALIC and BOLD founts. May be in the form of metal MATRICES for HOT METAL, film matrices, strips, grids or DISCS for the earlier PHOTOTYPESETTERS, or a DIGITAL FOUNT for current systems. Pronounced 'font'.

Fountain See DUCT.

Four-colour machine/press A machine that prints one side of a sheet in four colours in one pass through the machine.

Four-colour process Colour printing by means of the three primary colours (yellow, MAGENTA and CYAN, (blue)) and black superimposed. Each plate is produced from SEPARATIONS, which have been made from the originals on a SCANNER or process camera.

Four-colour process inks The inks used in the four-colour process.

Fourdrinier A paper machine on which liquid pulp drains through a moving wire to leave a WEB of damp paper which then dries on steam-heated cylinders before reeling up, COATING, trimming or further processing.

Freesheet (1) *(US)* A paper made only from CHEMICAL PULP and excluding GROUNDWOOD or MECHANICAL WOOD PULP. **(2)** *(UK)* A local newspaper without a cover price whose only revenue is from advertising sales.

French fold A sheet of paper with four pages printed on one side only, then folded twice with right-angle folds into quarters without cutting the HEAD. The inside pages are blank with an image appearing on pages 1, 2, 3 and 4, but actually on pages 1, 4, 5 and 8 of the IMPOSITION.

Frog eye *(US)* See BULL'S EYE.

Front end system The part of a computer or PHOTOTYPESETTING system responsible for the control of all input, correction, manipulation and storage. Often considered more important that the 'back end' (which outputs the type) by all but the most fastidious of typographers.

Front lay See LAY.

Front matter *(US)* The pages of a book before the main text, containing the title page, contents, etc. *(UK)* Prelims.

Frontispiece Strictly an illustration placed opposite the title page of a book by TIPPING IN, and so often printed on a different type of paper and by a different process. By extension any illustration facing the title page.

Fugitive colour An ink that is not stable (by design or by accident) when exposed to certain conditions of light, moisture or atmosphere.

Full/whole bound A CASE BINDING that is covered overall with one piece of the same material, for example, 'full cloth'. This is the normal style for publishers' edition binding. See also HALF BOUND and QUARTER BOUND.

Full colour Normally synonymous with FOUR-COLOUR PROCESS.

Full out Type set to the full MEASURE.

Full point A '.' *(US)* period.

Function codes Those codes that control a PHOTOTYPESETTER'S functions, contrasted with the codes that produce characters.

Furnish Term used in paper making for the materials used.

G

Galley proof A PROOF in which type is proofed in a column as it comes from the HOT METAL type caster onto a galley tray — so now a long narrow proof from a PHOTOTYPESETTER.

Gang (1) ARTWORKS mounted so that they can be REPRODUCED (and perhaps printed) together IN PRO/PORTION *(UK)*. **(2)** In printing may be synonymous with TRACK.

Gate fold Two parallel folds towards each other in which the fold can be opened like a double gate.

GATF The Graphic Arts Technical Foundation, Pittsburg, PA.

Gather To place in the correct order sections or sheets before binding. See also COLLATE.

Generic codes/mark up Codes inserted into WORD PROCESSOR- or computer-generated texts indicating typographical functions in a hierarchical fashion and which can be translated into typographic commands by any PHOTOTYPESETTING system as in ASPIC or SGML.

Ghosting Occurs when there is a very heavy area of colour of a regular shape being printed and the inking system of a press is not sufficiently powerful to supply enough ink to all areas.

Glytch A PROGRAM error that may be corrected by a BAND AID.

g/m² *(Eur)* Abbreviation of grammes per square metre. A method of indicating the substance of paper on the basis of its weight, regardless of the sheet size. Spoken (and sometimes written) as gsm. See also Paper table, pages 152-154.

Goldenrod *(US)* A yellow, light-proof, paper used for mounting FLATS.

Golf ball An IBM-type head used on typewriters and COLD TYPE setting equipment. The letters are placed round a golf ball-sized element that can be changed for different designs or sizes of FOUNT.

GPO (1) *(US)* Government Printing Office. **(2)** *(UK)* General Post Office, now the Post Office.

Grain (1) In film, the natural structure of its EMULSION, which becomes intrusive if the original is over-enlarged. **(2)** The roughness in the surface of some LITHO plates that enable it to hold moisture. **(3)** In paper, see MACHINE DIRECTION.

Grammage See or g/m²

Grammes per square metre See g/m²

Graphics tablet Used in computing, by COMPOSITORS and in ELECTRONIC PAGE COMPOSITION SYSTEMS

for layout or system control. A MOUSE or 'puck' on a drawing board either controls the movement of the CURSOR on the VDU or can be used to 'trace in' layout details. If there is a MENU of commands on the graphics tablet the mouse can pick these up from the tablet and input them to the system without keying.

Gravure printing A printing process in which the printing areas are below the non-printing surface. These recesses are filled with a liquid ink with the surplus removed from the non-printing areas by the DOCTOR BLADE before the paper 'sucks' the ink from the cells. Also called photogravure *(UK)* and rotogravure. *(US)*

Greaseproof *(UK)* A FREESHEET/WOODFREE paper, made translucent by extra beating of the pulp and subsequent treatment, and used for food wrapping.

Grey board See BOARD, GREY.

Grey scale A specially printed piece of ARTWORK with controlled DENSITY patches printed in steps from no colour through to black and used in controlling the consistent processing of photographic film or paper. (See page 39.)

Grey screen See CONTACT SCREEN.

Grid, fount See FOUNT.

Gripper Mechanism on a SHEET-FED press that takes the paper from the FEEDER and passes it to the printing units, or subsequently moves it in REGISTER to subsequent units and finally to the DELIVERY.

Gripper edge Allowance of extra space on a sheet of paper for the grippers to hold it where they might interfere with the printing image.

Groundwood paper/pulp *(US)* See MECHANICAL PAPER/PULP.

GSM See G/m².

Guard book A book bound with GUARDS at the spine to permit it to be filled with scraps, samples or patterns.

Guards Narrow strips of paper (projecting from the spine by approximately 10mm or ½inch) between pages of a book.

Guide, front/side Guides, lays or gauges at

the front and side of a FEEDER on a press to which paper is fed before being printed and which ensure that it reaches the printing units in the correct REGISTER.

Guillotine A device to trim paper or board before or after printing. Fitted with a powerful clamp to ensure that the paper is kept absolutely square during the cut, and may be computerised to carry out a complex sequence of cuts.

Gutter The margin down the centre of a double page spread, sometimes equal to two BACK MARGINS.

H

H&J See HYPHENATION AND JUSTIFICATION.

Hache Symbol used in computing to stand for the word 'number', but in British typography used only to indicate a space.

Half bound Binding in which the back and corners are covered in one material and the rest of the sides in another: eg cloth back and corners with paper sides.

Half up Instruction to prepare ARTWORK 50 per cent larger than final size so that it can be reproduced at 66 per cent to eliminate any blemishes in the original.

Half-sheet work See WORK AND TURN.

Halftone A photograph printed by any of the major printing processes that, while they cannot actually print intermediate tones, can adequately represent them by using dots of various sizes generated by a SCANNER or HALFTONE SCREEN. A mid-grey is thus depicted using a dot that is 50 per cent of solid.

Halftone screen Conventionally a glass plate cross-ruled with opaque lines leaving a grid of transparent squares and used to split a photographic image into HALFTONE dots. See also CONTACT SCREEN.

Handshake Setting up procedure used when connecting two computerized systems, such as a WORD PROCESSOR and a FRONT END.

Hard copy/proof Typed or printed copy from a computer, WORD PROCESSOR or FRONT

END, as opposed to the soft copy/proof on a VDU.

Hard dot A halftone either produced directly by a laser SCANNER or a FINAL FILM which has a dot that can only be minimally RETOUCHED or ETCHED.

Hard sized paper A paper, often a writing one, with a maximum of SIZE.

Hardback/hardcover *(UK/US)* Publishers' usual style of binding, typically a FULL BOUND CASE.

Hardware The electronic components of a computer, as opposed to the programming (SOFTWARE) or the intermediary FIRMWARE.

Head (or **Top**) The edge of a page above the printed matter.

Head/tail band A narrow band of plain or striped sewing round a strip of cane glued to the top and/or bottom of the spine of a CASED book, covering up the ends of the sections. They add to the strength of a binding as well as its appearance.

Head margin The space between the top of the printed image on a page and the HEAD TRIM.

Head to head/to tail IMPOSITION SCHEMES in which the pages are printed head to head or head to tail to suit the requirements of the binder. If paperbacks are being bound two copies at a time the cover imposition must allow for this.

Head trim The usual allowance is 3mm or ⅛ inch (or twice this between pages), to remove folds or clean up edges.

Header On a WORD PROCESSOR the normal abbreviation of HEADLINE.

Headline The line of type at the top of a page, sometimes separated from the text by white space. A running headline is the title of a book repeated at the top of every verso (left-hand page) of text with the chapter headings on the rectos (right-hand pages). If they appear at the foot of the page they are 'footers'.

Headlining machine See PHOTO-LETTERING.

Heat-set drying Accelerated drying, usually of a WEB, by passing it through one of several forms of DRIERS.

Height to paper The

standard height of type, blocks etc. This height is 23.317mm (0·918inch) in the UK, Australia, Canada, India, Mexico, New Zealand, South Africa, South America and the USA; in other European countries it varies from 20mm to 25.10mm (0.7874 to 0.9882inch).

Hex/adecimal Method of counting used in computers. Rather than using the 'human' decimal (base ten) or the BINARY (base two), a base of 16 is used and the figures are represented by the numbers '1' to '0' followed by 'A' to 'F'. Thus decimal '9' is still Hex '9', decimal '10' becomes Hex 'A', decimal '16' becomes Hex '10', decimal '26' becomes Hex '1A', and so on.

Hickie/hickey See BULL'S EYE.

High spaces Spaces cast to the height of the shoulder (non-image area) of type, used in a FORME that is to be ELECTROTYPED or STEREOTYPED.

High-level language A PROGRAMming language such as BASIC. Only skilled programmers work in MACHINE CODE so a high-level language acts as an interpreter from English to the computer's internal language. Some languages are transportable between different machines, but two dialects of the same language can be quite incompatible.

Highlight The lightest part of a halftone. See also DENSITY.

HMSO (UK) Her Majesty's Stationery Office, equivalent to the US Government Printing Office.

Holding line (US) See KEYLINE (UK).

Hollow The space at the back of a cased book between the CASE and the BOOK BLOCK.

Horizontal format (US) Rectangular page or printed sheet with its long sides at the top and bottom. (UK) Landscape.

Hot melt An adhesive used in book binding. At normal temperatures they are flexible, but solid. In the binding process they are heated (to melt them) before application.

Hot metal typesetting Method of typesetting used in MONOTYPE and SLUG CASTER setting. In either system a liquid alloy of lead, tin and antimony is poured into the matrices (see MATRIX) to form the letters required.

House corrections Corrections to proofs, other than those made by the author/client, which should be marked (and if possible carried out) before the proofs are sent out.

HSWO HEAT-SET WEB-OFFSET.

H/T See HALFTONE.

Hue That part of a colour that produces its main attribute — for example, its redness or blueness — rather than its shade (lightness or darkness).

Hyphenation and justification The computer routines that distribute spaces correctly in a line of type to attain the desired MEASURE. When this cannot reasonably be done without breaking words at the end of a line the computer will introduce hyphens. The position of the hyphen may be determined by using a computerized word break dictionary, by applying rules for the language being set, or a combination of the two.

I

Idiot tape Produced by a NON-COUNTING keyboard emitting perforated paper tape.

Image area The printing/ink-carrying areas of a LITHO printing PLATE.

Image master A film-based FOUNT.

Impact printer A DOT MATRIX or DAISY WHEEL printer as opposed to a NON-IMPACT PRINTER.

Impose The arrangement of pages to be printed in the correct sequence with the appropriate margins before making plates and printing.

Imposed proof Usually in book printing, a proof that may be printed on only one side and in which all the elements are combined so that the paper can be folded into its final form.

Imposition schemes Plans laid down in advance so that when IMPOSED, pages will be in the correct sequence when folded. They are agreed between the printer and the finisher.

Impression (1) The act of placing a printed image on paper — in LETTERPRESS, impressed onto the type. (2) All the copies of a job printed to one order.

Impression cylinder That part of any press that brings the paper, board, or other surface to be printed into contact with the printing PLATE, cylinder or other surface.

Imprint The printer's name and place of printing — a legal requirement for most printed jobs in most countries. The publisher's imprint is the name of the publisher and place and date the book was published. The imprint (UK)/copyright (US) page holds the printer's and/or publisher's name, an ISBN, credits and British Library (UK)/Library of Congress (US) CIP.

Indent A short line of type set to the right or left of the standard margin.

India paper A thin and opaque paper used for substantial books when lightness or less bulk is desired.

Indirect letterpress See LETTERSET.

Indirect work A HALFTONE made by the intermediary of a CONTINUOUS TONE negative and positive before the final SCREEN negative or positive is produced.

Inferior characters Letters (or numbers) smaller than the text and set on or below the BASELINE.

Infra-red See RADIATION DRYING.

In line Usually of FINISHING, but any operation taking place as an adjunct to the main printing — such as folding, numbering or glueing — and not involving a separate operation.

In pro/portion (1) Individual items of ARTWORK that are to be enlarged or reduced by the same amount during REPRODUCTION. (2) Instruction that one dimension of an artwork is to be enlarged/reduced in the same proportion as the other.

Ink jet A printing device (used on desk-top computer printers and for numbering on WEB-FED presses and in packaging) in which letters or graphics are

printed by directing individuals droplets of ink electronically onto the paper or board. Ink jet printers allow the image to be varied infinitely between copies.

Inner forme The half of an IMPOSITION where the pages fall on the inside of a sheet in SHEETWORK, for instance, pages 1 and 2 of a four-page job. The reverse of the outer FORME.

Input Any data entered for processing by a computer or phototypesetter.

Insert (**1**) A SECTION of a book printed separately, perhaps on a different paper, but bound in with that book. (**2**) A piece of paper or board placed loose between the pages of a book

Inset See INSERT.

Insetting To place a SECTION inside another — for instance to make two 8-page sections into one 16-page section.

Intaglio A printing process in which the image is below the surface of the plate or cylinder as in GRAVURE.

Integrated A book in which text and illustrations are printed together on the same paper.

Interactive A system or VDT on which the operator can see what is happening and which acts immediately to carry out instructions.

Interface Where two systems meet and where different LANGUAGES, PROTOCOLS or OPERATING SYSTEMS have to be reconciled. Some of the worst problems still come at the 'man-machine' interface.

Interlay Preparation applied between a LETTERPRESS PLATE and its mounting to increase the pressure on the darker tones while decreasing it on the lighter tones.

Interleaving (UK) Placing sheets of paper between the newly-printed sheets as they come off the press to prevent SET-OFF. Also known as slip sheeting (US).

International paper sizes The standard range of metric paper sizes laid down by the International Standards Organisation (ISO) and British Standards Institution. See page 152.

Intertype See LINE

CASTER.

IPH Impressions Per Hour.

IR INFRA-RED See also RADIATION DRYING.

ISBN International Standard Book Number. A unique ten-figure serial number that identifies the language of publication of a book, its publisher and its title, plus a check digit. Often also included in a BAR CODE.

ISO The International Standards Organization.

ISSN International Standard Serial Number. A unique eight-figure number that identifies the country of publication of a magazine or journal and its title. Refers to a complete run of a publication and not a specific issue. Often associated with a BAR CODE.

Italic The specially designed and sloped version of a FOUNT. On most PHOTOTYPESETTERS a SLOPED ROMAN can also be created electronically from the ROMAN fount, but differs from it in not having specially designed characters and is usually considered less satisfactory.

Ivory board See BOARD, IVORY.

J

Jobbing General printing, printing that is not specialized in any particular field.

Joints The hinges on a CASE binding — between the spine and the boards.

Justification See HYPHENATION AND JUSTIFICATION.

K

K (US) Key. Used to indicate black in the FOUR-COLOUR PROCESS to avoid confusion with 'B' for blue or black.

K or **KB** Kilobyte or 1,000 BYTES. Actually 1,024 bytes. A computer measure of storage capacity in which one byte is equivalent to one character or code.

Kerning The adjusting of the space between individual letters so that part of one extends over the rectangular area covered by its neighbour.

Key (**1**) Any BLOCK, FORME, PLATE or ARTWORK that gives the overall position for REGISTER with other colours. (**2**) A character key on a keyboard. (**3**) To

enter text via a keyboard. (**4**) See K (US).

Key forme See KEY.

Keyline (UK) (**1**) The outline on ARTWORK that, when transferred to a printing plate, will give the register with other colours. (**2**) A line on ARTWORK indicating to the REPRODUCTION department an area for TINT LAYING.

Kraft (**1**) A synonym for the SULPHATE process. (**2**) A brown wrapping paper.

L

L ruling machine A machine that uses an arrangement of moving disks to rule paper in two directions in one pass.

Lacquer A colourless varnish printed on (or rolled on off-press) to give a high-gloss finish. Glosses may be akin to LAMINATION, but do not give the product the same degree of protection or strength. RADIATION DRYING or curing (see page 108) by INFRA-RED (IR) or ULTRAVIOLET (UV) light is common.

Laid paper The smooth WOVE surface is replaced by a series of translucent WATERMARKED laid lines about 1mm (25 to the inch) apart crossed at 90 degrees by chain lines 25mm (1 inch) apart. These are impressed by a DANDY ROLL on a FOURDRINIER machine.

Laminating (**1**) Applying transparent or coloured plastic films, usually with a high-gloss finish, to printed matter to protect or to enhance it. Various films are available with different gloss, folding and strength characteristics. (**2**) Manufacture of paste BOARDS (see BOARD, DUPLEX and TRIPLEX) by pasting sheets or reels together.

LAN See LOCAL AREA NETWORK.

Landscape format (UK) See HORIZONTAL FORMAT (US).

Language (**1**) Any typesetting that involves a change of language. (**2**) A computer language is interposed between the computer's internal MACHINE CODE and the user to facilitate the writing of PROGRAMS.

Laser Light Amplification by Stimulated Emission of Radiation, a fine beam of

highly integrated and pure light, sometimes with considerable energy. It can be used in PHOTOTYPESETTING, colour SCANNERS, PLATE- and cylindermaking or engraving, and CUTTING AND CREASING forme manufacture.

Laser printing A type of ELECTROSTATIC PRINTING in which the image is created by modulating a LASER on and off according to digital information from a computer. The final image is then transferred to paper by an ELECTROSTATIC PRINTING sub-system as in electrostatic copying or XEROGRAPHY.

Latin The standard alphabet used in most European languages, consisting of the UPPER CASE and LOWER CASE characters 'A-Z', numbers and punctuation. Other alphabets are Greek, Cyrillic (Russian, etc) and the Oriental languages (including Arabic and Hebrew) usually classified as Exotics.

Lay, front/side (UK) See GUIDE, FRONT/SIDE (US).

Laydown See IMPOSE.

Layout Any indication for the organization of text and pictures with instructions about sizing and so on for REPRODUCTION or printing.

LC Abbreviation for (1) LOWER CASE or (2) (US) Library of Congress.

Lead/ing (1) Strips of metal less than type-high, used in HOT METAL setting as general spacing material (thicknesses: 1 point, 2 point, 3 point and so on). (2) To lead, in typesetting systems to add lead spaces between lines of type. In HOT METAL this is also done by using an over-size BODY for MONOTYPE or a larger SLUG on a LINE CASTER.

Leader A type character having two, three or more dots in line, used to guide the eye across a space to other relevant matter, (a six-dot leader) as in tables.

Leaf A single sheet of a publication with a page on each side. A section of 32 leaves therefore has 64 pages.

LED See LIGHT EMITTING DIODE.

Letter fit The adjustment of space between letters from that supplied by the manufacturer by KERNING or reducing/increasing the SET to give a better visual effect.

Letterflex A proprietary PHOTOPOLYMER plate used in the LETTERPRESS and FLEXOGRAPHY processes.

Letterpress printing The original printing process. The inked printing surface of metal, rubber or plastic is above the non-printing surface. The inking rollers touch only the raised printing surface which is then impressed onto the paper or board.

Letterset OFFSET LETTERPRESS printing, also called dry offset, but not to be confused with dry litho or waterless offset, which are LITHO processes that do not require moisture. In letterset a WRAP-ROUND letterpress plate is used, but on an offset litho press.

Letterspacing See LETTER FIT.

Library binding A reinforced binding for paperbacks or CASED books sold to libraries.

Lift Unquantifiable measure of the amount of ink transferred to the surface of paper in multi-colour printing: normally less in WET-ON-WET printing than when a series of single-colour presses are used to print the same number of colours.

Ligature Two or three letters joined together to make one type character as in 'fi', 'fl', 'ff', 'ffl', 'ffi' and more rarely 'ct', 'st'.

Light box A box with a translucent glass top lit from below, giving a balanced light suitable for COLOUR MATCHING on which colour transparencies, prints and proofs can be examined or compared.

Light emitting diode (LED) A semi-conductor that produces a light when powered. Frequently used as indicator lights, but also small enough for use in PHOTOTYPESETTING, in ELECTRONIC PRINTERS and in colour SCANNERS as an alternative to LASERS. The LED is either in contact with a photographic EMULSION or the light can be conducted to it by FIBRE OPTICS.

Light fast An ink or coloured material whose colour is not affected by exposure to light (or air or specified chemicals — colour fast).

Light pen Light-sensitive stylus used with certain VDTs as an aid to design (CAD—Computer Assisted Design), text editing or for reading BAR CODES.

Limp binding/cover A flexible book cover, as distinct from a stiff board cover, or CASE. Bibles are often bound in this way with overhanging, or yapp, edges.

Line art ARTWORK entirely in black on white with no intermediary tones and thus not requiring HALFTONE REPRODUCTION.

Line block/cut (UK/US) A relief block produced from LINE ART or a drawing.

Line caster HOT METAL typesetting machine that produces lines (or SLUGS) of type.

Line conversion Photographic or electronic method of progressively eliminating the MIDDLE TONES from a CONTINUOUS TONE photograph so that it can be treated as LINE ART

Line copy See LINE ART.

Line drawing A drawing in black and white producing a single tone.

Line feed The distance, in millimetres, inches or POINTS between BASE LINES of successive text lines in PHOTOTYPESETTING and equivalent to the LEADING in HOT METAL.

Line gauge (US) See TYPE SCALE (UK).

Line original See LINE DRAWING.

Line printer Typewriter-like, tape- or computer driven machine printing from a DOT MATRIX, DAISY WHEEL, GOLF BALL, THERMAL or chain printer on plain or sensitized paper. May also be a LASER PRINTER.

Line speed The BAUD rate of a telephone or other communications line.

Linen finish A finish impressed on COATED or uncoated papers to simulate linen by passing the WEB or sheet between cylinders engraved with linen (or other) patterns before or after printing.

Linen tester A magnifying lens used to check HALFTONE dot patterns.

Lining figure See MODERN NUMERAL.

Lining, first/second

After a MULL has been glued to the spine of a book, a further sheet of paper is glued in position to strengthen it.
Linotype See LINE CASTER.
Literal (UK) A typographical error, often the transposition of two adjacent letters. (US/UK) TYPO.
Lith A high contrast and high quality photographic emulsion used in graphic reproduction.
Lithographic printing (**litho**) A printing process where the image and non-image surfaces are on the same plane (a planographic process) while the paper makes contact with the whole plate surface (or BLANKET in OFFSET). The printing area is treated to accept ink and the non-printing surface is treated to attract water or other DAMPER solution so that it rejects ink.
Load To enter DATA or PROGRAMS into a computerized system from a MAGNETIC MEDIA.
Loading Clay or other mineral filing in the FURNISH of paper giving a more solid, opaque and smoother sheet. Also used as a component in COATING.
LOC (**1**) Letterpress to Offset Conversion, a retro-fitted conversion for ROTARY presses. (**2**) (US) Library of Congress Catalog number
Local area network Method of connecting a variety of electronic devices from VDUs to DISK drives and IMPACT/NON-IMPACT printers. The cable may be a twisted pair, coax or a special purpose cable and the network will usually be monitored by a network controller. Special SOFTWARE ensures that only one pair of devices is ON LINE at a time. Very high speeds are possible, which means that the user will not normally notice any delay while other devices are using the net.
Lock on See SPREAD.
Logo/type Several letters or a word on one BODY in HOT METAL, thus any group of letters together such as LIGATURES, dipthongs or company emblems.
Long grain See MACHINE DIRECTION.
Look through See SEE THROUGH.
Loose leaf Single sheets

of paper or board bound together in a ring or other binding mechanism that allows for easy removal or additions.
Loose line A line of text in typesetting in which too much space has been added between the words in HYPHENATION AND JUSTIFICATION to give a pleasing effect.
Lower case (**1**) Small letters (or miniscules) of the alphabet as distinct from capitals, from (**2**) the name of the divided wooden tray that holds the lower case sorts of metal type.
LPM Lines per minute.
LWC Light Weight Coated — a publication paper.

M

Machine code The lowest level of language used in computing. It is the least like English, but directly addresses the computer's functions and is the most efficient method of programming.
Machine composition Any TYPESETTING not done by hand, but mainly applied to HOT METAL.
Machine direction The length of the paper web and the direction in which the majority of the cellulose fibres are orientated due to the motion of the FOURDRINER or CYLINDER MACHINE used in paper making. The sheet has stronger physical properties in the machine direction and shrinks/stretches less in changing humidity.
Machine finished See MF.
Machine glazed See MG.
Machine proof A proof made on a machine similar to the one on which it will be printed.
Machine readable Typeset or typewritten characters that can be read by a machine — such as OCR or MICR.
Machine revise Sheet submitted to the proof-reader during MAKE READY for checking against the customer's final proof before printing. More common in LETTERPRESS than in LITHO.
Machining Printing.
Made (up) fraction See BUILT FRACTION.
Magenta The red ink used in the FOUR-COLOUR PROCESS.
Magnetic ink character recognition A form of

MACHINE READABLE character.
Magnetic media Any material coated with an oxide capable of being magnetized for the storage of computerized information including DISK/ETTES, MAGNETIC TAPE, cards, cartridges or cassettes.
Magnetic tape A form of MAGNETIC MEDIA that in computing or PHOTOTYPESETTING has the information laid down in a fixed number of TRACKS and BITS PER INCH.
Mainframe The most powerful computers, comparatively rare in even the largest PHOTOTYPESETTING houses.
Make ready Preparation of a printing press before the run, setting it up for colour, size and SUBSTANCE of paper, REGISTER and so on.
Make up Arranging of typesetting into columns and/or pages, leaving spaces for illustrations if necessary, before IMPOSITION.
Makeover (US) Materials and labour lost or wasted on a printing job. (UK) Spoilage.
Making A special order of paper — usually to a special size, sometimes to a special SUBSTANCE or colour. The minimum making quantity will vary from mill to mill.
Manilla A strong paper, originally made from old manilla ropes.
Manuscript Written by hand: also (incorrectly) used to refer to typescripts.
Marbling A decorative colouring that can be applied to book edges, but more commonly to paper for use in book binding. For work in larger quantities more often produced as a photographic facsimile by PHOTOLITHOGRAPHY.
Marching display A small display of the text being entered, usually limited to one line on older keyboards.
Margin The space around the images and type on a page, between the trim or the spine.
Marked proof The proof that has the READER's or client's corrections on it.
Mark-up To indicate on ARTWORK or MANUSCRIPT/typescript instructions for REPRODUCTION or TYPESETTING.

Masking (**1**) Indication of the area of an illustration to be REPRODUCED (either on the reverse or on an OVERLAY). (**2**) Technique used for COLOUR CORRECTION when preparing SEPARATIONS on a camera or enlarger rather than on a SCANNER.

Master proof The MARKED PROOF with both the client's and editor's changes on it.

Masthead (*UK*) See FLAG (*US*).

Mat/rix Also matrice. (**1**) In TYPEFOUNDING and HOT METAL, a copper MOULD from which type is cast for hand composition or on MONOTYPE or SLUG MACHINES. (**2**) Thus in PHOTOTYPESETTING the photographic negative on discs, film strips, grids or drum from which the image is generated. (**3**) The horizontal and vertical rows of dots used to form a character on a VDU or on a DOT MATRIX printer.

Matchprint A proprietary DRY PROOF.

Matt art A COATED paper with a dull eggshell finish.

MB See MEGABYTE.

MDR See MULTIDISK READER.

Measure The length of a line in TYPESETTING, normally measured in PICAS or POINTS, but sometimes in inches or millimetres.

Mechanical (*US*) See ARTWORK (*UK*).

Mechanical paper (*UK*) Any paper containing a proportion of MECHANICAL WOOD PULP (groundwood (*US*)).

Mechanical wood pulp (*UK*) Produced by grinding wood mechanically, a pulp used in the cheaper papers, such as NEWSPRINT. It can be combined with varying proportions of CHEMICAL WOOD PULP to produce better quality papers.

Medium (**1**) A synonym for a CATCHLINE. (**2**) The substance (usually linseed oil or varnish) in which the pigment of printing ink is carried. Also called a vehicle. (**3**) The weight of a typeface midway between light and bold. (**4**) A standard size of printing paper (455 × 585mm, 18 × 23inches).

Megabyte 1,048,576 BYTES. Usual measure of storage or processing power of larger computer systems.

Memory Part of a computer in which PROGRAMS or the DATA currently in use are stored. In the case of a RAM its maintenance is normally dependent on a constant suppy of electricity while with ROMs it is not.

Menu A choice of operations displayed on a VDT. A program is said to be menu-driven when the operator is given a menu to choose from, rather than having to remember the instructions.

Merge Combining DATA or PROGRAMS on different MAGNETIC MEDIA into one, using a computer or FRONT END SYSTEM to incorporate amendments or new copy into existing copy and to produce clean media for typesetting.

Metallic inks Inks in which the normal pigments are replaced by very fine metallic particels, typically gold or silver in colour.

Metric weights Quantities calculated by metric weight, volume or size covered by British Standard 3814:1964 'Systeme Internationale (SI) Units'.

MF paper Abbreviation for machine finished or mill finished. A paper finished on the papermaking machine and possibly CALENDERED, but not super calendered.

MG paper Abbreviation for Machine Glazed or Mill Glazed. Papers, like poster papers, that are rough on one side and highly glazed on the other. The smoothness is imparted by the use of a chromed and heated cylinder to dry the WEB.

MICR See MAGNETIC INK CHARACTER RECOGNITION.

Microchip See CHIP.

Microcomputer The smallest of the computers, typically fitting on a desk top (or even portable) and used for the smaller FRONT ENDS.

Microfiche A sheet of film, processed and cut from the reel, typically to 105 × 150mm (4 × 6inches). It may contain from 48 to several hundred 'pages' depending on the reduction originally used.

Microfilm Film, typically 35mm format or smaller, used for the photographic recording of data.

Microform Images photographically reduced and stored on MICROFICHE, MICROFILM, or microfilm in an apperture card. Microforms can be in colour or monochrome. Special viewers or READER-PRINTERS are used so that the images can be read at the original size or larger.

Microprocessor The main microCHIP that forms the CPU in a MICROCOMPUTER.

Mid/dle space A type space having a width of one quarter of its own body POINT size.

Middle tone See DENSITY.

Milking machine Slang for TEXT RETRIEVAL TERMINAL.

Mill board See BOARD, MILL.

Mill finished See MF.

Mill glazed See MG.

Minicomputer In between the MICROCOMPUTER and the MAINFRAME. Used in the larger and more powerful FRONT END systems and generally the size of a filing cabinet or desk.

Mini-web A WEB FED press, using the OFFSET process. Typically printing eight large QUARTO pages TO VIEW.

Mitre Cutting the ends of metal rules in letterpress printing at an angle of 45 degrees so that the corners fit neatly in MAKE UP — also applied to PHOTOTYPESETTING.

Mixing Having more than one typeface, style or size in a job.

Modem A MOdulator/ DEModulator. See DATA PHONE/SET.

Modern numerals Numbers that are the same size as the capitals, with no part going below the BASE LINE, unlike old style faces in which 3, 4, 5, 7 and 9 can go below the base line with only 6 and 8 as high as the Capitals.

Modern typefaces Designs, such as Bodoni, in which the main emphasis is vertical.

Modification On digital PHOTOTYPESETTERS, and PHOTOLETTERING machines or special graphics modifiers, characters can be condensed, expanded and sloped by electronic or optical means.

Moiré A pattern, like that in watered-silk, which is created when a

photograph that already has a HALFTONE SCREEN has to be re-screened rather than being reproduced DOT FOR DOT. It can also happen when the SCREEN ANGLES are not set correctly in colour work.
Monitor A VDU.
Monochrome A single colour.
Monospace Typewriter-like FOUNTS in which all the characters are of equal width, usually ten or twelve to the inch (25·4mm).
Monotype Typesetting system setting single characters in HOT METAL.
Mordant (1) An adhesive for fixing gold leaf. **(2)** Any fluid used to etch lines on a printing plate.
Mold (US)/**Mould** (UK) In HOT METAL that part of the type casting or TYPEFOUNDING system in which the BODY of the type is formed.
Mount The base on which a LETTERPRESS printing plate is fixed to make it TYPE-HEIGHT.
Mouse Electronic device, usually used with a GRAPHICS TABLET, for drawing or 'pointing' to certain areas of the VDT on a computer.
Ms See MANUSCRIPT.
MS-DOS A widely used MICROCOMPUTER Disk OPERATING SYSTEM.
Mull An open-meshed fabric glued to the spines of CASED books to give extra strength.
Multidisk reader Floppy DISK reader configured to read disks that may be of different size and coded in different ways. The MDR may also write new disks and contain a PROTOCOL CONVERTER.
Multiplexer Switching device used where several devices need to send OUTPUT to a single device. Several terminals may be connected to a PHOTOTYPESETTER or a DATA PHONE in this way, with the multiplexer automatically giving priority to each device in turn. Alternatively a single high-speed communications circuit may be divided into several slower channels.
Mump To move (or copy) HOT METAL or PHOTOTYPESETTING FOUNTS/MATS from one establishment to another — often unauthorized.
Mutton An EM.
MUX See MULTIPLEXER.

N

Needle printer A form of DOT MATRIX PRINTER.
Neg/ative A photographic film or paper in which all the dark areas appear light and vice versa and used in the REPRODUCTION process. It is made either direct from the ARTWORK or from a POSITIVE.
Negative line feed System used in some PHOTOTYPESETTERS in which the movement of the film or paper can be reversed. This permits the setting of vertical RULES or a second column of type alongside one already set.
Network A system of high-speed links between computers and some components in certain FRONT END systems. A network allows a group of users to share common facilities such as DISK storage, and gives data transfer rates many times faster than an RS-232-C interface.
Neutral See BLANK.
Newsprint A relatively cheap paper made for newspaper production — mostly from GROUNDWOOD/MECHANICAL pulp.
NIP See NON-IMPACT PRINTER.
Nip The point between any two rollers (typically on a press) where a substance can be drawn into that system. As well as being a point of danger, nips can be used to draw a WEB through a press.
Nipping (UK) A pressing that takes place in book binding after the CASE has been applied (and before the adhesive is dry) to improve its formation.
NJ Non Justified. See NON-COUNTING.
No-flash See FLASH.
Non-counting keyboard A keyboard used to enter copy for typesetting, with the operator producing a continuous stream of codes or characters on paper tape or on MAGNETIC MEDIA. These are fed to the PHOTOTYPESETTER for HYPHENATION AND JUSTIFICATION (H&J). Thus an NJ (Non Justifying) keyboard produces an unjustified tape or disk.
Non-impact printer Unlike IMPACT printers they use imageing systems that do not rely

on substantial impact to produce the image. With the exception of INK JET and electro-erosion systems the non-impact printer relies on a XEROGRAPHIC sub-system to convey an image generated by a LASER or LEDs to the paper.
Non-lining figures See MODERN NUMERALS.
Non-woven A book-binding material made on a paper machine and treated chemically or with latex/plasticizers to give more strength. Non-wovens are usually embossed to mimic genuine book cloths (which have become comparitively rare) and are now the normal covering used in CASE BINDING.
Notch (burst) binding A form of ADHESIVE BINDING in which, rather than cut off all of the spine fold, a series of notches are cut in the spine on the binding machine to let the adhesive penetrate.
Null modem Cable used to connect two computers — usually RS-232-C to RS-232-C — over a short distance to save the expense of two MODEMs.
Numbering at/on press Numbering a job on the printing machine IN-LINE by means of numbering boxes or a LASER or INK JET, rather than as a separate operation.
Nut An EN.

O

Oblong See HORIZONTAL FORMAT (US).
OCR See OPTICAL CHARACTER RECOGNITION.
Octavo A standard book format obtained by folding the sheet thrice at right angles.
Oddment A section that has to be printed separately when a job does not comprise an EVEN WORKING.
OEM An Original Equipment Manufacturer — the computer industry's 'Badge Engineering'. A producer who supplies hardware for resale under another company's name.
Off line See ON LINE.
Offprint Pages of a journal article printed with the main run for separate distribution.
Offset (1) A LITHOGRAPHIC (and sometimes LETTERPRESS)

method of printing in which the ink is transferred from the printing plate to an offset BLANKET CYLINDER and then to the paper, board, metal or whatever on which it is required. (**2**) To REPRODUCE a book in one EDITION by photographing a previously printed edition.

Ok press *(US)* An indication that a job has had all the corrections made or indicated by the client and is ready for print. *(UK)* Pass for press.

Old style face See MODERN FACE.

Old style numeral See MODERN NUMERAL.

On line Computers and PHOTOTYPESETTERS are on line when they have direct access to another piece of equipment, as opposed to off line when the connection is made by transferring a DISK or other magnetic media between the devices.

Onion skin An airmail paper given a crinkly finish.

Opacity The ability of paper, or other material, to impede the passage of light and thus reduce SEE THROUGH.

Opaquing Use of a paint-like material to remove blemishes (spotting) or larger areas on film NEGATIVES and sometimes on POSITIVES.

Open ink An ink that can be left on a press without it drying on the rollers.

Open time *(US)* Unused production time, due to a break in the schedule. *(UK)* Standing time.

Opening Any pair of facing pages — which may or may not form a double page SPREAD.

Operating system (OS) The SOFTWARE (often supplied as FIRMWARE) that controls all a computer's operations. Software written for a particular operating system may be 'portable' between different computers using that OS.

Optical character recognition Procedure whereby material typewritten in a special FOUNT (and sometimes printed matter using any fount) is capable of being read opto-electronically by a special scanner into any computerized system.

Optical disc A glass or plastic platter, up to 305mm or 12inches in diameter, and superficially similar to a video disc. Any data can be written to and read from its surface using a laser head. Optical discs carry significantly more data than MAGNETIC MEDIA, though most are of the 'write once, read many times variety'.

Orange peel A fault in LAMINATION that can occur if too much SET OFF SPRAY is used on the SUBSTRATE.

Original Any ARTWORK or copy to be REPRODUCED photographically.

Origination *(UK)* All the preparatory stages for printing, including PHOTOTYPESETTING, the making of HALFTONES and colour REPRODUCTION.

Orphan See CLUB LINE.

Ortho/chromatic film/paper Photographic emulsion, insensitive to red light, and only suitable for monochrome REPRODUCTION or on SCANNERS using non-red LASERS.

OS See OPERATING SYSTEM.

Outer forme The opposite to an INNER FORME.

Output Any computer output — thus MAGNETIC MEDIA, MICROFORME or paper or film from a PHOTOTYPESETTER.

Outside sort A PI CHARACTER.

Outwork *(UK)* See BUYOUT *(US)*.

Overdraw See SPREAD.

Overlap cover A cover on a LIMP BINDING that extends beyond the trimmed edges of the pages, which have to be trimmed before covering.

Overlay (**1**) A sheet of flimsy paper (usually tracing paper) on artwork with instructions for REPRODUCTION. (**2**) Film (or paper ARTWORK) with SEPARATIONS of colours in addition to the KEY working.

Overmatter Typesetting that will not fit in the space allocated and thus has to be abandoned or fitted in elsewhere.

Overprinting *(UK)* To print a second image (not always in an additional colour) on a previously printed sheet.

Over-running To turn over words from one line to the next (or for several successive lines) after an insertion or other

correction. The opposite is to run back.

Overs The quantity allowance delivered to the finisher or customer above the quantity ordered to cater for losses during production. They may be chargeable on a pro rata basis, but only within agreed limits.

Overstrike To place one character on top of another on a VDU, PRINTER or PHOTOTYPESETTER, for instance a '/' over a '0'.

Ozalid See BLUES.

P

Packager *(UK)* (outhouse publisher *(US)*) A company conceiving and producing books (which are usually highly illustrated) for regular trade publishers whose IMPRINT appears on the title page and who will sell the book as if it were one of their own titles.

Packet switching A computer controlled communications network in which the data is divided into 'packets' before transmitting them at high speed so that all users appear to have simultaneous access to it, while sharing the line with many other users.

Page One side of a LEAF.

Page make up In HOT METAL the type and any illustrations needed are assembled by hand. On FRONT END SYSTEMS for phototypesetting incorporating page make up facilities the items can be moved around on the VDT (or in memory) until in the correct position when a complete page can be transferred for output on the PHOTOTYPESETTER.

Pagination Making up into pages, or giving page numbers, by hand or electronically.

Pan/chromatic film A film used in ordinary photography and in REPRODUCTION that is sensitive to most of the visible spectrum.

PANTONE Pantone, Inc's check-standard trademark for colour preproduction and colour reproduction materials. Each colour bears a description of its formulation (in percentages) for subsequent use by the printer.

Paper A material made mainly from CELLULOSE and usually less than 200

g/m², 10 POINTS (US).
Paper sizes See tables on pages 152-153.
Parallel folds More than one fold on the same axis, as in an ACCORDION or GATE fold.
Parallel transmission The BITS of a BYTE are transmitted simultaneously down separate cores of the cable, unlike SERIAL transmission.
Parchment (US) See GREASEPROOF (UK).
Parity A BIT included in a BYTE to enable a computer to check that the data is not corrupted.
Pass (1) Client's instruction to printer to proceed with printing. (**2**) A cycle of a press or PHOTOTYPESETTING system.
Pass for press (UK) See OK PRESS (US).
Paste board See BOARD, PASTE.
Paste up (1) Proofs of type and illustrations pasted up on layout sheets to give position. (**2**) Any matter pasted up as ARTWORK for REPRODUCTION, also known as camera-ready copy or CRC.
Patch (1) To place in position correction lines or paragraphs in PHOTOTYPESETTING. (**2**) (UK) See BAND AID.
PC Personal Computer — a name coined by IBM for the IBM PC and widely used by its imitators for their small business MICROCOMPUTERS.
PCB See PRINTED CIRCUIT BOARD.
PC-DOS The Disk OPERATING SYSTEM of the IBM PC, similar to MS-DOS.
PE See PRINTER'S ERROR.
Peculiar A PI CHARACTER.
PEL From Picture ELement, more usually PIXEL.
Perfect binding See ADHESIVE BINDING.
Perfected sheet A completed sheet, printed on both sides.
Perfecting To print both sides of a sheet or WEB, or its second side.
Perfector A press that prints both sides of a sheet or WEB.
Perforating at press Making perforations on a printing press, usually by way of some ancilliary attachment.
Perforation Small holes or slots through paper or board, which may be inserted on press or a folding machine to

facilitate the folding of thicker materials.
Period (US) See FULL POINT (UK).
Peripheral Any device not essential to a computer's operation, but connected to it, such as a printer or DATA SET.
pH A measure of acidity/alkalinity on a logarithmic scale. 0 represents the extreme of acidity and 10 of alkalinity.
Photocomposition See PHOTOTYPESETTING.
Photoengraving A photomechanical method of making relief plates for the LETTERPRESS process.
Photogravure See GRAVURE.
Photolettering machines Specialist PHOTOTYPESETTERS used in setting DISPLAY type.
Photolithography A combination of photography and LITHO to produce a printed image, unlike the original chromolithography in which the image was prepared on the plate by hand.
Photomechanical transfer Also known as Diffusion or Chemical Transfer, a process that relies on the silver-based image on a NEGATIVE (which has been exposed in the normal way) being developed in contact with POSITIVE material. During this process the image is transferred from negative to positive and the negative is then discarded. The final image may be on paper, film, or metal LITHO printing plates. It may also be negative or in colour. (US) VELOX.

Photopolymer A light-sensitive polymer or plastic used either as a coating for LITHO plates or as a relief printing plate in its own right for LETTERPRESS or FLEXO, in which case it may have the non-image areas developed away by a solution of alcohol.
Photosetting See PHOTOTYPESETTING.
Phototypesetting The setting of typematter (and sometimes other images) on film or photographic paper, from a film MATRIX fount or a digital fount, as opposed to STRIKE ON and HOT METAL setting.
Pi characters (Pies) (US/UK) (**1**) Any character, such as fractions or musical

symbols, not normally included in the normal FOUNT. Also called special sort. (**2**) A mixed or disordered collection of printing type.
PIA Printing Industries of America, an employers' federation.
Pica Twelve POINTS in the Anglo-American system.
Pick An OPERATING SYSTEM developed in the 1950s that is multi-tasking and multi-user. It runs on computers from micro to mainframe and addresses up to 8 MB of disk as if it were RAM.
Picking Damage to the surface of paper or board during printing, caused by a poor surface or too tacky an ink.
Piece accents (US) See FLOATING ACCENTS.
Pigment The mineral, vegetable or synthetic material that gives colour to an ink.
Pin register Method of securing the REGISTER of an OVERLAY or FLAT by punching them at fixed intervals and then inserting the pins through each in turn.
PIRA Printing Industries Research Association, Leatherhead, Surrey.
Pixel The individual 'picture elements' that form the smallest visible and manipulable part of a colour image in electronic colour imageing systems.
Planning (UK) IMPOSING or FILM ASSEMBLY.
Planographic See LITHOGRAPHIC PRINTING.
Plate (1) Usually metal, but possibly plastic or paper, image carrier used to transfer ink to paper in LETTERPRESS printing or to the BLANKET in LITHO and (rarely) in GRAVURE. (**2**) An illustration for a book printed separately from the text and usually on a different paper.
Plate cylinder Cylinder on a press that carries the printing PLATE.
Platen (1) A small LETTERPRESS machine in which both the paper and type or PLATES are held flat and brought together in a parallel or near-parallel motion. (**2**) A large CUTTING AND CREASING press that may be integrated with printing units in the production of packaging.
Plucking See PICKING.
PMS PANTONE Matching System.
PMT See

PHOTOMECHANICAL TRANSFER.

Point (1) (*US*) 1/1000inch – (*UK*) a thou (a thousandth of an inch). **(2)** (*US*) Used to refer to the thickness of board.

Point system Type measurement systems. **(1)** Anglo-American in which the point is 0·013837 of an inch or 0·351457mm and 12 points make a PICA EM. **(2)** Didot in which the point is 0.376065mm and 12 points makes a CICERO. (See page 80).

Polyvinyl alcohol (PVA) A COLD MELT adhesive used in book binding.

Portrait A vertical format — the shorter dimension being at the width.

Pos/itive A photographic reproduction on film, made from a NEGATIVE or on a DUPLICATING film in which the highlights in the original are clear and the shadows are solid.

Powderless etching Proprietary system for ETCHING relief BLOCKS for LETTERPRESS in zinc, magnesium and sometimes copper.

Prelims (*UK*) See FRONTMATTER (*US*).

Presensitized plate A LITHO printing plate on which the coating is factory-applied, as opposed to WIPE-ON plates and the older plates that required careful coating before use.

Press proof See MACHINE PROOF.

Primary colours In printing these are cyan (a blue), magenta (a red) and yellow inks used (with the addition of black) in FOUR-COLOUR PROCESS work with the requisite separations.

Print down To use a VACUUM FRAME to transfer a photographic image from one film to another, or to a printing PLATE.

Print out The product of a PRINTER on plain or specially sensitized papers.

Print to paper Instruction to a pressman to divide all the paper supplied equally among all the WORKINGS of a job, rather than produce a specified number of copies.

Printability The ability of a paper to print adequately without undue PICKING and so on, as opposed to RUNNABILITY.

Printed circuit board The basis of all computers on which the

individual components are mounted. The circuit details are SCREEN PRINTED onto the boards before the mounting.

Printer Computer output device, divided into IMPACT and NON-IMPACT varieties.

Printer's error Any error in typesetting that is the typesetter's and not the client's responsibility.

Printers' flower/ornament Decorations, some of which are called Arabesques, that were added to pages by hand in HOT-METAL setting and which are also available in TRANSFER LETTERING and on some PHOTO-LETTERING machines.

Printing cylinder See PLATE CYLINDER.

Process camera Specially designed graphic arts camera used in the REPRODUCTION of HALFTONES, SEPARATIONS and other ARTWORK.

Process colour Synonymous with FOUR-COLOUR PROCESS.

Program The SOFTWARE used to control any computer.

Progressive proofs Proofs used in FOUR COLOUR PROCESS to show all four colours both singly and in combination with the others.

PROM A Programmable READ ONLY MEMORY.

Proof A representation on paper of any type or other image made either from the plates (or type and blocks in LETTERPRESS) or direct from the film used in their production.

Proof correction marks Standardized codes used in marking either textual (or colour) corrections on proofs. (See also page 83).

Proportional spacing System used in typesetting by which all the letters take up an appropriate amount of space for their design, with an 'm' being wider than an 'i' and contrasted with the MONOSPACING used on most typewriters.

Protocol The set of codes that control a computer system's internal communications — or its communications with other systems.

Protocol converter Device used to convert the PROTOCOLS used by one device so that they can be acted upon in the correct fashion by

another system — typically from a WORD PROCESSOR or computer to a FRONT END or PHOTOTYPESETTER.

PSS Packet Switchstream, see PACKET SWITCHING.

PSTN Public Switched Telephone Network — the normal telephone lines as opposed to the special leased lines that may offer higher data speeds or lower error rates or both.

Puck See MOUSE.

Pull A PROOF

Pulp The raw material of paper and board manufacture. See CHEMICAL or MECHANICAL/GROUNDWOOD PULP.

Pulp board See BOARD, PULP.

Punch tape A paper ribbon perforated with codes to control a computer or PHOTOTYPESETTER and largely replaced by MAGNETIC MEDIA.

PVA See POLYVINYL ALCOHOL.

Q

Quad (1) A space whose width is normally that of its height, thus to quad is to fill out a line of typesetting with such spaces. **(2)** A sheet of paper that is four times the standard size.

Quad left, right or centre To make lines flush on the left or the right or to centre them with QUADS.

Quarter bound A book whose back covering is of one material while the sides are of another, typically a cloth back and paper sides. See also FULL and HALF BOUND.

Quarto A page size, typically about A4, and obtained by folding a sheet once in each direction. See table on page 154.

Quire stock See SHEET STOCK.

Quotes Single or double inverted commas — '' or " "

Qwerty The standard typewriter-like keyboard layout used for computers, WORD PROCESSORS and PHOTOTYPESETTING. The name is due to the arrangement of the first few letters of the top row of letter keys.

R

RA See INTERNATIONAL PAPER SIZES table page 152.

Radiation drying

Accelerated drying of specially-formulated inks or varnishes by ULTRAVIOLET or INFRA-RED radiation that excites the molecules in the MEDIUM, or VEHICLE, of the ink or varnish, and dries, or cures, it instantly. Radiation drying units can be fitted to printing presses and to special laquering equipment that is designed to apply a thick layer of high-gloss VARNISH.

Ragged right/left Use of a fixed word space so the type does not ALIGN vertically on the right/left, otherwise called un-justified. Compare FLUSH LEFT/RIGHT.

RAM Random Access Memory. The working space instantly available to a computer user without the need to ACCESS data on MAGNETIC MEDIA.

Random access See ACCESS.

Random access memory See RAM.

Range To cause type or illustrations to line up on a certain point vertically or horizontally.

Ranged left/right See FLUSH LEFT/RIGHT.

Ranging figures See MODERN FIGURES.

Raster In most PHOTOTYPESETTERS and VDUs the image is 'drawn' with each image being made up of a series of parallel (rastered) lines that are switched on and off as they cross the image area. The alternative method used on some display terminals is for a VECTOR to draw the outline only of each letter.

Raster image processor See RIP.

RC Resin coated, a coating applied to photographic papers.

Read only memory See ROM.

Reader (1) Person responsible for ensuring that any errors made on a proof are identified and corrected. **(2)** A device that 'reads' paper tape or MAGNETIC MEDIA or MICROFORM.

Reader-printer A viewer, combined with a photocopier, for reading MICROFORMS. When page has been selected a copy on paper is made without removing the microform.

Real time processing Unlike BATCH PROCESSING, in an RT computer system every operation takes place immediately a keystroke is made. Such systems tend to be both more INTERACTIVE and faster than batch systems.

Ream A unit of paper quantity — usually 500 sheets.

Rebind (1) A second binding from stored printed sheets of a book. **(2)** To remove a faulty binding and replace it.

Recto A right-hand page, see also HEADLINE.

Reduction (1) To reduce ARTWORK in size during REPRODUCTION to improve sharpness or make it fit the space allocated. **(2)** To dilute an ink or varnish to give it less TACK on the press.

Reel-fed See WEB-FED.

Reflection copy Unlike a transparency a reflection copy or ARTWORK is REPRODUCED on a camera by reflected light and not back-lit. Reflection copy includes PHOTOTYPESETTING on paper and REPRO PULLS, as well as drawings and photos.

Refresh rate The frequency with which the image on a VDU is replaced, which effects the degree of flicker on the screen and thus its ease of use.

Register To print two or more images so that they fit together perfectly if printed on the same side of the sheet or BACK UP accurately if printed on opposite sides of the same sheet.

Register marks Marks on sets of OVERLAYS, ARTWORK, film, PLATES or FORMES so that when they are superimposed during the printing the rest of the work is in REGISTER.

Release paper A silicone-coated backing paper used with some adhesive materials, which allows the latter to be peeled off when the adhesive material needs to be used.

Relief process Where the printing surface is raised, as in LETTERPRESS.

Remake *(UK)* To remake a printing plate or film due to an error at the first attempt. *(US)* Makeover.

Repeat See GHOSTING.

Reprint Any printing of a work (with or without correction) subsequent to the first printing.

Repro REPRODUCTION or a REPRODUCTION PROOF.

Repro/duction The entire printing process from the completion of typesetting until LITHO plates reach the press. This includes the use of PROCESS CAMERAS, SCANNERS, RETOUCHING and the IMPOSITION and PLATEMAKING operations.

Repro/duction proof/pull A LETTERPRESS proof on a smooth paper, such as BARYTA, that has a sharp black image suitable for LINE or HALFTONE.

Repro house (UK) A colour separator (US).

Rescreen If a photograph that has already been printed with a HALFTONE SCREEN on it has to be used as ARTWORK it will either have to be REPRODUCED DOT FOR DOT or rescreened in such a way that the new screen does not 'clash' with the existing screen and cause a MOIRE pattern.

Resist A coating on the surface of a printing PLATE used in order to stop or impede an etching solution.

Rest in proportion See RIP.

Retouching Treatment of a photographic NEGATIVE or POSITIVE by hand to modify the tonal values or to remove imperfections, or applied to the ARTWORK before REPRODUCTION. Carried out electronically on ELECTRONIC PAGE COMPOSITION SYSTEMS. See also AIRBRUSH.

Reversal To reverse an image from black to white or from NEGATIVE to POSITIVE, or from left to right.

Reversal film A film that produces a POSITIVE image rather than a black-and-white or colour NEGATIVE — that is, a transparency.

Reverse leading On a PHOTOTYPESETTER the film or paper may be moved in the opposite direction to the normal to set a column alongside one already set. Used to obtain multi-column work, rules or in mathematical setting.

Reverse out To make an image appear white out of black or a colour (which can then be printed in another colour), usually by a photographic REVERSAL.

Reverse reading See WRONG READING.

Reverse video Characters displayed on a VDU in black on white in

contrast to the usual white on black (or vice versa in the case of a VDU that normally displays dark characters on a light background). In PHOTOTYPESETTING reverse video may be used to output in negative on paper or film, rather than the more normal positive.

Reversing See REVERSAL.

Revise To correct a proof, or a FORME on press, in accordance with the client's or reader's instructions.

Right reading Paper or film in POSITIVE or NEGATIVE that can be read in the usual way, that is, from left to right.

Right side See FELT SIDE.

Rigid disk MAGNETIC MEDIA made up of a series of circular 'platters' that rotate on a central spindle. Unlike a floppy DISKETTE the reading and writing heads are not in contact with the surface, but 'float' above it in a near vacuum to make possible the very high speeds that they attain.

RIP (1) Rest In Proportion, an instruction to REPRODUCE one side of an ARTWORK in the same proportion as the side marked. **(2)** A Raster Image Processor, device used in some PHOTOTYPESETTERS and ELECTRONIC PAGE COMPOSITION SYSTEMS that processes the digital information passed to it relating to individual letters and images and processes them for output in the correct position and orientation.

River A series of word spaces (usually only in badly JUSTIFIED typesetting) that form a linked and regular pattern of white space down a page.

ROM (1) Read Only Memory. A CHIP with operating instructions and other FIRMWARE for permanent use by the computers, which cannot be changed by the user. **(2)** See also ROMAN.

Roman The standard characters of a FOUNT, in which the letters are upright, as opposed to ITALIC.

ROP Run Of Paper/Press/Print. In newspaper and similar work, colour printing carried out at the same time as the main run, rather than supplied to

the newspaper preprinted. Run Of Paper is also used synonymously with PRINT TO PAPER.

Rotary A press in which the image to be printed is either a LITHO plate, a LETTERPRESS WRAP ROUND plate or a GRAVURE cylinder or PLATE and on which the image is transferred to the paper by a rotary (rather than reciprocal) motion.

Rotogravure See GRAVURE.

Rough An unfinished layout or design.

Rough proof A proof that is not necessarily in position or on the correct paper, usually LETTERPRESS.

Round cornering A FINISHING or binding operation in which a special die is used to round the corners of a book or other item — possibly before it is CASED in.

Rounded and backed The CASED bookbinding operation that shapes a book after sewing or ADHESIVE BINDING so that the back becomes convex (and thus the FOREDGE becomes concave) and at the same time forms a shoulder against which the CASE boards fit.

Rout On a LETTERPRESS BLOCK a mechanical operation to remove material in non-printing areas so that they do not make contact with the inking rollers or the paper.

Royal See Paper sizes table on page 154.

RS-232-C Standard 'Receive Send-232-C' of the US Electronic Industries Association (EIA) governing data transfer between different computer systems.

Ruling Process used to prepare MANUSCRIPT books and note pads in which a liquid ink is 'ruled' onto the paper by special pens or discs.

Run (1) To print. **(2)** To start a computer PROGRAM working.

Run back (1) See OVER-RUNNING. **(2)** The opposite to RUN ON.

Run in (US) Instruction that two paragraphs should be set as one without the customary break.

Run on (1) Sheets printed in addition to the basic quantity. **(2)** UK

equivalent to the US term Run in.

Run through In RULING when the lines run from one edge of the paper to the other without break.

Runability The resistance of paper to curling or WEB-breaks and other problems as opposed to PRINTABILITY.

Run-around To layout type on a page so that its line-ends follow the outline of an illustration, which may be regular or irregular.

Running foot/head See HEADLINE.

S

Saddle (wire) stitching The usual way of attaching pages in brochures by cutting a continuous wire to form staples of a length appropriate to the number of pages and firing them through the fold of the SPINE and finally closing them on the inside.

Sans Serif A class of typeface without SERIFs.

SBN See ISBN.

SC (1) Super calendered (see CALENDERED) **(2)** Small caps.

Scale To calculate the percentage of enlargement or reduction required to obtain the desired size from ARTWORK.

Scamp A rough layout.

Scanner An electronic device in which the original subject (which can be a transparency or REFLECTION COPY) is scanned by a conventional light source, a LASER or some other illuminant and the results analysed so that the digital information can be conveyed to an output unit and then onto film. With suitable filtration colours can be SEPARATED and output on film or carried, electronically into an ELECTRONIC PAGE COMPOSTION SYSTEM.

Scatter proof A PROOF in which all the elements are assembled in a random position without regard to the IMPOSITION or TRACKING.

Score To make a crease in a board so that it folds on the intended line.

Screen See HALFTONE SCREEN.

Screen angle When HALFTONES are printed in two or more colours there is a risk of a MOIRE pattern being created if the angle used for each

HALFTONE SCREEN is not correctly selected. In the FOUR-COLOUR PROCESS the angles are commonly black 45 degrees (as in monochrome), MAGENTA 75 degrees, yellow 90 degrees and CYAN 105 degrees.

Screen clash See MOIRE.

Screen printing Formerly called silk screen. Rather than print from a PLATE or cylinder, a stencil is prepared by hand or photographically on a screen or mesh. Ink is then forced through the screen and onto the SUBSTRATE. HALFTONES can be reproduced, very thick ink films carried, and printing is possible on difficult surfaces such as the inside of bottles.

Screen ruling See HALFTONE.

Screen tester A device used to ascertain the fineness of the HALFTONE SCREEN that has been used.

Screened negative/ positive/print Any film or print (of a colour or monochrome subject) that has been REPRODUCED using a HALFTONE SCREEN. Typically a screened NEGATIVE or POSITIVE will be used to produce a further positive or negative, while a print is normally used as part of camera-ready ARTWORK.

Script A typeface that mimics handwriting or calligraphy.

Scrolling The ability of a user to use a VDT as a 'window' on the data in the computer memory and move up and down so that a whole job can be viewed.

Scumming Effect caused in litho printing when the non-image areas of the PLATE do not repel the ink so that a dirty image is printed.

Search and replace Facility on WORD PROCESSORS and FRONT END systems that allows specified words or codes to be searched for and/or replaced with other combinations, which do not have to be the same length. Used in correcting and editing and also for PROTOCOL CONVERSION.

Section Paper folded to form a part of a book or booklet. Sections can be made up of sheets folded to 4, 8, 16, but rarely more than 128 pages, perhaps from two 64-page sections.

See/show/look through *(UK/US)* (**1**) The appearance of paper when held up to the light. (**2**) In less opaque papers the printed image on one side being visible on the other, as opposed to STRIKE THROUGH.

Self copy paper A form of CARBONLESS PAPER in which all the chemicals needed to create an image are ENCAPSULATED in a single sheet.

Self cover A booklet whose cover is of the same material as the text or illustrations.

Self ends A binding in which the ENDPAPER is part of the first and/or last SECTION of the book, as opposed to being TIPPED IN separately.

Semiconductor The material of which CHIPS are made. The material, typically derived from silicon, is less conductive than metals, but more conductive than insulators and may contain the equivalent of over 100,000 transistors on one component.

Separated artwork ARTWORK that has been prepared as a series of OVERLAYS, each one providing the SEPARATION for each colour to be printed.

Separation See COLOUR SEPARATION.

Serial access See ACCESS.

Serial transmission Transmission over a single wire, or more usually a pair of wires, BYTE by byte to complete each BIT unlike PARALLEL transmission.

Serif The small terminating strokes on individual letters/characters, except in *SANS SERIF* types.

Set The width of an individual type character. In the MONOTYPE system, the width, or set, of the widest character (an EM) is measured in points and sub-divided into units, which are one-eighteenth of the set, with all the others being multiples of these units. In PHOTOTYPESETTING systems there are similar units derived from HOT METAL, but they are normally finer.

Set off Marking of the underside of a sheet by the wet ink on the sheet on which it drops at the DELIVERY of a SHEET-FED press.

Set off spray A fine powder used at the DELIVERY of SHEET-FED presses to avoid one sheet touching another and causing SET OFF.

Set solid Type set without any LEADING or LINE FEED.

Set width See SET.

SGML Standard Generalized Mark-up Language. A heirarchical mark-up code structure suitable for converting WORD PROCESSOR output to PHOTOTYPESETTER, or any other electronic medias' codes.

Shadow See DENSITY.

Sheet stock Printed sheets held by the printer either in store or simply awaiting binding, contrasted with bound stock or folded sheet, or quire, stock.

Sheeter A machine used at paper mills and on some WEB-FED presses to cut the web into sheets.

Sheet-fed rotary A press on which the printing PLATE surface is fixed around a cylinder and is fed with single sheets as opposed to a WEB-FED press.

Sheetwork Pages imposed on two separate PLATES or FORMES, one to print each side, each BACKED-UP sheet producing a PERFECTED copy.

Shelf life The period during which a material, such as photographic EMULSIONS, PLATES or CARBONLESS PAPERS, can be stored and still remain usable.

Shore hardness Scale of hardness, most commonly measured on the Shore Mfg Co's 'A' Scale in which a hammer with a diamond point strikes the material being calibrated (such as an OFFSET BLANKET or FLEXOGRAPHIC printing plate), with a greater degree of bounce being recorded for the harder materials.

Short grain See MACHINE DIRECTION.

Show through See SEE THROUGH.

Shrink and spread See SPREAD.

Shrink wrap Wrapping items on pallets/skids in a sleeve of plastic film which is then heated until it shrinks tightly around the contents.

Side lay See LAY.

Side notes Short lines of text set in the MARGIN.

Side sewing/stitching To stitch through the side of

a book/booklet from front to back at the binding edge with a thread or wire.

Signature (1) A consecutive number or letter printed at the foot of the first page of a SECTION to enable a binder to check the correctness and completeness of a binding. The letter or number may be accompanied by a rule on the back of each section so that when they are folded and GATHERED these appear in a stepped pattern. (2) Thus the section itself.

Silk screen See SCREEN PROCESS.

Silver print (US) See BLUE.

Simplex See DUPLEX.

Singer sewing Machine sewing of single sheets on their edge (unfolded) into sections. They are then sewn onto tapes or webbing to produce a book or pamphlet in a LIBRARY BINDING.

Single-colour press A printing press that can only print one colour at each pass.

Size A resin, starch or other synthetic material included in the FURNISH of paper to bind the CELLULOSE fibres and LOADING together to provide resistance to ink penetration and strength.

Skiver A leather binding material made by splitting sheepskins. .

Slave A device such as some PHOTOTYPESETTERs that are totally dependent on another for their operation.

Slip proof See GALLEY PROOF.

Slip sheeting (US) See INTERLEAVING.

Slitting Cutting a sheet into two or more parts on a press or folder, rather than on a GUILLOTINE.

Sloped roman A distortion made on some PHOTOTYPESETTERS that allows the ROMAN fount to be used as a substitute for a true ITALIC. It is typographically unsatisfactory, but saves computer RAM and the cost of the italic FOUNTS themselves.

Slot binding See NOTCH BINDING.

Slug A complete line of type from a LINE CASTER.

Slug setting See LINE CASTER.

Small caps Type FOUNTS, especially those used for book work, may be

provided with an extra alphabet whose CAP HEIGHT of the ROMAN fount is the same as the X-HEIGHT, but without the strokes being thinner than the rest of the fount, as happens if ordinary capitals are reduced to their x-height. There are no true ITALIC small caps.

Small offset Traditional classification for OFFSET presses below A2 in size — usually A4 or A3.

Smart cable A connecting cable for WORD PROCESSOR/computer INTERFACES that enable the user to tell which wires carry which part of a signal.

Smash (US) See NIPPING (UK).

SMPS Society of Master Printers of Scotland — The employers' body for Scotland.

Soft copy/proof The display on a VDU, which in the case of a soft proof of typematter should be WYSIWYG.

Soft dot A HALFTONE dot that is less dense at the edge than at its centre and is thus easy to retouch.

Software The PROGRAMS that enable the computer's HARDWARE to perform its tasks.

Solid See SET SOLID.

Sort (1) A single character of type. (2) A computer operation to rearrange data in any order chosen.

Spaces A non-printing area between letters or words. In HOT METAL formed from blanks less than TYPE-HEIGHT and in PHOTOTYPESETTING they are achieved by moving the paper or imaging device the required distance without making an exposure.

Special sort See PI CHARACTER.

Spelling checker A computer PROGRAM that compares a text file with a spelling dictionary and marks any words that are not recognized as correctly spelled.

SPH Sheets Per Hour.

Spine See BACK.

Splice To join a WEB of paper on a press.

Split duct working When small areas of colour are to be printed at some distance from each other two or more colours can be printed on a SINGLE-COLOUR PRESS. The effect is achieved by confining the coloured inks to just that part of the ink DUCT that supplies the image.

Spoilage (UK) See

MAKEOVERS (US).

Spotting A localized OPAQUING to remove blemishes from negatives.

Spray See SET OFF SPRAY.

Spread (1) Reproduction — a variety of terms such as lock on, overdraw, spread and choke are used to describe the need to make two adjoining images slightly thicker than on the original ARTWORK so that they are easier to REGISTER in two-colour printing. (2) A double truck/page spread (US/UK) occurs where an illustration fills two pages, which can only take place on the centre pages of a SECTION. Elsewhere it is a 'false double'.

Square back See FLAT BACK.

Squared/up (US/UK) A HALFTONE illustration that has been trimmed to a square or rectangular shape.

Squares The 3mm or ⅛ inch projections on the cover of a CASED book and beyond the page trim.

SRA See INTERNATIONAL PAPER SIZES table on page 152. original size.

Stabbing See SIDE SEWING/STITCHING.

Stabilization A photographic process sometimes used in processing PHOTOTYPESETTING paper and which is carried out without the need for 'fixing'.

Stamping (US) See BLOCKING.

Standing time (UK) See OPEN TIME (US).

Standing type Type matter kept in CHASE or stored in pages for reprinting and, by extension, film, paper assemblies or FLATS so stored.

Start/stop bits Extra BITS automatically added to a BYTE to indicate to another computer system the start and stop points of each byte in ASYNCHRONOUS communications.

Step and repeat To repeat an image at planned and regular intervals, for instance when IMPOSING labels.

Step index See CUT IN INDEX.

Stereo/type A duplicate RELIEF printing plate cast in metal, plastic or rubber

from a MATRIX or mould.

Stet An instruction to ignore a deletion mark or other correction on a PROOF.

Stitch To sew, staple or otherwise fasten pages together by a thread or wire in binding.

Stock (1) Any material to be printed on. **(2)** See also SHEET STOCK.

Straight matter/text Copy to be set to a common MEASURE and without any complex typographic commands or TABULATIONS.

Strike on See COLD TYPE.

Strike through Action of an ink's MEDIUM/VEHICLE that, by penetrating the paper, causes a discolouration on the reverse side of the sheet.

String Any combination of characters or command codes in computing or PHOTOTYPESETTING.

Stripping (1) To insert a correction in film or paper during PHOTOTYPESETTING. **(2)** To glue a strip of cloth or paper to the back of a paperback book or pad as a reinforcement. **(3)** To remove the waste material from between cartons and other work after CUTTING AND CREASING. See also FILM ASSEMBLY.

Subscript The opposite to SUPERSCRIPT.

Substance See g/m²

Substrate Usually synonymous with STOCK.

Sulphate A WOODFREE (FREESHEET) pulp prepared by cooking the wood chips in a solution of sodium hydroxide and sodium sulphide.

Sulphite A WOODFREE (FREESHEET) pulp produced by cooking the wood chips in a solution of sulphurous acid and one of its base salts — calcium, sodium, magnesium or ammonia.

Super calendered (SC) See CALENDER.

Superscript/superior characters Letters or numbers that are smaller than text-size and are positioned above the X-HEIGHT of the type BODY.

Supershift A second level of shift on a keyboard that has the effect of giving the keys access to another FOUNT or set of codes.

Surprinting *(US)* See OVERPRINTING or DOUBLE BURN.

Suss box A tester used to determine which

connection is which on an RS-232-C interface.

Swash characters ITALIC letters with exaggerated strokes available in some FOUNTS.

Swatch A collection of colour patches to show the colour of papers or inks.

Synchronous The opposite to ASYNCHRONOUS. The devices at each end of a data link work in step with each other so that there is no need to include a START/STOP BIT with each BYTE.

T

Table, look up Look up tables are used in computers for a number of purposes. In typesetting the main purposes are to provide the dictionaries for HYPHENATION decisions, the variables for FOUNT widths in justification and the STRING conversions when text from one machine is read by another.

Tablet See GRAPHICS TABLET.

Tabloid See BROADSHEET.

Tabulate To arrange type in regular columns, usually of figures.

Tack the degree of stickiness of the MEDIUM/VEHICLE of a printing ink or varnish.

Tail See FEET/FOOT.

Tailband See HEADBAND.

Tape (1) A paper ribbon punched with from 5 to 31 rows of holes used to control computers, telex and PHOTOTYPESETTERS, but largely replaced by the different MAGNETIC MEDIA. **(2)** In better book binding, tapes are laid across the SPINE before the book is sewn to give extra strength.

Tapper A keyboard operator.

Teletex A high-speed dial-up network on the PSTN linking different makes of WORD PROCESSORS and computers intended to replace telex.

Teletext A synonym for broadcast videotex, such as the British Ceefax and Oracle or Canadian Teleidon.

Teletypesetting See TTS.

Text retrieval terminal A device used to take data from one computer to another. It may store the data on any MAGNETIC MEDIA and usually connects to the individual computers by an RS-232-C

interface. Also called a MILKING MACHINE or FART BOX.

Thermal printer A computer printing device that images a heat-sensitive paper.

Thermography An imitation of DIE STAMPING in which a raised image is obtained by printing with a very sticky ink or varnish. This is then dusted with a fine powder, which may be pigmented, and which is then heated to fuse it to the paper in a relief pattern.

Thick space A type space one-third of an EM.

Thin space A type space one-fifth of an EM.

Thou 1/1000 inch. POINT *(US)*.

Thread sealing Method of book binding in which the SECTIONS are 'stabbed' with thread, the loose ends then being sealed with adhesive.

Three-knife trimmer A GUILLOTINE designed with three knives for trimming small stacks of books or magazines. One trim removes the FEET and HEADS and another the FOREDGE.

Throw-out Usually an extension to a double page SPREAD where a special IMPOSITION allows for an extra page or pages to fold out from the FOREDGE.

Thumb index A book index where the dividers are cut into the FOREDGE rather than stepped as in a CUT in or tab index.

Timesharing The ability of large computer systems to split their processing power so that many users (not always on the same site) can appear to be using it exclusively while actually sharing its facilities.

Tint block A solid LETTERPRESS PLATE used to print flat colours.

Tint laying The positioning of tints by STRIPPING.

Tints Shading on film, dry TRANSFER LETTERING sheets or on BLOCKS. Complex layouts are accomplished by cutting the tints in one or more colours by hand, by producing them on a camera or programming a SCANNER or ELECTRONIC PAGE COMPOSITION SYSTEM.

Titling fount (1) In HOT METAL a fount of capitals that are the full BODY height, with no allowance

for DESCENDERS. (**2**) In PHOTOLETTERING any fount.

To view Used to refer to the number of pages appearing on one side of a printed sheet (for example, 32 pages to view would equal 64 pages per sheet).

Tone The gradation from light to dark in black or any colour, contrasted with line work that has no intermediate tones.

Tooling (*US*) See BLOCKING.

Top side See RIGHT SIDE.

Touch screen A VDT that accepts commands by the operator touching areas of the screen. The position of the finger is usually sensed by a framework of sensors.

Track (**1**) In printing a line from the front edge of a PLATE to the back. Items IMPOSED in track will all be subject to the same inking adjustments on press. (**2**) In MAGNETIC MEDIA the information is laid down in tracks, for instance often nine tracks on tape and from 35 to 80 on a DISKETTE.

Tranny A transparency.

Transfer lettering A plastic sheet that has letters (or other designs) SCREEN PRINTED on its reverse side and that can be rubbed down on ARTWORK.

Transpose To swap two letters or other items, in error or by design.

Trap (*US*) See SPREAD.

Trapping The ability of a film of ink to accept a subsequent layer, often a problem when printing WET ON WET.

Trim To cut a sheet of paper to the required size before printing, or a printed product during FINISHING.

Trim marks (*UK*) See CUT MARKS (*US*).

TRT See TEXT RETRIEVAL TERMINAL.

True small caps See SMALL CAPS.

Ts Typescript.

TTS (**TeleTypeSetting**). The coding of paper tapes used on newspaper and the earlier PHOTOTYPESETTERS and based on codes used by teletype keyboards over a telephone/ telegraph system.

Turned in The material used on the CASE of a book is turned in round the edges, so as not to leave the boards' edges exposed, rather than CUT FLUSH.

Turner bar On a WEB-FED press the web is sometimes split before folding. The sub-webs are then re-aligned to the left or right of the previous direction by pairs of turner bars placed at 45 degrees to the axis which turn the web twice by 45 degrees.

Twin-wire paper (**1**) A high-quality, even-sided, and usually unCOATED paper produced from two WEBS joined together on the FOURDRINIER machine while still wet, with their WIRE SIDES at the centre. (**2**) Publication papers produced from a single web on a machine that has a small supplementary top wire pressing down on the sheet or on a VERTIFORMER in which the sheet is formed between two vertical wires as it moves downwards.

Two (or more) set/up To impose a job for printing with multiple images to view, so as to obtain more copies from the sheet when printed, reduce the length of run and utilize the full size of the press.

Two-colour machine A press that prints one side of the sheet in two colours in one pass. Some two-colour presses are also CONVERTIBLE.

Type area That area of a page set aside for type, that is, excluding the margins.

Type scale (*UK*) See LINE GAUGE (*US*).

Typeface classification Typefaces may be classified by their design characteristics and style or by their historic origin. The current International Standard uses the former.

Typefounding Traditionally the manufacture of type by pouring an alloy through a mould into a specially prepared MATRIX for each character. The producers of digital type who are not also equipment manufacturers are called digital typefounders.

Type-height LETTERPRESS printing PLATES are type-high when mounted at the correct height for letterpress printing. See also HEIGHT TO PAPER.

Typesetting See HOT METAL TYPESETTING or PHOTOTYPESETTING.

Typo Commonly used term for a typographical error.

Typographer (**1**) (*UK*) A typographic designer. (**2**) (*US*) See COMPOSITOR (*UK*).

Typositor A make of PHOTOLETTERING MACHINE using a 5 centimetre (2 inch) film strip FOUNT.

U

U&lc Upper and lower case, or capitals and small letters.

UCR See UNDERCOLOUR REMOVAL.

Ultraviolet See RADIATION DRYING.

Unbacked A sheet printed on one side only.

Undercolour removal Technique of removing unwanted colour in SEPARATIONS either to reduce the amount of ink to be used (for economy or to reduce TRAPPING) or where these colours 'cancel each other out' in the various ACHROMATIC systems.

Underside The side of a WEB on the wire side of the paper making machine. The 'wrong' side from the printers' point of view.

Unit (**1**) Multi-colour printing presses are divided into units, each unit printing one or more colours on one or both sides. (**2**) The division of the EM of the BODY size, each character of a FOUNT having its own unit widths. The systems vary according to manufacturer and are essential for JUSTIFICATION. See also SET.

Unix An OPERATING SYSTEM that can enable multiple-user microcomputers to run multiple tasks.

Unjustified setting Lines of type aligning vertically on one side only, and ragged on the other. The word space is usually kept to a constant value.

Unjustified tape See NON-COUNTING KEYBOARD.

Unsewn binding See ADHESIVE BINDING.

UPC Universal Product Code — see BAR CODE.

Upper case (**1**) A name for the capital letters or caps. (**2**) From the type case that held the capital letters in metal type.

UV UltraViolet. See RADIATION DRYING.

V

V Series The ISO/CCITT standards from V1 to V53 governing data transmission in Europe

and most countries outside North America.

Vacuum frame A device (which may have an in-built light source) used to expose a sheet of film in contact with another film or a PLATE. A vacuum pump excludes the air to make sure that the EMULSION to emulsion contact is perfect.

Vandyke See BLUE PRINT/BLUES.

Variable space The space inserted between words to justify them. See HYPHENATION AND JUSTIFICATION.

Varnish To apply varnish or lacquer to printed matter to improve its appearance or possibly to increase its durability. Not as strong or glossy as LAMINATION.

Vat machine See CYLINDER MACHINE

VDT Visual Display Terminal, or a television-like display screen with a keyboard attached

VDU A VDT with no keyboard.

Vector An outline used to describe a shape on a VDU. On some PHOTOTYPESETTING systems the character can be stored as a vector to save space, and, when set, each character is converted to a RASTER 'on the fly' by the computer.

Vehicle See MEDIUM.

Vellum The inner side of a calfskin, used for binding fine books.

Vellum finish A finish applied to paper and smoother than 'parchment'.

Velox *(US)* See PHOTOMECHANICAL TRANSFER.

Verso A left-hand page.

Vertiformer A TWIN-WIRE paper machine in which the normal horizontal wire of a FOURDRINIER paper machine is replaced by a pair of vertical wires. The headbox is at the top and the sheet is formed between the two wires as they move downwards.

Viewer A lighted box or booth on/in which to view transparencies, proofs or ARTWORK under standardized conditions.

Vignette Effect applied to HALFTONES that, instead of being squared up or CUT OUT, have the tone etched gently away at the edges.

Viscosity The fluidity of inks, and so on. LETTERPRESS, LITHO and SCREEN PROCESS inks are highly viscous while those used in GRAVURE and FLEXOGRAPHY have a low viscosity.

Visual *(UK)* See COMP *(US)*.

Visual display terminal/unit See VDT or VDU.

Volume A measure of the thickness of papers in relation to their SUBSTANCE.

W

Wally box Slang for a PROTOCOL CONVERTER.

Waterless offset See DRY LITHO.

Watermark A design impressed into a newly-formed WEB of paper in a similar way to LAID lines by a DANDY ROLL rotating in contact with the partly

formed web.

Web Paper made in a roll, or web, on a FOURDRINIER or a CYLINDER MACHINE.

Web offset Reel-fed OFFSET LITHO printing. The three main systems are: BLANKET TO BLANKET when two PLATE and two BLANKET cylinders on each unit print and PERFECT the WEB; three-cylinder systems in which plate blanket and IMPRESSION cylinders print one side of the paper only; and satellite or planetary systems in which two, three or four plate and blanket cylinders are arranged around a common impression cylinder printing one side of the web in as many colours as there are plate cylinders.

Web-fed Presses that are fed by paper from a reel as distinct from SHEET-FED machines.

Wet on wet When multi-colour work is printed on presses that print more than one colour at a pass, with the succeeding colours being added before the previous colour can dry.

Weight of type The 'colour' of a face — the light, medium, BOLD, or other FOUNT in a family of designs.

WF (1) Wrong FOUNT, a character from one fount appearing in setting in another. **(2)** *(UK)* Woodfree, see FREESHEET *(US)*.

White out (1) Painting out

matter not required for REPRODUCTION on artwork. (**2**) To space out type matter to improve the design.

Whole bound See FULL BOUND.

Widow A short line at the end of a paragraph left at the top of a page. See also CLUB LINE.

Winchester disk A group of rigid magnetic disks rotating in a vacuum, giving greater storage capacity than a FLOPPY DISK.

Wipe on plate A printing plate that has the light-sensitive coating wiped on by hand immediately before exposure, instead of being factory-coated.

Wire side The side of a WEB of paper that was in contact with the paper making machine's wire.

Wiremark The mark left by the paper making machine's wire on the underside of the WEB of paper.

Woodfree paper (UK) See FREESHEET (US).

Word break The point at which a word must be HYPHENATED if the MEASURE is to be maintained.

Word processor A computer used to input, edit and store text. Dedicated machines are designed exclusively for word processing, but word processing PROGRAMS are also widely available that work on most computers.

Word spacing Spaces. added between words that must be greater than those between letters for

clarity, but not so great that when used to achieve HYPHENATION AND JUSTIFICATION they cause RIVERS.

Wordwrap In text entry systems when a word is too long to fit on the current VDT line the computer automatically transfers the whole word to the start of the next line as it is being typed by the operator.

Work and back See SHEETWORK.

Work and tumble/turn/twist Work that is printed entirely (and on both sides of a sheet) from one plate or FORME while changing the gripper edge (tumble), or without changing the gripper edge (turn) or turning the sheet at right angles (twist). (See also page 60.)

Working A single printing operation imaging one or more colours on one or both sides of the sheet depending on the type of press being used.

Wove Paper with an even, fine 'woven' surface, rather than the parallel line pattern of LAID sheets.

Wrap round (**1**) A PLATE that wraps around a plate cylinder. The norm in LITHO, but not universal in LETTERPRESS. (**2**) One sheet or SECTION wrapped around another in binding.

Wrappering To add a paper or board cover in binding by a strip of glue or stitching at the spine,

or to wrap extra pages round a SECTION to make it up to the required number of pages or to add illustrations around text-only sections.

Wrong fount (**WF**) A character in a FOUNT in setting in another.

Wrong grain See MACHINE DIRECTION.

Wrong reading Film that has been made so that it reads from right to left from the side in question.

Wrong side See WIRE SIDE.

WYSIWYG Abbreviation for 'What You See Is What You Get'. A VDT/VDU, used for text input, editing, PAGINATION or for SOFT PROOFS in which the type on the screen more or less perfectly emulates the final output.

X

Xenix An OPERATING SYSTEM similar to UNIX.

Xerography Proprietary name for a form of ELECTROSTATIC PRINTING.

x-height That part of a letter with no ASCENDER or DESCENDER — an 'a' or an 'x' for example.

Y

Yapp See LIMP BINDING.

Z

Zero make ready press See AUTOMATIC TRANSFER PRESS.

Zinco Synonymous with a LINE BLOCK (UK) or cut (US).

The 'A' series is a system for sizing paper and was first used in Germany in 1922 where it is still called 'Din A'. Each size is derived by halving the size immediately above it. Each size is the same as another geometrically as they are halved using the same diagonal. A0 is the first size and is one square metre (10¾ square feet, approximately) in area. A series sizes always refer to the trimmed sheet. The untrimmed sizes are referred to as 'RA' or 'SRA'. About 26 countries have officially adopted the A series system and it is probable that it will slowly replace the wide variations in the sizing of paper in Great Britain and America. The 'B' series is used when a size inbetween any two adjacent A sizes is needed, which is relatively rare. The British and American systems, unlike the metric A system, refer to the untrimmed size of the sheet. As quoting just the A or B number can cause confusion, both the A or B size and the size in millimetres or inches should be given when specifying paper.

	inches	mm			inches	mm
A0	33.11 x 46.81	841 x 1189		**A6**	4.13 x 5.83	105 x 148
A1	23.39 x 33.11	594 x 841		**A7**	2.91 x 4.13	74 x 105
A2	16.54 x 23.39	420 x 594		**A8**	2.05 x 2.91	52 x 74
A3	11.69 x 16.54	297 x 420		**A9**	1.46 x 2.05	37 x 52
A4	8.27 x 11.69	210 x 297		**A10**	1.02 x 1.46	26 x 37
A5	5.83 x 8.27	148 x 210				

	inches	mm			inches	mm
RA0	33.86 x 48.03	860 x 1220		**SRA0**	38.58 x 50.39	980 x 1280
RA1	25.02 x 33.86	610 x 860		**SRA1**	25.20 x 35.43	640 x 900
RA2	16.93 x 24.02	430 x 610		**SRA2**	17.72 x 25.20	450 x 640

ISO B series (untrimmed)

	inches	mm			inches	mm
B0	39.37 x 55.67	1000 x 1414		**B6**	4.92 x 6.93	125 x 176
B1	27.83 x 39.37	707 x 1000		**B7**	3.46 x 4.92	88 x 125
B2	19.68 x 27.83	500 x 707		**B8**	2.44 x 3.46	62 x 88
B3	13.90 x 19.68	353 x 500		**B9**	1.73 x 2.44	44 x 62
B4	9.84 x 13.90	250 x 353		**B10**	1.22 x 1.73	31 x 44
B5	6.93 x 9.84	176 x 250				

ISO C series envelopes

	mm	inches
C0	917 x 1297	36.00 x 51.20
C1	648 x 917	25.60 x 36.00
C2	458 x 648	18.00 x 25.60
C3	324 x 458	12.80 x 18.00
C4	229 x 324	9.00 x 12.80
C5	162 x 229	6.40 x 9.00
C6	114 x 162	4.50 x 6.40
C7	81 x 114	3.20 x 4.50
DL	110 x 220	4.33 x 8.66
C7/6	81 x 162	3.19 x 6.38

Paper usage formulae

To calculate the number of sheets of paper required to print a book (excluding covers):

$$\frac{\text{Number of copies to be printed x Number of pages in book}}{\text{Number of pages printing on both sides of sheet}} = \text{Number of sheets required}$$

To calculate the number of copies obtainable from a given quantity of paper:

$$\frac{\text{Number of sheets x Number of pages printing on both sides of sheet}}{\text{Number of pages in book}} = \text{Number of copies}$$

American paper sizes (untrimmed)

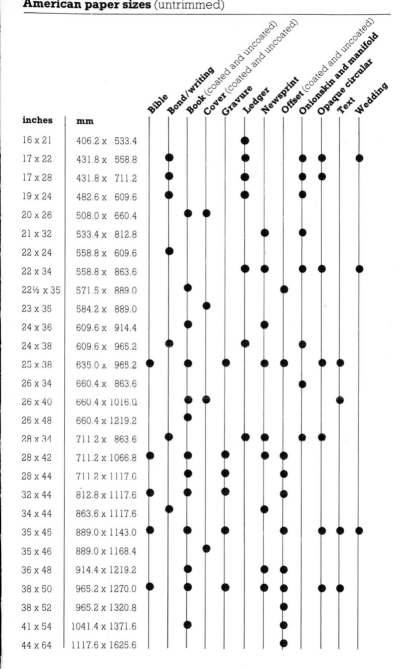

Column headers (left to right): Bible · Bond/writing · Book (coated and uncoated) · Cover (coated and uncoated) · Gravure · Ledger · Newsprint · Offset (coated and uncoated) · Onionskin and manifold · Opaque circular · Text · Wedding

inches	mm
16 x 21	406.2 x 533.4
17 x 22	431.8 x 558.8
17 x 28	431.8 x 711.2
19 x 24	482.6 x 609.6
20 x 26	508.0 x 660.4
21 x 32	533.4 x 812.8
22 x 24	558.8 x 609.6
22 x 34	558.8 x 863.6
22½ x 35	571.5 x 889.0
23 x 35	584.2 x 889.0
24 x 36	609.6 x 914.4
24 x 38	609.6 x 965.2
25 x 38	635.0 x 965.2
26 x 34	660.4 x 863.6
26 x 40	660.4 x 1016.0
26 x 48	660.4 x 1219.2
28 x 34	711.2 x 863.6
28 x 42	711.2 x 1066.8
28 x 44	711.2 x 1117.6
32 x 44	812.8 x 1117.6
34 x 44	863.6 x 1117.6
35 x 45	889.0 x 1143.0
35 x 46	889.0 x 1168.4
36 x 48	914.4 x 1219.2
38 x 50	965.2 x 1270.0
38 x 52	965.2 x 1320.8
41 x 54	1041.4 x 1371.6
44 x 64	1117.6 x 1625.6

US book sizes

mm	inches	mm	inches
140 × 216	5½ × 8½	156 × 235	6⅛ × 9¼
127 × 187	5 × 7⅜	136 × 203	5⅜ × 8
140 × 210	5½ × 8¼	143 × 213	5⅝ × 8⅜

British standard book sizes

	Quarto		Octavo	
	mm	**inches**	**mm**	**inches**
Crown	246 × 189	9.69 × 7.44	186 × 123	7.32 × 4.84
Large Crown	258 × 201	10.16 × 7.91	198 × 129	7.8 × 5.08
Demy	276 × 219	10.87 × 8.62	216 × 138	8.5 × 5.43
Royal	312 × 237	12.28 × 9.33	234 × 156	9.21 × 6.14

Conversion tables USA weights to g/m²

500 sheets 25×38 inches		500 sheets 24×36 inches		500 sheets 20×26 inches		500 sheets 17×22 inches	
lb	**g/m²**	**lb**	**g/m²**	**lb**	**g/m²**	**lb**	**g/m²**
20	30	25	41	50	135	8	30
25	31	30	49	55	149	10	38
30	44	35	57	60	162	12	45
35	52	40	65	65	176	14	53
40	59	45	73	70	189	16	60
45	66	50	82	75	203	18	68
50	74	55	90	80	216	20	75
55	81	60	98	85	230	22	83
60	89	65	105	90	243	24	90
65	96	70	114	95	256	26	98
70	104	75	122	100	270	28	105
75	111	80	130	105	284	30	113
80	118	85	138	110	298		
85	126	90	147	115	310		
90	133	95	155	120	324		
95	140	100	163	125	338		
100	148	125	204	130	352		
105	155	150	244	135	366		
110	162	175	285	140	379		
115	170	200	325	145	392		
120	178	225	365	150	405		
125	185	250	400				
130	193	275	450				
135	200	300	490				
140	208						
145	215						
150	222						

Conversion factors

To convert	To	Multiply by
Inches	Centimetres	2.54
Centimetres	Inches	0.3937
Feet	Centimetres	30.4800613
Centimetres	Feet	0.0328
Yards	Metres	0.914
Metres	Yards	1.094
Miles	Metres	1609.3

To convert	To	Multiply by
Metres	Miles	0.000621
Square inches	Square centimetres	6.45162581
Square centimetres	Square inches	0.155
Square feet	Square metres	0.093
Square metres	Square feet	10.764
Square yards	Square metres	0.836
Square metres	Square yards	1.196
Cubic inches	Cubic centimetres	16.39
Cubic centimetres	Cubic inches	0.061
Cubic feet	Litres	28.3
Litres	Cubic feet	0.0353
Cubic feet	Gallons (imperial)	6.24
Gallons (imperial)	Cubic feet	0.1602
Cubic feet	Gallons (US)	5.1959
Gallons (US)	Cubic feet	0.1924
Gallons (imperial)	Gallons (US)	1.20095
Gallons (US)	Gallons (imperial)	0.83267
Gallons (imperial)	Litres	4.546
Litres	Gallons (imperial)	0.22
Gallons (US)	Litres	3.785306
Litres	Gallons (US)	0.264179
Cubic feet	Cubic metre	0.028317
Cubic metre	Cubic feet	35.31467
Cubic yards	Cubic metres	0.7645549
Cubic metres	Cubic yards	1.307951
Square miles	Square kilometres	2.58999
Square kilometres	Square miles	0.3861022
Pounds (avoirdupois)	Kilogrammes	0.4536
Kilogrammes	Pounds (avoirdupois)	2.2046
Ounces (avoirdupois)	Grammes	28.35
Grammes	Ounces (avoirdupois)	0.0352
Grains	Grammes	0.065
Grammes	Grains	15.432
Hundredweight (short)	Kilogrammes	45.359237
Kilogrammes	Hundredweight (short)	0.02204623
British fl.oz	US fl.oz	0.961
Us fl.oz	British fl.oz	1.04058
Us fl.oz	ml	29.57270
ml	US fl.oz	0.033815
British fl.oz	ml	30.7728
ml	British fl.oz	0.0325
Hundredweight (long)	Kilogrammes	50.8
Kilogrammes	Hundredweight (long)	0.01968
Tons	Kilogrammes	1016.0
Kilogrammes	Tons	0.000984
Hundredweight (long)	Pounds (avoirdupois)	112.0
Pounds (avoirdupois)	Hundredweight (long)	0.00893
Hundredweight (short)	Pounds (avoirdupois)	100.0
Pounds (avoirdupois)	Hundredweight (short)	0.01
Pounds (avoirdupois)	Tons (long)	2240.0
Tons (long)	Pounds (avoirdupois)	0.000446
Pounds (avoirdupois)	Tons (short)	2000.0
Tons (short)	Pounds (avoirdupois)	0.0005
Tons (metric)	Tons (short)	1.102
Tons (short)	Tons (metric)	0.90718

Bibliography

The dates given are of the latest known edition. Unfortunately there are no recent
titles in some subject areas. While some of the titles are out of print, they are still
available in reference libraries.

General reference
Authors' and Printers' Dictionary, F H Collins (University Press, Oxford, 1973)
Bookmaking, Marshall Lee (R R Bowker Company, New York and London, 1979)
Book Production Practice, (Publishers Association and the British Printing
Industries Federation, London, 1984)
Hart's Rules for Compositors and Readers at the Oxford University Press,
(University Press, Oxford, 1983)
Introduction to Science for Printers, G R Marshall (Heinemann, London, 1963)
Elsevier's Dictionary of the Printing and Allied Industries, F J M Wijneus
(Elsevier Publishing Company, London & Amsterdam, 1983)
Rookledge's International Typefinder, Christopher Perfect and Gordon
Rookledge (Sarema Press, London, 1983)

Binding
Bookbinding and Warehouse Calculations, F W Avis (F Avis, 1967)
Introduction to Bookbinding, L S Darley (Faber & Faber, London, 1965)
Modern Bookbinding, A J Vaughan (Charles Skilton Ltd, 1960)
While there are no recent books on bookbinding much information is contained in
Bookmaking – see General reference above.

Composition
ASPIC — Authors' Symbolic Prepress Interfacing Codes, (BPIF, London, 1984)
Electronic Typesetting, Lawrence W Wallis (Paradigm Press/Institute of Printing,
Tunbridge Wells, 1983)
Electronic Composition, Alan Holmes (Practical Printing Handbooks/Emblem
Books, Northwood, 1984)
Guide to Copy Preparation and Proof Correction, BS5261 (British Standards
Institution, 1975 and 1976)
A Manual for Phototypesetting, L G Heath and Ian Faux (Lithographic Training
Services, London & Manchester, 1978)

Design and typography
An Approach to Type, John R Biggs (Blandford Press, London, 1961)
Browns Index to Photocomposition Typography, Bruce Brown, (Greenwood
Publishing, Minehead, 1983)
The Designer's Handbook, Alastair Campbell (Macdonald, London, 1983)
The Encyclopedia of Type Faces, Jaspert, Berry and Johnson (Blandford Press,
Poole, 1983)
A History of Book Illustration, David Bland (Faber & Faber, London, 1969)
Introduction to Typography, Oliver Simon (Faber & Faber, London, 1963)
Methods of Book Design, Hugh Williamson (Yale University Press, London, 1983)
The New Western Type Book, (Hamish Hamilton, London, 1980)
The Twentieth Century Book, its Illustration and Design, John Lewis (Herbert
Press, London, 1984)
Type for the Book Page at the Pitman Press, (Hamish Hamilton, London, 1984)
Typography: Basic Principles, John Lewis (Studio Vista, London, 1963)
Typography for Students, E G Shepherd (Macdonald & Evans, London, 1966)
The Use of Type, John R Biggs (Blandford Press, London, 1964)

Graphic reproduction
Camera and Process Work, E Chambers (Benn, 1964)

Graphic Reproduction Photography, James Walter Burden (Focal Press, London, 1980)
Handbook of Process Engraving (Graphic Reproduction Federation, London, 1955)
Illustration and Reproduction, John R Biggs (Blandford Press, London, 1951)
Illustration of Books, David Bland (Faber & Faber, London, 1962)
Line and Halftone Photography for Printing, Paul Chambers (Practical Printing Handbooks/Emblem Books, Northwood)
The Preparation of Colour Artwork, Institute of Practitioners in Advertising, London, 1972)
Standardising Process Colour Printing, (BPIF, London, 1982)

History
500 Years of Printing, S H Steinberg (Penguin Books, Harmondsworth, 1961)
A Chronology of Printing, Colin Clair (Cassell, London, 1969)

Paper
Introduction to Paper, T Brown (H Whitaker, 1967)
Paper, its Making, Merchanting and Usage, S C Gilmour (Longman, London, 1965)
Sizes of Paper and Board, BS4000 (British Standards Institution, 1983)
What the Printer Should Know about Paper, William H Bureau (GATF, Pittsburgh, USA, 1983)
What the Stationer and Printer Ought to Know About Paper, H A Maddox (H Whitaker, 1967)

Printing processes
Complete Book of Silk Screen Printing, J I Biegeleisen (Dover Press, 1964)
Inks for Offset Three- or Four-colour Printing, common ES and BS466 (British Standards Institution, 1971)
Photographic Screen Printing, Albert Kosloff
Printing by Lithography, Ian Faux (Practical Printing Handbooks/Emblem Books, Northwood)
Screen Printing Techniques, Albert Kosloff

Credits

Photographs and illustrations
11, 14, 53-4, 95, 101, 104, 106-7 Hussein Hussein; **11, 16-7, 23, 74, 92-3** Mick Hill; **12** St Bride Printing Library; **12-3, 27** Pershke Price Services Ltd; **16** Heidelberg; **18, 69, 71** Pete Zeery; **22** Rotaprint PLC; **22, 39, 65, 94-5** Colin Cohen; **31** Caslon Ltd; **47** Leslie Hubble Ltd; **55, 68-9** Crosfield Electronics Ltd; **56-7, 58-9, 106** Andy Luckhurst; **56-7** TRP Slavin; **58-9** David Luckhurst; **62-4, 66** BPCC/Hazel, Watson and Viney Ltd; **64** The Archer Press; **76** Visutek Graphic Products Ltd; **79** Data Communications; **88-9** Fishburn Inks Ltd; **92-3** Lawrence Brookman; **92** Tullis Russell; **94** The Wiggins Teape Group Ltd; **100-1, 105** Graphic Arts Equipment Ltd; **120** Apple Computers Inc.

Index

Page numbers in *italic* refer to illustrations and captions.